PHOTOFINISH

PHOTOFINISH

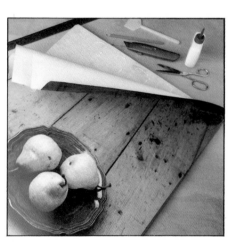

Alex Morrison

VAN NOSTRAND REINHOLD COMPANY
NEW YORK CINCINNATI TORONTO LONDON MELBOURNE

Photofinish
by Alex Morrison
was conceived, designed, and produced
by Imprint Books Limited
12 Sutton Row, London W1V 5FH

Art Direction: Michael Rose
Special Projects: Martin Atcherley
Editorial: Penny Grant
 Sheila Shulman
Production: Kenneth Clark
 John Reynolds

Printed and bound in Belgium by H. Proost & Cie, Turnhout

Published by Van Nostrand Reinhold Company
A division of Litton Educational Publishing, Inc.
135 West 50th Street,
New York, N.Y. 10020, U.S.A.

Van Nostrand Reinhold Limited
1410 Birchmount Road
Scarborough, Ontario M1P 2E7, Canada

16 15 14 13 12 11 10 9 8 7 6 5 4 3 2 1

Library of Congress Cataloging in Publication Data

Morrison, Alex.
 Photofinish.

 Includes index.
 1. Photographs—Trimming, mounting, etc.
I. Title.
TR340.M67 770'.28'4 80-22711
ISBN 0-442-21262-3

Contents

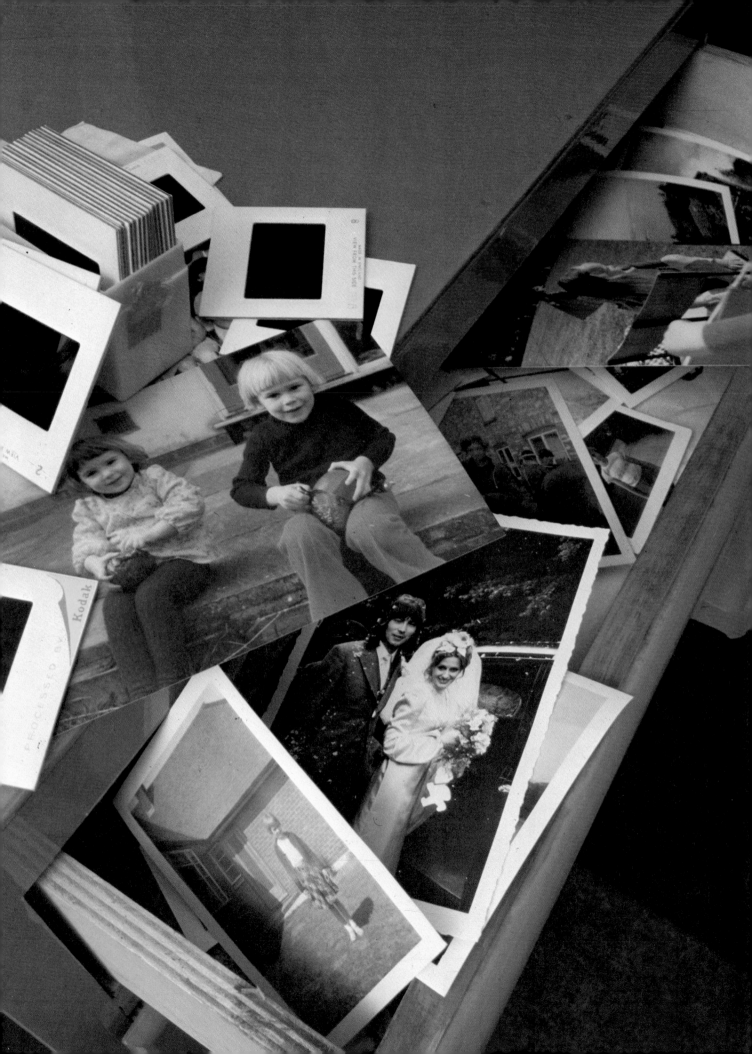

Where to Begin

Learning to work with photographs—to look at old ones again, to take new ones with a specific plan for their use in mind, to consider the many possible ways to display them, to learn about the associated crafts of mounting and framing, perhaps even to process prints in your own darkroom—opens up a whole world of visual pleasure, intellectual excitement, and the satisfaction of working creatively with your eyes and hands. Working with photographs also makes it possible to decorate and beautify your home in a highly personalized style.

Photographs, often casual and disregarded, are little illuminations, fragments of lives, of being. They are not to much purpose hidden in a drawer, or between the covers of an album that you look at perhaps once a year, or stuck, shrivelling and curling, in the frame of a mirror. They need to be displayed to be revealed, to have the life in them released and enhanced. Treated with care, and craft, and style, and a sense of fun, photographs can, in turn, enhance the walls of our rooms, our lives, not only the spaces we live in, but the spaces that live in us. This reciprocal enrichment is not dependent upon "great" or even professional photographs.

Almost everyone has a hoard, large or small, of old photographs, whose charm can come simply from their age, or their family associations, or from the vanished styles of life they reflect. And what amateur has not, even accidentally, caught a friend or a child or a place at a felicitious moment?

Photography can stop time, capture space, reawaken memory, recreate history (personal or public), and perhaps most importantly, "open the doors of perception" for the photographer and the viewer. It can hold the fleeting moment—the ephemeral smile, the transitory evening light on a hillside, the spark of life in a human encounter, the drop of rain on a blade of grass, or the turbulence of a giant wave—with a power, precision, and flexibility possible with few other media. These powers are of course illusory—the moment passes, the spark goes out, the wave crashes—but the two-dimensional record, the photograph, retains its capacity to convince and remains either an embodied memory or an encapsulated vision, a crack in the flat, dull surface of ordinary reality, an opening into a more living universe.

Photographs used creatively will not only beautify your home, but may also enrich your life.

Overwhelmed as most people are by the drawers, envelopes, and boxes full of photographs, negatives, and slides they have accumulated, it is difficult to see them as a valuable and exciting source of interior decoration. Before you begin to sort out your pictures, browse through this book to get an idea of the many ways that photographs can be used creatively. Next, look critically at your home. Are there walls that seem rather bare? Are there areas which could be enhanced by bright spots of colour? Perhaps a *trompe l'oeil* photo window would bring a dark corner to life. Maybe an arrangement of family photographs, brightly matted and framed, would bring a sparkle to your bedroom. And why not use a colour print of a seascape slide you have taken, rather than waiting until you can afford a painting to hang over the couch in the living room?

Sift through your photographs and look at them in terms of their potential. You will probably find that the photographs you have can be separated into groups with, of course, some overlapping. Some photographs, particularly those which have been enlarged, need only mounting or framing to be suitable for photo decor. Other photographs, and often these can be simple snapshots, will reveal themselves as intriguing only when they are grouped thematically, so that the arrangement, and the interrelations within it, becomes the source of interest.

You will find that some of your pictures will

Where to Begin

require some reworking. Cropping or simply enlargement could change them radically, or a salient detail could be picked out and become a complete and striking image. Some photographs are basically good, but the only print is not. This is easily remedied if you have the relevant negative from which a new print can be made. When, on the other hand, all you have is a snapshot, but a snapshot with potential, a photographic studio can easily make a copy negative from which new and better prints and enlargements can be made. Sometimes

attractive old photographs are in a state of decrepitude. A good retoucher can eliminate cracks, tears, and other signs of age and make a print that retains the antique appearance without the faults.

After sorting your photographs and looking at them carefully, you may find some that could be enhanced by vignetting, sepia toning, or even hand tinting—simple techniques which are explained in this book. Other photographs might be dramatized by posterization or solarization.

Undoubtedly among your photographs there will be those that can be most effectively used as interesting elements in collages. But some

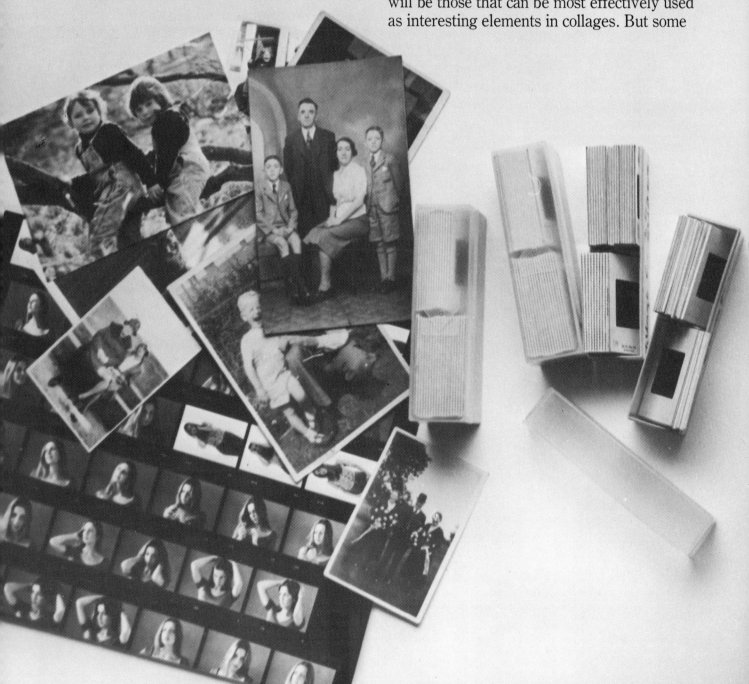

black and white prints, if they are clear, simple images with a high degree of contrast, can be transferred on to linen, china, or even metal, creating effects of considerable interest and charm. Or colour prints can be made from slides, enlarged, printed on resin-coated paper, and then laminated and used for many projects ranging from placemats to a shoeshine kit to the doors of your kitchen cabinets.

All these possibilities considered, if your existing collection of photographs does not meet your decorative needs or ideas, there is, of course, always the possibility of taking new photographs for a given purpose or place.

You may become involved with equipment and processing to varying extents. Equipment can mean anything from a cutting board, glue, and a craft knife, to a full-blown darkroom. Professional services are, of course, available for all kinds of projects, from the simplest to the most complex. As your interest, experience, and sense of accomplishment grow, you will probably want to do more and more at home, and this will, after any initial investment in tools and equipment, be less costly and more satisfying than having things done professionally. This book gives you all the basic information and instruction.

For even a simple project, you need a clean, dry, well-lit place to work, and a bit of convenient space for storing tools and equipment. At the beginning this need be no more than a solid table you can walk all the way around, with a drawer or two for storage. The important thing to remember is that although your photographs can be an end in themselves, they can be far more rewarding as a continually growing source of aesthetic and decorative possibilities and transformations.

Displaying Your Photographs

For untold millennia, since long before anything we choose to call civilization, human beings have lived surrounded by reflections of various facets of their lives and environments, displayed in some mode of visual imagery on whatever could be called a wall. Historically, people have found such reflections reassuring, enlightening, entertaining, educational, a source of magical power, or simply aesthetically pleasing. The earliest examples we know are the wonderful lively cave paintings at Lascaux, in France. Highly stylized yet realistic animals cavort among tiny human figures and even smaller handprints, perhaps those of the children who watched while their mothers made the paintings to tell them about the world outside the cave. No one really knows who painted them or why. They were done during the Aurignacian period, almost twenty thousand years ago, yet they are still vibrantly alive. It is not too much to assume that part of their purpose was to decorate the walls of a dwelling, and enliven the life inside.

From the cave paintings at Lascaux, through Egyptian and Minoan wall frescoes, and all the modes of wall decorating that followed, including the modern trend towards photo decor, the same basic human impulse has been at work —the desire to live among pleasing visual images. The principles of photo decor are no different from those of any other kind of display— maximum and most effective visibility, exploitation of harmonies and contrasts, a balance of rest and movement for the eye, and an enlivening of the surroundings. All that it involves is learning a few simple techniques and exercising your own creative imagination.

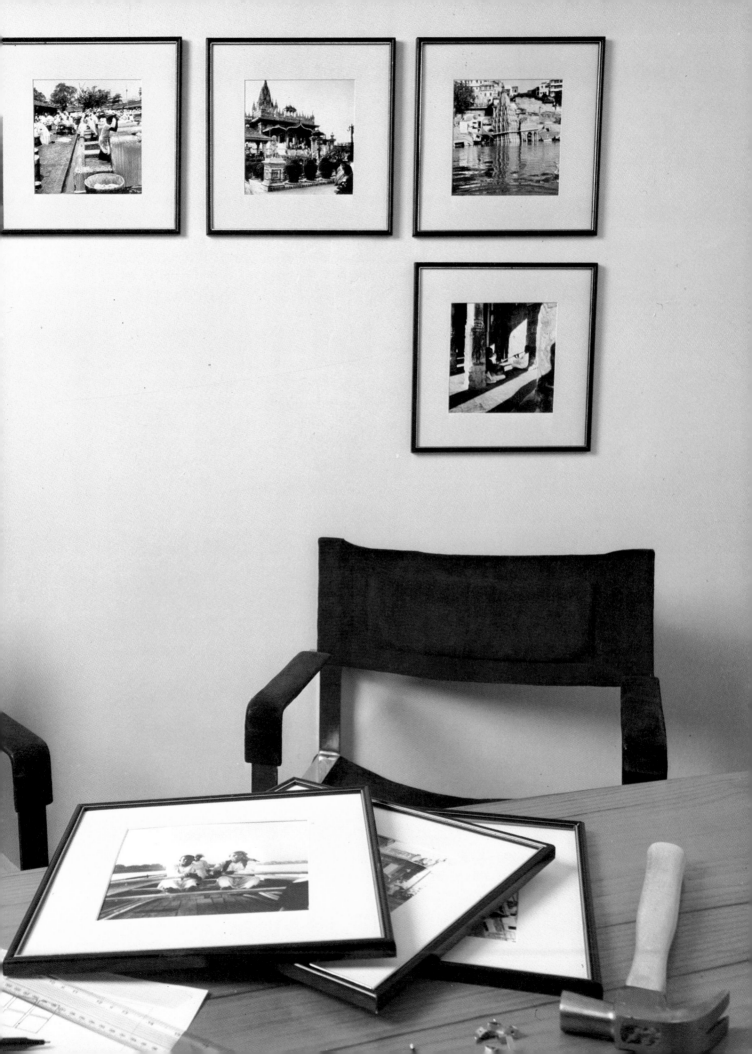

Thinking Creatively About Colour

No matter how beautiful a photograph is, as photo decor it cannot be appreciated in isolation. It should fit in with and enhance its surroundings. One of the major ways of tuning a photograph to its environment is by using colour, even when working with black and white photographs.

You can use colour in many different ways. The colour of the furnishings can be echoed in the photograph, mat, or frame. Colours can harmonize or contrast. They can be subdued, intensified, and even altered by proximity to neighbouring colours. Not only the mood of a picture, but even its size and tonality can appear to change when it is given a differently coloured mat or frame, or is hung in a room with a different colour scheme.

You can, if you like, change the colours of prints to suit existing decor. A black and white photograph can be hand tinted (page 77), toned (page 25), or printed on coloured paper. You can order a monochrome print of any colour from a photographic laboratory. The colour of even a colour print can be altered by solarization (page 61).

Numerous books deal with the theory of colour and the colour wheel. Although it is not necessary to have an extensive knowledge of colour theory for the purposes of photo decor, it is worth looking at a few simple books on the subject, as well as the ways designers, artists, and interior decorators handle colour. This will help you develop a personal, intuitive colour sense and, perhaps, give you courage to experiment with new colour relationships.

Studying the natural environment can provide endless inspiration. The warm colours of an autumn woodland scene or the cool, hazy blues of a winter landscape can equally inspire beautiful colour schemes for your home. Be brave enough to take chances and risk the occasional failure. When dealing with photographs it is reasonably easy, and relatively inexpensive, to alter any unfortunate effects.

This is the basic theory of colour at its simplest. There are three primary colours—red, blue, and yellow—from which all other colours are made. When two primary colours are mixed together, they make a secondary colour—purple, green, or orange. A primary and a secondary colour can be mixed to give an intermediate colour—red and orange, for example, make red-orange.

Conventionally, the colours are arranged in a wheel, moving around from dark to light and back again—blue, green, yellow, orange, red, purple. On the wheel, each primary colour is opposite the secondary colour made from the other two primary colours. Blue is opposite orange, red opposite green, yellow opposite purple. These are called complementary colours and they provide maximum contrast. The colours which lie next to each other on the wheel, blue and green, for example, are called related colours, and they harmonize with each other.

This principle of harmony or contrast becomes important when you are choosing which photograph to hang in a room, or which colours are best for a frame or mat. If, for example, the walls or furnishings of a room are dominated by blue, a predominantly blue or green photograph, such as a seascape, will blend with the decor and create a peaceful and harmonious mood. A picture of a flaming orange sunset will, by contrast, intensify the blue and give the room a more vibrant and stimulating atmosphere.

In the same way, the colours of a sunset can be intensified by matting the photograph in a contrasting colour —blue, purple, or blue-green. If you prefer an harmonious overall effect turn to the red zones of the colour wheel for the mat or frame.

Intensity is another factor to be considered when choosing a colour to go with furnishings or photographs. A pure colour, to which no black, white, or grey has been added, is at its full intensity and said to be fully saturated. Adding varying amounts of white to pure colours will give a range of tints, such as lavender or powder blue. Black added to pure colours will create a range of shades—such as maroon or midnight blue. And by adding grey, tones are created.

Because the addition of black, white, or grey subdues brilliance of colour, shades, tints, and tones are often more suitable than fully saturated colours for mats. Strong, intense colours come forward and dominate. This happens even when a fully saturated cold colour like blue is placed next to a warm but pale colour. A mat of pure colour might be too strong for a picture and distract attention from it. Strong colour tends to work best when used only in small amounts, for example in a very thin border.

The tint, shade, or tone of a mat colour should be related to the strength of colours in the print. A pale photograph would need a mat of a softer, paler colour than a photograph of bold

red, blues, and yellows. A brightly coloured photograph might look best with a mat which is a tint, shade, or tone of a stronger colour so that the mat recedes and permits the picture to come forward.

Tone should also be considered with black and white prints. Prints which consist mainly of dark tones with few light ones are called low key, and photographs which have mainly light tones are called high key.

When matting and framing these two very different types of black and white picture, try to relate the depth of tone in mat and frame to that of the picture. Since a dark mat might overpower a fine, pale print, it would be

only reasonable to use a paler mat. The frame for a pale print could be anywhere along the tonal range, but, as a rule of thumb, the darker the frame is, the thinner and finer it should be. Conversely, a dark print can carry much greater depth of tone in both mat and frame without being overwhelmed.

The size of the mat and frame in relation to the size of the picture also plays a significant part in the overall balance of tone. A small, dark print, for example, can work well on a wide pale mat, which will accentuate the detail of the photograph.

The principles of harmony and contrast apply to the use of tone as well as to colour. The closer the tones of the print are to those of the mat, frame, wall, and furnishings, the more harmonious the result will be. A dark picture on a white wall, or a black frame with a white mat, will provide maximum contrast and drama.

A colour or tone can be modified by the colours or tones surrounding it. A pale colour surrounded, for example, by a dark colour will seem darker than

when it is seen alone or surrounding the dark colour, so that the colours and mood of a picture can be altered to a large extent by the colour and tone of a mat.

A striking way to link the picture with its environment is through the mat or frame. A colour common to both print and room could be picked out in the mat. It need not be an exact match, which would be difficult to achieve anyway, but rather a tint, tone, or shade of the colour. Or it could, perhaps, be a dissonant colour, somewhere between a complementary and a related colour.

The pattern or colour of the wall on which a picture will hang should be a significant factor when you're choosing a mat and frame. If the wall is a pale or neutral single colour, there will probably not be any problems and you can concentrate on the colour relationships between print, mat, frame, and furnishings. If, however, the wall has a strong colour, a busy pattern, or a heavily textured surface, the print might need to be isolated by a wide mat or by wide moulding. Either solution will help to calm the wall pattern and prevent the picture from being lost in a sea of pattern or colour.

A famous writer once talked about the fearful experience of seeing all the colour drained out of the landscape during an eclipse of the sun. Try to imagine that, even for a few moments, and then look out at the brightly coloured world. You will realize again what an enormous source of pleasure colour is. A little experimentation will show you the sheer fun of it.

13

The Photo Wall

The most effective way to display finished photographic prints is to hang them on a wall. This may seem quite a simple process, requiring only a blank wall, one or more attractive pictures, and a few reliable nails and hooks. But it is not as simple as it seems. A picture may look absolutely right in one setting, but lose all its impact and charm when hung somewhere else. Just as the colour of a picture appears to change in different surroundings so does its mood,

personality, and even its size. A photo wall, even if it displays only one picture, needs attention and careful designing. You will want to create a unit pleasing in itself, which also fits in with the rest of the room as an integral part of the decor.

Photographs have a decorative advantage over paintings. The size, colour, mood, and even the period feel of a print can be easily changed to harmonize with existing decor. A photo-

graph can be enlarged to fit the available wall space, hand tinted or colour toned (page 77), or printed on coloured paper to pick out or contrast with the colours of the furnishings. Although photography is essentially a modern medium, prints can be sepia toned (page 25) or vignetted (page 57) so that they are perfectly in keeping with antique furniture. For a contemporary-looking display photographs can be posterized (see pages 101 and 121).

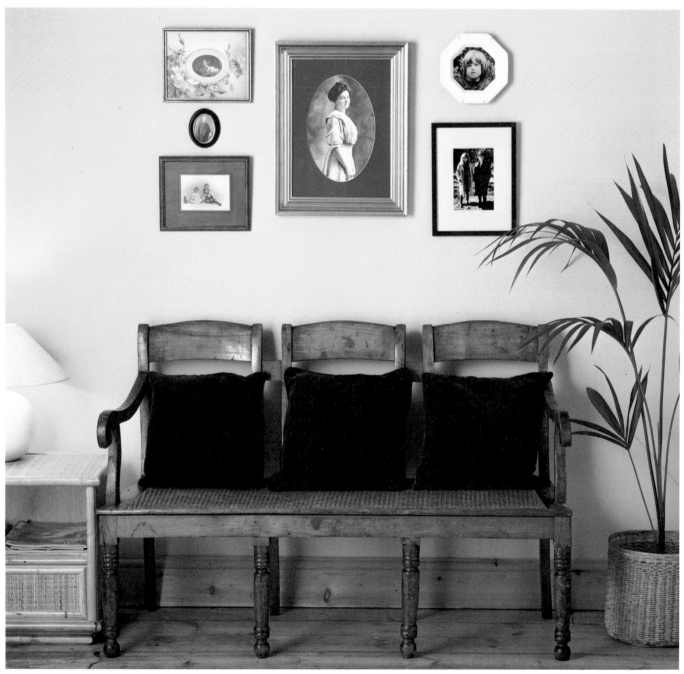

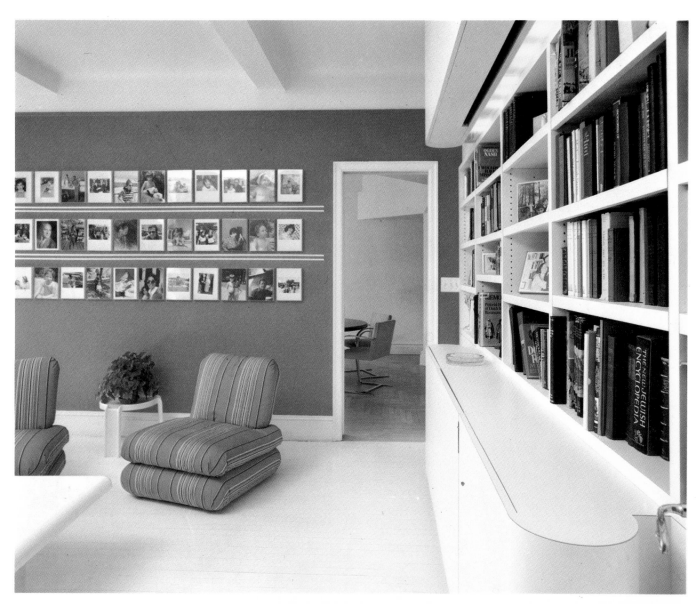

A simple idea has been carried out to striking effect above. Prints of different sizes have been mounted to an identical size, arranged in precise rows, and underscored with lines of white paint. They look bold and sharp against the red wall.

On the left, photographs treated very differently were arranged into an harmonious grouping. The portrait in the centre has been sepia toned and vignetted, the photo of the little boy was printed on a plate, and the baby picture was matted in a page from an old album.

The family photographs at the right were printed the same size, block mounted, and fixed to a cork-board wall. The arrangement is simple but dramatic.

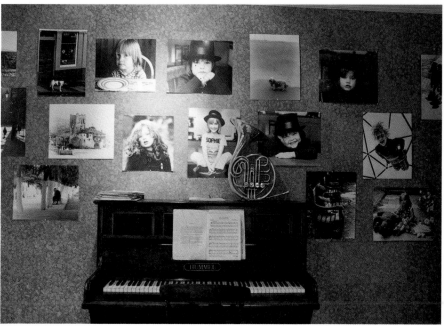

Designing a Photo Wall

There are no strict rules to be obeyed when designing a photo display. Each home is unique and reflects the occupant's tastes. What will give a photo wall its personality is your choice of subject matter, the colours and style of framing you choose, the panache of the arrangement. Some general guidelines and suggestions may be helpful, however, in finding solutions.

First take a good long look at the wall in question, and at the rest of the room in relation to the wall. Consider some practical details.

Are you dealing with a large, rectangular, bare wall above a sofa? This might suit one large dramatic picture or a carefully arranged group. If you want to hang photographs on the wall of a long, narrow corridor, remember that there is no way to stand back from the pictures, so very large photographs are

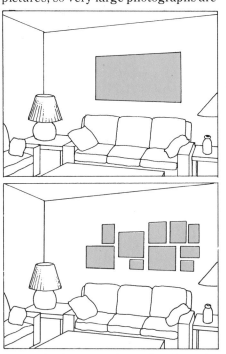

probably inappropriate. Smaller pictures, with interesting detail which would reward study at close range, hung as a horizontal composition, might be the best solution.

Pictures that are horizontal in format are particularly suitable for hanging in these long, low arrangements. A high, narrow space between two doors, on the other hand, might call for a vertical cluster of pictures with vertical emphases, or for one tall, thin picture, its elongated

quality accentuated by a mat wider at the top and bottom than at the sides.

How often is the picture wall going to be seen? Extremely large, dramatic, or brightly coloured photographs might be too overpowering for a living-room wall, where you would look at them for long periods every day. They might be perfect, however, for an area which is only used for passing through, like an entrance hall or the top or bottom of a flight of stairs.

The height at which a picture is hung also affects its impact. The best position for a picture is at eye level. This will vary according to how the room is used. In a sitting room, for example, the photo wall should be comfortably visible when people are seated. Pictures hung above a sofa or chair must be sufficiently above the heads of those who will be seated there. The pictures in a child's room should be hung low enough for the child to enjoy them.

Once the holes have been made in

the wall and the pictures have been hung, it is a little late to discover you have made a mistake. Therefore, spend some time beforehand designing the wall and experimenting with different arrangements.

A good method is to cut out pieces of stiff paper exactly the same shape and size as the framed prints and arrange them on the wall. They can be stuck on temporarily with masking tape and will give you a good idea of how the final arrangement will look. (The pieces of paper can be used later as templates for marking off the position of the holes to be drilled for hooks or other hanging devices.) Use dark cutouts for dark pictures and, if possible, use paper of approximately the same overall colour as the print and mat.

Some of the prints may have strong compositional lines—tree trunks or skyscrapers, for example—or colour emphases. These can easily be indicated on the paper cutouts. Sketch directional lines in pencil or charcoal and indicate strong colours with coloured paper or large wax crayons. This will prevent a plan which works beautifully in terms of relative sizes and shapes from being ruined by an imbalance of colour or by clashing directional lines.

A room plan and an elevation drawing of the photo wall can also be helpful, particularly when a large arrangement is involved. These are not easy to do. Unless they are measured and drawn accurately they can be misleading, and when the pictures are hung the arrangement will look nothing like the plan.

The scale must be large enough for you to see what you are doing and small enough to be manageable. A scale of one inch to one foot (2.50 to 30 cm) may be preferable.

The room plan should show windows, doors, and any furniture around which the pictures might have to fit. It can also be useful to indicate where people stand, sit, or lie in the room, how they move around in it, and the direction in which they generally face, since all these factors may affect the placing of the pictures.

The elevation drawing—a nonperspective, vertical drawing of the wall—should also show doors, windows, and furniture. The positions of the pictures

can be indicated in several ways. The pictures can be drawn in, also to scale, on the drawing or on a tracing paper overlay carefully taped to the drawing. Remember that the size of the photographs can be changed to suit the arrangement, so draw the pictures in the sizes you feel suit the arrangement, and don't be hampered by the present sizes of the pictures. By using tracing paper overlays, successful arrangements can be recorded and the best one chosen.

Another approach is to cut out small pieces of card to represent the pictures and move them around on the drawing. This is a flexible working method. It is one of the best ways to learn about spacing and grouping pictures, and to see how different shapes harmonize.

Cut the card to the same scale as the elevation drawing, so that the pieces represent the possible or actual picture sizes. It may be easier to make them correspond to the sizes of photographic paper obtainable. For quick reference, mark the sizes on them and which photograph each represents. Indicate strong colours or directional emphases. You might also want to cut cards to represent moveable items of furniture.

Use heavyweight card, so that the pieces will be easy to pick up and won't become dog-eared. The arrangement will be easier to see if you use coloured card which will show up against the drawing.

Displaying a Single Picture

You can create a dramatic focal point in a room with a single picture of the right size in the right space. It is even more important than with a group of pictures to balance the single picture with the surrounding decor. A cupboard, chair, or curtain near the picture will form an important part of the overall composition and should be carefully considered when you place the print.

The size of the print in relation to the size of the wall space is crucially important. A small print will be lost on a large expanse of bare wall, but might be just right in a small, intimate corner, fitted between doors or between pieces of furniture. A large picture also needs to be placed for maximum impact. The room should be large enough so that

the viewer can stand back from the picture and the wall should preferably be free of other pictures or ornaments. A big picture can look bold and impressive on a large expanse of bare wall.

It is quite easy to change the size of a photograph, so don't feel limited by the dimensions of any existing print. Decide what size the picture should be and arrange to make the print accordingly. Bear in mind that a mat and frame will make the picture larger.

Once you've decided on the size, the photograph can be enlarged to your specifications. Giant black and white prints can be made from negatives and some colour laboratories produce inexpensive photoposters either from negatives or from transparencies. A print can often be copied if no negative exists.

The shape of the wall space may call for a particular picture shape. The shape of the print can be changed as easily as its size. The print can be cropped to emphasize either a vertical or a horizontal format. Altering the proportions of the mat will affect the apparent shape of the print. A vertical print, for example, can be made taller and thinner by widening the mat at top and bottom, while a horizontal print will look wider if the top and bottom of the mat are narrower than the sides. An oval can be created by vignetting the print. And a print block mounted on plastic foam board can be cut to almost any shape.

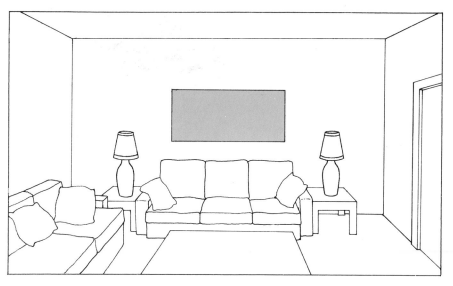

Effective Arrangements

Revery is a crucial part of the creation of wall arrangements. Spend time looking, musing, imagining. Stare at the wall. This may well be the most fruitful part of the project. Try to imagine, vividly, how you want the wall eventually to look. The arrangement you imagine is the one to aim for. If you are careful and patient, you may achieve it. After the initial stage of visualizing a photographic display, the juggling begins, the struggle with the concrete elements of the composition—the photographs, mounts, mats, and frames, and, of course, the intractable wall. What is

the relationship of the photographs to each other? How can you best exploit that relationship? A thematic carryover may be appropriate, for example, framing tropical photographs in bamboo frames. An historical relationship—the story of a family over several generations —is also an interesting possibility. The relationships between the photographs may also be purely visual. The arrangement may be an entirely abstract design, depending on elements of shape and colour to hold it together in a unified composition.

A large part of the joy in creating

photographic wall arrangements lies in the interplay of fancy and imagination with the minute particulars of the materials you're working with and, in turn, with the simple realities of the room—the colours, decor, the objects already present.

Like any other creative work, designing a photo wall—even if you are thinking only of how best to display a certain number of photographs of a certain kind—will be a significant reflection of your personality, an expression of the way you respond to the world and live in it.

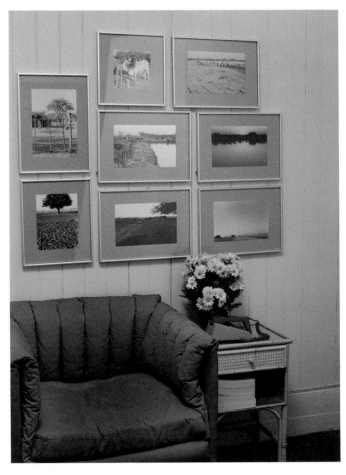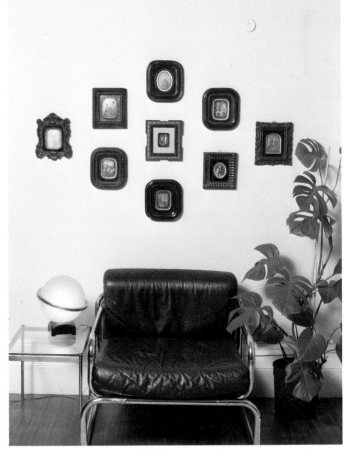

The warm tones of the countryside photographs above in their quiet, grey mats, create a welcoming and tranquil atmosphere that harmonizes beautifully with the walls, the chair, and the bright flowers.

The striking arrangement above right is a classic example of a simple, symmetrical arrangement made intriguing by the use of intricately moulded old frames and a stark black and white colour scheme. The same order of contrast is carried out in playing old-fashioned photographs against modern furniture.

The designer of the arrangement on the right has achieved an unusual balancing feat in a rather unlikely place. The heavy line created by the large photographs in the top row echoes the line of wooden moulding below the arrangement, creating a linear frame that holds the photographs together.

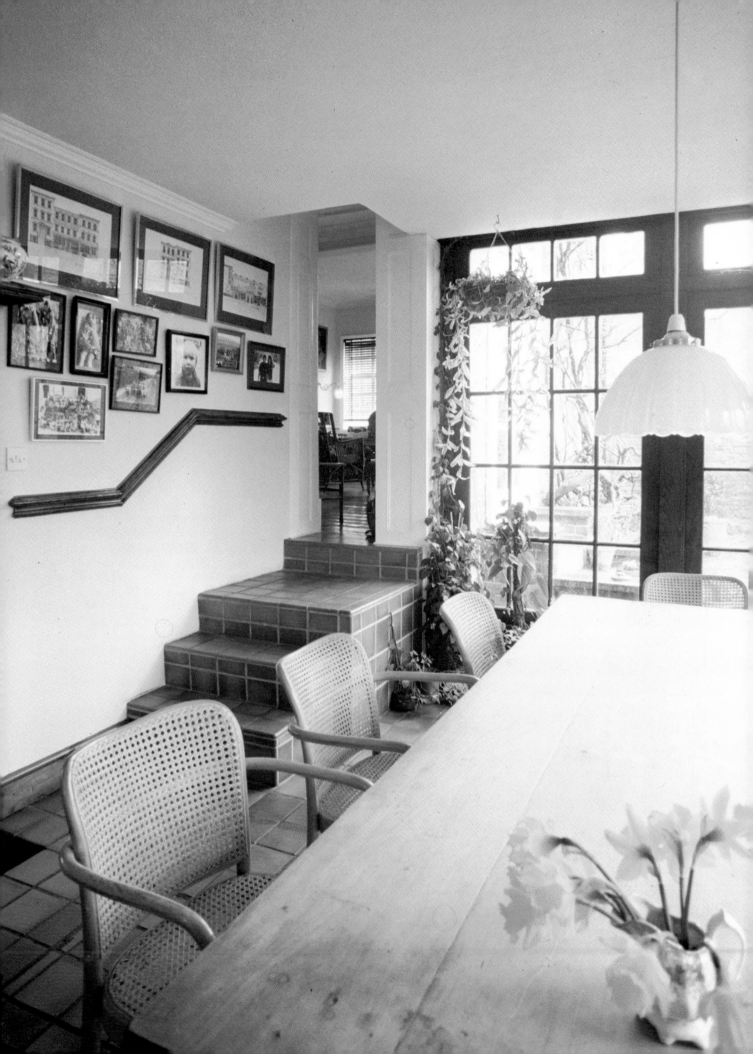

Arranging a Group of Pictures

When you're arranging more than one photograph on a wall, the challenge is unifying the group so that the photo wall can be seen as a whole rather than as a collection of unrelated pictures. There are no hard and fast rules, but some general guidelines do exist which may be helpful.

To begin with, what about the pictures themselves? Are they all the same size, shape, and subject, or are they all completely different? Are they all in black and white, all in colour, or a mixture of the two? Are they abstract or representational, old or recent? All these factors are relevant to the arrangement you will eventually create. It would be difficult, for example, to make a formal, symmetrical arrangement from pictures of different sizes, shapes, subjects, and types.

Whatever the nature of the prints and however they are to be arranged, the simplest, most basic way of unifying them is to align them in some way. This means that the top, bottom, or sides of each picture will line up with those of one or more of the other prints. This need not mean merely lining up the edges of the frames. Often other linear elements, such as the mat edges or even such directions as horizon lines in the composition of the prints themselves, can be aligned in this way.

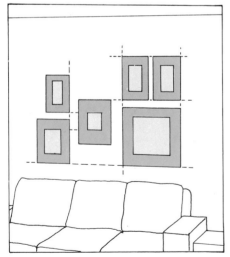

If you want a formal, symmetrical arrangement, then the prints should all be made to the same size and shape. They should be uniformly matted and framed, and all of them should be precisely aligned—tops, sides, and

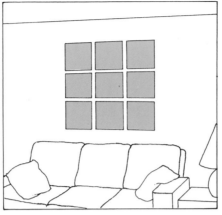

bottoms. Total symmetry, however, can be not only formal but boring, so it might be wise to break the alignment slightly with one larger or otherwise somewhat different print.

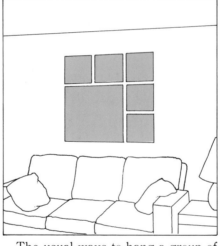

The usual ways to hang a group of pictures are to cluster them or to hang them in a line. A long horizontal line of pictures can be a good solution in a hall or corridor, where the viewer will be standing or walking along. The pictures

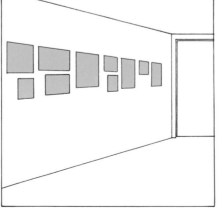

should be hung at eye level so that you can examine them comfortably without having to stoop or crane your neck.

A vertical line of photographs often suits the space between two doors, for example, or between two tall pieces of furniture. To prevent monotony, break the line occasionally by a cluster of pictures or by a larger print.

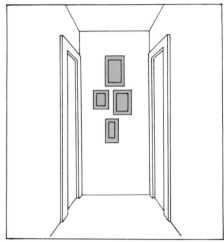

The arrangement of a cluster of pictures can be either formal or informal. Formal arrangements are strictly symmetrical. An even number of pictures are placed on either side of an imaginary line, as if in a set of invisible scales. Pictures of the same visual weight balance each other. It is not necessary for all the prints in the group to be the same size and shape. Use a mixture, as long as there is an even number of each size or shape so that one of each can be placed on either side of the "line." The formal feeling will be best sustained if the matching pictures have similar or even identical mats and frames.

Informal arrangements are usually asymmetrical. Each picture in the group can be different since the point is to balance the general areas of the arrange-

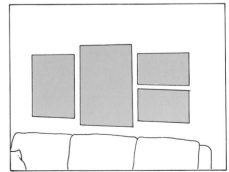

ment rather than the individual prints. In other words, a group of small prints may balance one large one, or several tall, narrow prints one rectangular one, but, as you'll see, balance is a far more variable factor than this side-to-side juggling.

A good way to begin designing the photo wall if the pictures are all different sizes, is to place the largest picture near the centre of the arrangement and build out from it with the smaller prints.

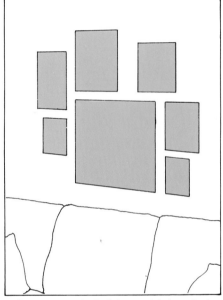

It can be helpful to think of the design as a tree with trunk and branches. The large picture is the trunk supporting the smaller prints which grow from it like branches and leaves. Like a real tree, the arrangement can grow into many different shapes—tall and narrow or broad and wide, controlled by the trunk which is the centre of balance.

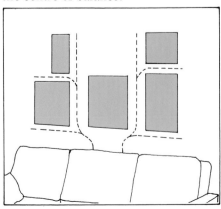

As the design grows, keep looking at the composition and checking to be sure it is neither top heavy nor lopsided. Watch to see that the overall shape remains pleasing and that pictures of the same size are distributed throughout and are not grouped together in one place.

Some pictures, if they are block mounted, can be slightly overlapped to hold them together both visually and thematically. A photograph of a person, for example, can be linked in this way with a picture of his or her family, house, or native country.

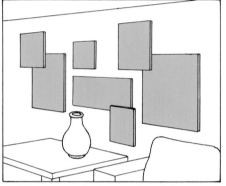

The spaces between the pictures are almost as important as the pictures themselves and play a great part in the success or failure of an arrangement. Take care neither to overcrowd the pictures nor to leave such wide spaces between them that they lose touch with each other and no longer seem to be part of the same arrangement. As a general rule, the size of a picture determines the amount of space needed around it. Large prints usually should be placed farther apart than small ones. Some open spaces of various

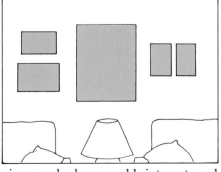

sizes and shapes add interest and variety. But don't leave any spaces trapped inside the arrangement, enclosed on all sides by photographs.

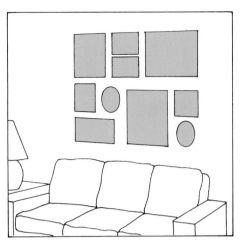

Sometimes colour and black and white photographs sit uneasily together in an arrangement. The colour prints may dominate and make the black and white seem flat and dull or, on the other hand, the subtle tones of the black and white can make the colour look crude. If this begins to happen, there are several possible solutions.

The black and white prints can be transformed into colour prints by hand tinting (page 77) or by printing them on coloured paper. Photographic laboratories will also produce monochrome prints of any colour desired. Prints with strong tonal contrast are best for this purpose. Black and white prints can also be toned (page 25) to make them blend in better with the colour prints. There are toning baths of many different colours available. Sepia can be effective, particularly if the colour prints are warm and earthy. A blue tone works well with prints which are predominantly blue or green.

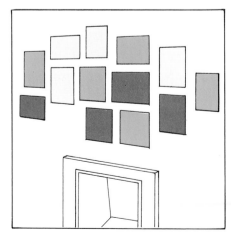

Up and Down the Stairs

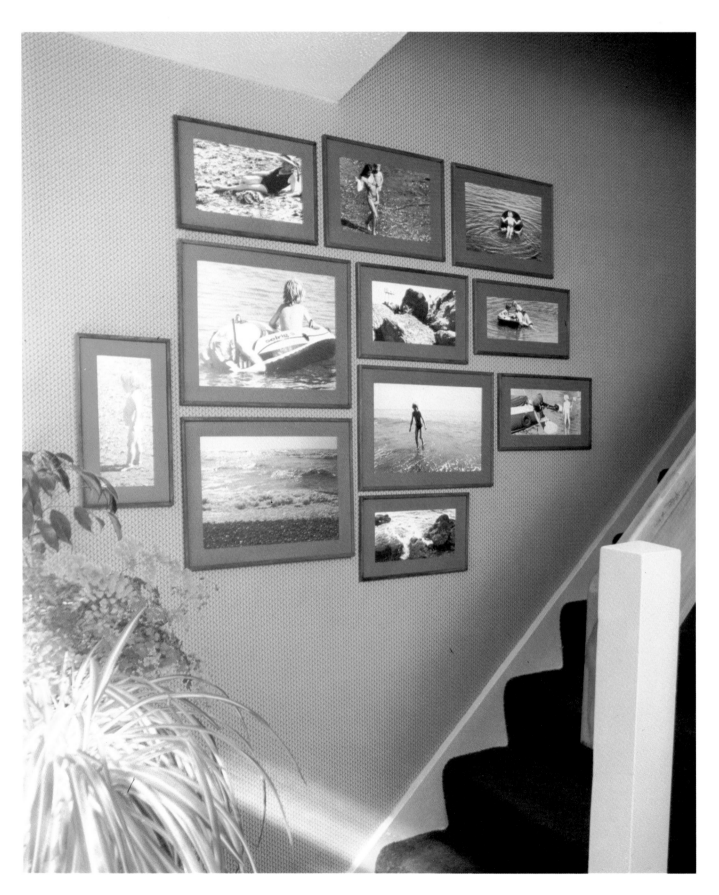

Photographic arrangements on stairways pose unique problems, and therefore unique challenges. They are often seen from below, or from above, or from anywhere in between and while the observer is in motion. Any stair

The austere arrangement, below, of three chastely framed black and white photographs in a simple diagonal, harmonizes with the clean lines of the arch and staircase.

arrangement should, ideally, look good from each of these unusual perspectives. It should look as interesting when glanced at in passing as when it is contemplated more quietly.

An obvious solution would be to make an arrangement to go up, or down, in steps. Such an arrangement would be interesting if there were some thematic or visual point to the progression—someone at various stages of his or her life, or different views on the way up a mountain, or down a

series of caves. But this is by no means the only solution. Others, less obvious, can be more satisfying. For these, the shape and size of the staircase, the position of the staircase in the room, and the points from which it is most likely to be viewed, must be taken carefully into consideration. All these factors are really like counters in a game. The more relaxed and playful the approach, the more likely is an intriguing and satisfying arrangement. Climbing stairs, too, can be an adventure.

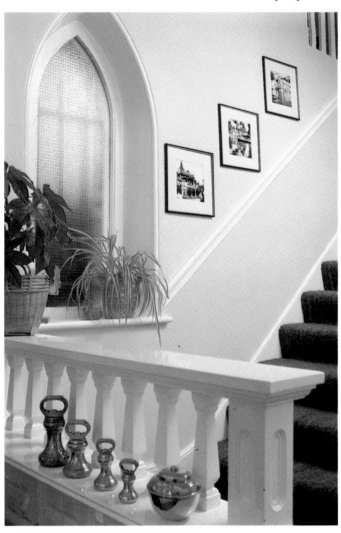

Family snapshots in the arrangement on the stairway left have been enlarged, sepia toned, and matted and framed in brown. They are arranged simply, but the proportions have been worked out with care, and the colours blend well with the walls and carpet.

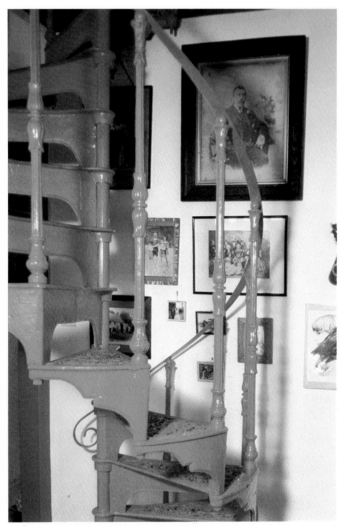

The group of diverse and variously, some inventively, framed photographs above cluster happily along the path of a spiral staircase, artfully distributed so that they are easily visible and well-balanced with the curve of the stairway.

23

A New View of Staircases

A staircase has a different shape and function from the rest of the house and the photo decor in this area should be planned around its special characteristics.

To begin with, unlike wall arrangements in any other part of the house, those on either side of the steps have to be designed around the diagonal shape of the staircase. The diagonal design can be quite obvious, with groups of pictures placed parallel to the staircase. It can also be invisible. Even if the prints are hung in vertical or horizontal arrangements, the only pictures which will really be seen are those hung along the one diagonal line which corresponds to the eye level of the person ascending or descending.

The question of eye level is always important when hanging pictures. It is even more important when hanging pictures on a staircase wall, unless the stairs are wide enough to make it possible to stand back from the arrangement. Stairs are precarious places on which to crouch, stand on tiptoe, or lean out at an angle. In a busy household, anyone taking time to sit on the stairs to examine a picture hung low on the wall might find himself or herself rather unpopular. Although pictures may be clustered all over the wall for a general effect, the best ones should be hung along the diagonal eye level. Those hung above and below the average eye level would probably not be seen often.

A spiral staircase is the exception to this rule. Since such a staircase usually stands in a corner or against a single wall, a vertically oriented picture arrangement is usually the only one possible.

The landings of a staircase, of course, resemble the rest of the house in terms of the design of wall arrangements. There is often a tall houseplant on a wide landing or a small table with a lamp or a vase of flowers. The display of photographs on the wall should be thought of as a design unit together with whatever else is on the landing, so that the whole ensemble forms an harmonious unit.

When hanging a picture on the wall at the top of the stairs, consider whether you prefer the whole image to be visible from the bottom of the stairs, or to reveal itself gradually on the way up.

The type of picture which works well on a staircase may also be different from that which enhances a living room or bedroom. Staircases and landings are essentially traffic routes. The walls are glanced at briefly, if at all. The pictures, therefore, like advertisements in the street, have merely a brief moment in which to catch the passerby's attention. They will not make their point at all unless they are instantly striking. So staircases and landings provide an ideal opportunity for using those dramatic or dazzling photographs which are perhaps too powerful to live with for long periods every day, but are exciting and stimulating in small doses.

Consider carefully the scale of the pictures used on a staircase. To say that a dramatic picture may work better in a given area does not necessarily mean that it should be large, nor are large pictures practicable on all staircases.

A wide, spacious stairway in the grand manner can do justice to large pictures. There is plenty of room to stand back, and they can sometimes even be seen from the rooms above and below. Most modern houses, however, have quite narrow staircases, and the only places where a large picture might have any real impact are the landings and the walls at the top and bottom of the stairs. Prints can only be viewed at close quarters on the side walls, so giant enlargements will look grainy and indistinct. Smaller prints are probably more suitable, since they can bear close scrutiny.

If the staircase has been painted and carpeted in neutral tones, the pictures on the walls can determine the whole mood and colour scheme. A staircase, unlike other areas in the house which are full of furniture, curtains, and ornaments, has a mimimum of other objects to conflict with the prints, so they can be the dominant factor. The pictures cannot, however, be chosen arbitrarily. The style and period feel of the photographs should either harmonize with or be in contrast to those of the staircase and, to a certain extent, to those of the rest of the house. Colourful block-mounted prints might not look good with a wide, old-fashioned staircase and its carved bannisters, nor might old prints in period frames look in place hung alongside modern, open tread stairs. But all this remains a matter for personal taste

Spiral staircases are relatively rare, and tricky to arrange photographs around. Somehow the display has to be vertical without being merely linear.

This display is a beautiful exercise in working out proportion. The single picture on the left, and the three large ones, balance the others well.

and experimentation. There are no rules.

When designing a photo wall for this area of the house, remember that the whole staircase, including the landings and each flight of steps, should be considered as one wall arrangement. Nothing looks stranger than a sudden change of mood or theme halfway up a staircase.

Of course, all the pictures do not have to be identical in subject matter and tonality. There can be a great deal of variety within one general scheme.

The style of the framing and matting in the wall display will go a long way towards unifying the design. The same general style should be used throughout. The pictures could, for example, all be block mounted or all displayed in period frames.

An exception to this principle might be a display intended to show a progressive theme, with the style of the photographs moving gradually from past to present. The arrangement could begin with old family photographs in Victorian frames and finish with brightly coloured solarized prints in aluminium frames showing the activities of the present day teenagers.

The very nature of a staircase makes it an ideal place to explore a theme. But remember that it is used for coming down as well as for going up, so the arrangement has to read from both ends.

A simple, strict diagonal line seems like an obvious thing to do on a staircase, but it has to be done so that the line echoes the stairs exactly.

Sepia Toning

Prints toned in sepia were popular with photographers in the nineteenth and early twentieth centuries and, strangely, even the first Polaroid instant prints, in 1947, were sepia. Often, the use of this technique can give prints a nostalgic appeal and, when combined with vignetting (see page 57) beautiful effects can be produced. Today, sepia toning is regaining popularity.

The technique involves bleaching the black and white image, then colouring it in a toning bath. The whole process can be done in normal room conditions, so it is possible to tone prints without a darkroom.

For best results, the original print should have a good range of tones and be correctly developed. The print should be well fixed and washed before toning.

Place the black and white print in a bleaching bath. There are many formulas for bleacher which can be used. This one is recommended:
Potassium ferricyanide 100g.
Potassium sulphide 50 g.
Add water to make one litre (35 fluid ounces). Dilute this solution one part with five parts water before use.
After being put in the bleaching bath the image will become pale in two or three minutes.

Wash the print in cold water.
Put the print in a toner bath:
Sodium sulphide 200 g.
Add water to make one litre (35 fluid ounces). Dilute the solution one part with five parts water before use.
Leave the print in the toner bath until the required depth of tone is reached. This usually takes about six minutes.
Wash the print well and allow it to dry.

When toning, the use of a strip mask permits areas of a bromide print to be toned selectively. Apply the strip mask to those parts of the print which are to be left uncoloured, then immerse the whole print in the toning bath.

Abstract Harmonies

Photography has a long history as a representational medium. In the late nineteenth century there was an outcry that painting had been made redundant by that odious contraption—the camera. At the same time, painters whose eyes were open realized that photography could verify what they saw and also help free them from the constraints of the merely representational. If photography could record the ordinary visual realities, then painting could go off and explore.

It is no accident that the artistic explosion of the Impressionists, Post-Impressionists, Cubists, and all that followed, coincided with the arrival of photography in the public consciousness. Since then, photographers have realized the potential of their medium and the wheel has come full circle. Photography, too, is a wonderful medium for abstract art, and equally capable of producing a wide and beautiful range of images which open our eyes to unsuspected harmonies of colour and shape and texture. Such images, caught and framed, are an unparalleled source of decorative art, and potentially available to anyone with a camera.

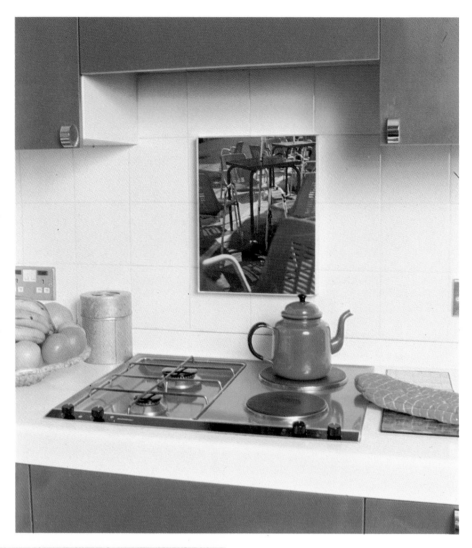

It is hard to imagine that metal tubing and red plastic would combine as an exciting image, but the handsome photograph above, shot in a café in Arles, is a striking composition in itself, while at the same time it reflects and highlights the rich red of the kitchen decor.

The glowing harmony of blues and golds in the room at the left was arrived at simply. The images in the square frame are colour photostats of colour negatives, and the photographs in the oblong frame are of the medallions on the doors of Peruvian taxicabs.

Bold metal framing reflects the rich hue of the table, right, which in turn is enhanced by the golds and deep greens in the framed pictures. The images are simply enlarged photographs of details at a fairground.

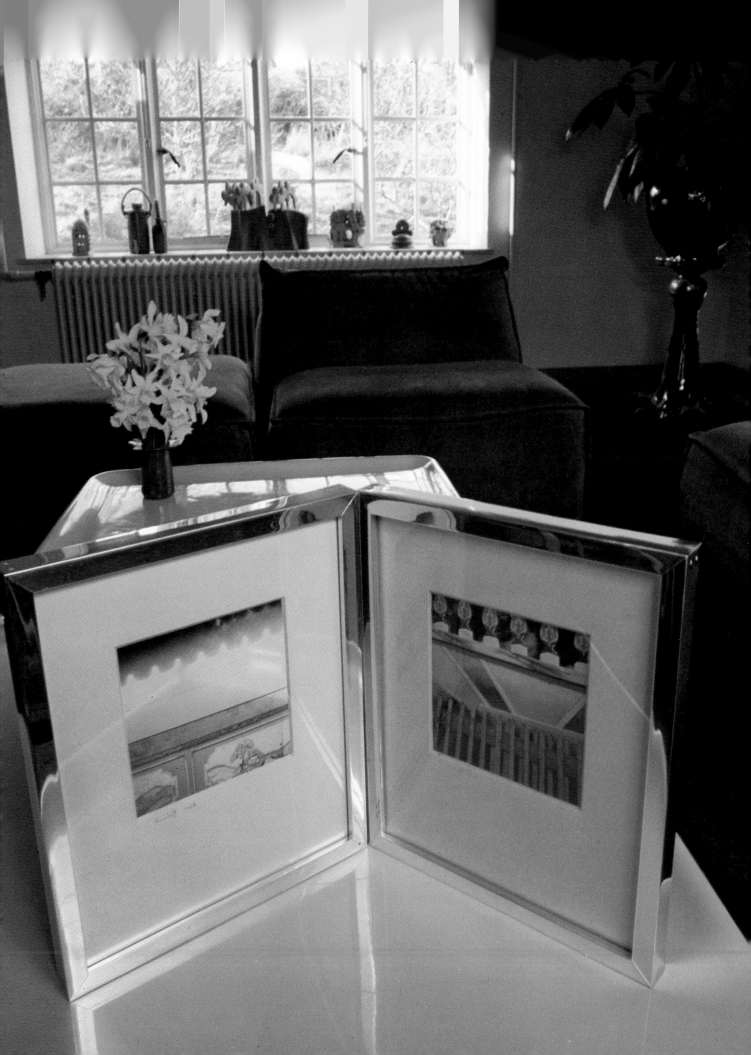

Hanging Your Pictures

The effective way to display most photographs—large or small, framed or block mounted—is to hang them on a wall. Many types of hanging devices and wall attachments are available. Some are invisible, others ornamental, some are specially designed for light or for heavy pictures and for different wall surfaces.

The devices most widely used for hanging framed pictures are screw eyes, or D-rings, sawtooth hangers, and picture plates. Magnetic tape can be used to hang pictures on metal and Velcro is an excellent hanging device for lightweight pictures.

Screw eyes and D-rings are attached to both of the vertical sides of the frame, about one-third down from the top, and as close to the inside edge as possible. It is advisable to use an awl or a push drill to make a pilot hole before

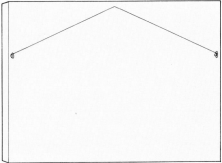

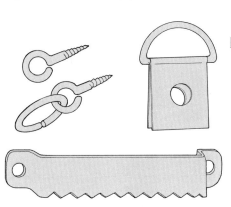

screwing in the eye. Picture wire is then threaded through the eyes, taut enough so that it does not show above the frame. The ends of the wire should be wound tightly and close to the eye.

To give extra strength when hanging heavy pictures, two additional screw eyes or D-rings can be inserted into the bottom edge of the frame, about one-third of the frame length in from the sides. The ends of the wire are attached to these two eyes and threaded through the eyes on the sides of the frame.

It is not advisable to use nylon cord instead of picture wire. The cord frequently stretches and the picture does not remain aligned.

Although screw eyes and picture wire constitute one of the simplest and most traditional methods of hanging a framed picture, it has several disadvantages. The picture tends to slip out of alignment easily, and often the top of the frame tips forward from the wall. These problems can be solved by using two hooks on the wall instead of one and by placing the screw eyes as near to the top of the frame as possible.

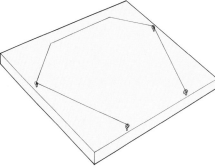

This method is, however, more suitable for hanging single pictures or groups which are spaced irregularly, than for hanging symmetrical rows of pictures. **Sawtooth metal hangers,** which have pointed notches that hook on a nail in the wall, will keep the framed picture flat against the wall and prevent it from going out of alignment. One type of hanger has square indentations, as well as the sawtooth notches, and can

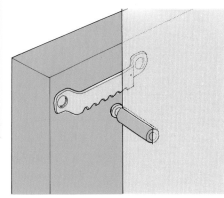

be used with picture hangers. The hangers are fastened to the top corners of the frame, with one screw fastened to the vertical side, so that weight is evenly distributed. For heavier pictures, screws set in plugs in the wall and not screwed fully home, can be used instead of nails.

Picture plates can be used to hang prints which are block mounted or have frames with wide moulding. A dome-headed screw is set into a plug in the wall and screwed in so that the head stands out slightly. The plate hanger, which is screwed into the back of the frame or mounting board has a keyhole-shaped hole which fits over the head of the screw. A slot must be cut in the frame or board to accommodate the head of the screw.

Magnetic tape makes it possible to hang pictures on partitions and other surfaces that are metal. Simply put the tape on the back of the prints, then press it against the wall. Since it adheres quite strongly, the tape should only be put around the edges of the picture. By using metal plates, it is possible to use magnetic tape on surfaces that are not metallic.

Velcro fabric fastener makes a secure hanging device for lightweight pictures. It consists of two strips of material, one with tiny loops and the other with minute hooks. When the two are pressed together, they grip tenaciously. When one strip is glued to the wall and the other to the print, it can support quite a substantial weight.

Ornamental Devices

Sometimes the decor of a room, the picture itself, or the ornateness of the frame seems to demand that an ornamental hanging device be used. Decorative rings which screw into the frame are available. Some pictures are enhanced when hung with brass chains or elegant velvet cord from hooks on a picture rail. Pictures in small, light frames can be attached to ribbons and hung in strips.

Hanging Frameless Pictures

A frame serves to separate a picture from the surrounding wall and to define it visually. Sometimes when a picture has been block mounted or framed without a frame, it is desirable to hang it away from the wall to give it greater definition. Wooden strips, about one-half to one-inch (1.25-cm to 2.50-cm) thick can be glued to the back of the board, well inside the edges so that they cannot be seen.

Another way to create the same effect is to glue or nail a wooden frame flush to the picture edge. The depth of the frame will vary with the size of the print from about six inches (15 cm) for a large print, to one inch (2.50 cm) for a small one.

A frameless picture mounted on wood or hardboard should, particularly if it is large, be braced so it will not warp when hung. The simplest way to do this is to construct a grid from strips of wood and to glue it to the back of the mount.

A good way to hang these frameless mounted pictures is to use interlocking cleats, one glued to the wall and one to the back of the mounting board, about two inches (5 cm) from the top. The cleat which is on the picture hooks over the cleat on the wall. Cleats can be made from strips of extruded aluminium available from a hardware store and cut to length with a metal saw, or from one-by-two-inch (2.50-by-5-cm) pieces of wood, with one edge cut on the slant so that the pieces interlock. Another piece of wood, the same thickness as the cleat, must be glued to the lower part of the mount so that the picture will lie flat.

Steel cleats are commercially available for hanging heavy pictures. A picture with a flush-mounted frame can be hooked over a square cleat attached to the wall. A long wall cleat can be used as a rail on which a number of pictures are hung.

An interesting variation on the picture rail is the use of parallel strips of moulding attached to the wall into which pictures of the same height on heavy mounting board can be slid. Aluminium strips or strips of wood can be used, provided they have one rebated edge to keep the pictures in place.

Wall Attachments

A variety of wall attachments are available which are designed for different kinds of wall and for hanging pictures of varying weights.

The picture hanger, a small metal hook used with a slim masonry nail which leaves only a tiny hole in the wall, yet can support a fairly heavy picture, is the simplest and easiest to assemble. The hook can also be used with wood nails or even with screws, if the hole in the hook is drilled to a larger size. This is quite adequate for most inside walls and for wood and fibre or composition board cladding.

A carpenter's nail will also suffice for hanging a picture on an inside wall, but, for additional security if the picture is heavy, insert a Molly or toggle bolt into the wall.

Nails or screws will be quite secure for wooden walls, provided the wood is at least one-half-inch (1.25 cm) thick.

Toggle bolts, which have a folding claw that will pass through a hole and, when tightened, will open out to grip the back of the panel, are excellent for thin panelled walls. Pop riveting can also be used to hold hooks to thin panels, especially if these are made of metal.

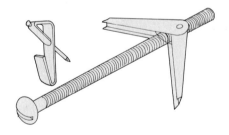

A plug inserted into the wall for a nail or wood screw is best for masonry and brick walls. There are a number of plugs available, including expanding ones made of metal or plastic. They come with full instructions. Also available is a substance which, when mixed with water, hardens around the screw. Plugs can be made, too, from dowelling or wood splinters. To fit these, make a hole in the wall with a quarter-inch (60-mm) masonry drill bit. The hole should be one-half to three-quarters-inch (1.25 to 2-cm) deep. The dowelling or wood splinter is hammered into the hole and should fit snugly.

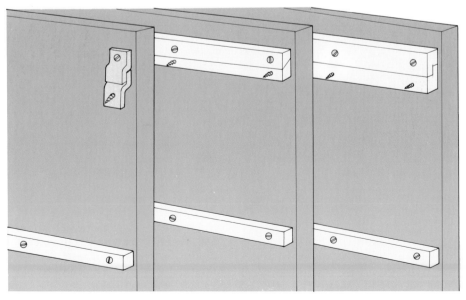

Photos and More

Flexibility is the concept to think about when using photographs decoratively. They can become part of almost any environment, any setting. As with any good stage set, a few well-chosen props and a world is changed, or brought into being. Photographs can be arranged with other things, antiques perhaps, or other kinds of pictorial art, or souvenirs, or indeed almost anything from a treasured bit of lace to a favourite shell, and they will create evocations of other times and places, of memories or moods. Combined with personal mementos or treasured objects, they can become potent reflections of personality, self-expressions that include personal history and private imagery—visual poetry on a wall.

The creative possibilities of such arrangements range from formal and distanced to casual and intimate, from the meditative austerity of a Zen monk's cell to the friendly profusion of an old-fashioned cottage kitchen. Depending upon lighting, upon what is used with the photographs, and upon the photographs themselves, the possible moods available are almost infinite. The important thing to remember is that all this can come of almost nothing, perhaps merely from some thought given to arranging things and old pictures that have been around for years, gathering dust when they could be giving pleasure.

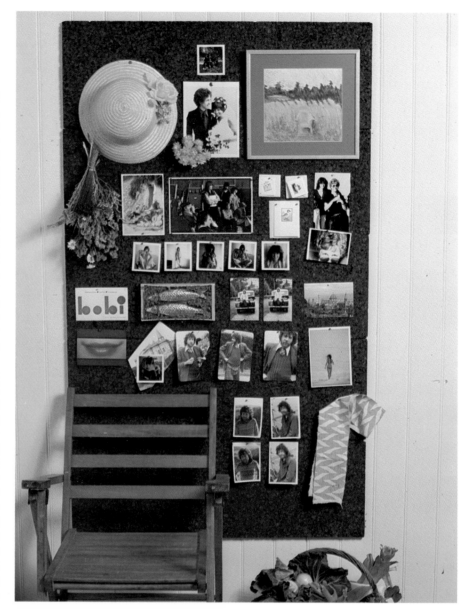

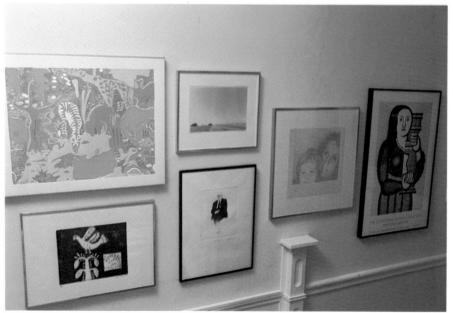

The informal arrangement above is casually, though thoughtfully, mounted on cork, and is a perfect decorative solution for a young person whose life changes rapidly and who will want to go on reflecting those changes. Snapshots, mementos, reproductions of paintings, and even a bit of cloth, from what is no doubt a favourite garment, mingle happily.

The more formal arrangement left, in which paintings, prints, and photographs are mixed, is quiet and cool yet seems actively to catch light and air. And the arrangement is enhanced by the incorporation of the computer photoprint of a mother and child.

30

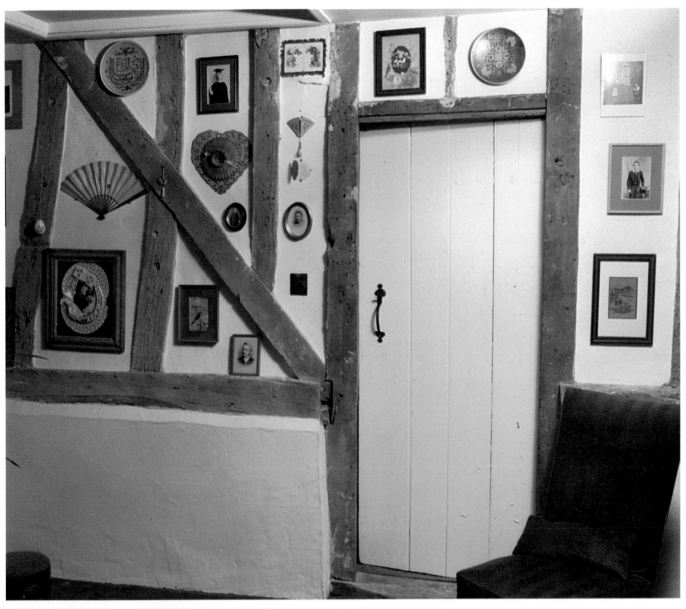

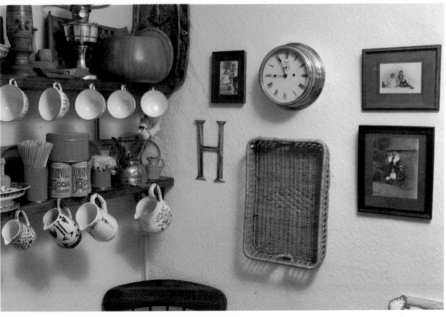

The integral beams of the room above are used as a natural frame for the lovely collection of Islamic plates, old fans, flower prints, and old photographs that are so well placed they seem to have always been on the wall. The varying frames, the wedding picture collage, and the ivory and china baubles all add touches of depth and variety.

A few ordinary domestic objects, simple and well-made, combine left with three old sepia photographs to make an arrangement of quiet charm. The eye rests gratefully on the harmony of the warm gold tones of the brass and wicker with the browns of the photographs.

31

Mixing and Matching

Wall arrangements that make use of diverse elements—sculpture, graphics, embroidery, and paintings as well as photographs—are a fascinating way to explore a particular theme in a more varied and evocative way than using one medium alone. Photographs both generate and gain excitement when juxtaposed with other artifacts and objects.

Many objects normally thought of as freestanding can look striking on the wall. Collections of small three-dimensional objects, such as netsuke sculpture, can be gathered together in shadow boxes and hung. Large objects—African baskets or hats, for example—provide dramatic focal points for mixed wall arrangements. The objects need not be works of art. Quite mundane things—maps, certificates, or inexpensive souvenirs—can make a significant contribution in the right context.

Begin by choosing one unifying theme and amass the different elements, often quite unexpected, in relation to the theme.

Family life has endless potential as a theme for a wall display. Interpretations of family life in gouache by the kids can alternate, to everyone's amusement and perhaps edification, with the camera's more dispassionate view of the same subjects.

The display could conceivably present an historic view of the family, stretching back over the generations. A family tree, drawn by an artistic member of the family, is always popular and can be embellished with portraits, both painted and photographic. Landmarks in the history of the family can be commemorated by photographs of the events surrounded by actual awards, degrees, old passports, and naturalization certificates. Examples of crafts and handiwork of forebears and of the present generation could include everything from the needlework samplers and watercolours of the past to the batiks and model aircraft of the present. Knick-knacks of a bygone age, such as Victorian shell pictures, add a period charm to sepia prints of nineteenth-century ancestors.

From a dynastic wall display to one centred around a single individual—different stages in the life of your child can be traced through a collection of "first-time" objects. The first dress or shoe, the first piece of writing, the first homemade Christmas, Mother's Day, or Valentine card, the first school report can be attractively interspersed with photographs.

A vacation wall is fun to assemble and, placed in some quiet corner of the house, provides a wonderfully therapeutic escape from daily routines and stresses. Relive a particularly enjoyable trip and evoke the atmosphere of a foreign country by the careful juxtaposition of photographs with local crafts, postcards, and memorabilia. Such a wall display provides an opportunity to cherish a selection of the many souvenirs carted home with affection and enthusiasm which never quite fitted in with the existing decor and got pushed into drawers together with the snapshots that were taken.

The objects could range from the mundane to the exquisite. In this context, a museum entrance ticket, a funny ceramic plate, and an expensive carving can sit side by side without incongruity. Each treasured thing shows a different facet of the country concerned. Individualize the whole display with photographs of family and friends enjoying themselves on foreign soil.

For nature lovers and enthusiastic ramblers, a nature wall could be informative as well as evocative. Cases of birds' eggs, butterflies, insects, or shells could hang next to photographs of the creatures in their natural environment. Life cycles could be illustrated, showing the hatching of the eggs or the dramatic transformation of the caterpillar into a gorgeous butterfly.

A hobby wall is ideal for a den or teenager's room. Actual objects interspersed with photographs will help to capture the flavour, style, and mood of a favourite sport or hobby.

A tastefully executed collector's wall can be an elegant feature in a living or dining room. Well-made and smartly finished cases containing such prize objects as coins, scent bottles, snuff boxes, or small pieces of sculpture, hung next to giant enlargements of the choicest pieces, can show every aspect of the collection.

Lighting

Good lighting is an important element in a photo display, at least as important as mounting, framing, and hanging. Properly used, lighting can bring out the best in each image, dramatize the display, and expand the visual environment. It can change moods, and profoundly affect spatial relations in the room, creating effects of intimacy or of distance, as you prefer.

Lighting is either natural or artificial. Consider which suits your photo display best, and when and how to modify or intensify the available lighting to achieve the desired effect.

Most natural light will come through windows or a skylight. The changing effect of sunlight throughout the day has a marked and often lovely effect on walls, furniture, carpets, and pictures. Curtains, blinds, or screens are the most usual way to control natural light, and they can each be used with considerable subtlety. Remember, however, that strong sunlight will cause colour photographs to fade, so do not display them on walls that receive direct sunlight.

Much more control is possible with artificial lighting. A picture can be spotlighted dramatically or given discreet and almost natural lighting from whatever angle is most appropriate. The lighting already in your home can be rearranged so that it will illuminate the photographs. An angle poise lamp or spotlight can be directed fully, but not too closely, on a print for dramatic emphasis, or a shaded table lamp can give discreet indirect lighting.

Of course, lighting systems are available which are specially designed for display without fighting with lighting already present. And modern dimmer controls make it possible to set the light level quite precisely for the desired effect.

Display lighting falls into two main categories—track lighting and recessed lighting. Track lights are attached to electrified tracks on the ceiling and can be moved along to where they are needed. Tracks are available in different lengths, with extensions which can be fitted on the existing tracks if necessary. Some systems will even accommodate corners. The lights can be grouped so that they create a wash of light over the whole wall or isolated to illuminate one

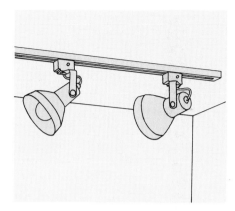

or more separate pictures. Track lighting is a relatively inexpensive, easy-to-install, and flexible method of lighting. It is available in a wide range of styles and colours, to suit almost any interior.

Recessed lighting is permanent, immobile, and more expensive than track lighting. Since holes must be cut in the ceiling to install it, the job should probably be done professionally and it can be fitted only if there is sufficient space above the ceiling. Despite these apparent disadvantages, recessed lighting is less obvious than track lighting and can look sleekly elegant.

To achieve the best effect with track or recessed lighting, take special care about the distance from the display at which the lighting is fitted. If the light is too near the display, hot spots will form on the pictures. If it is too far away, the light will be dissipated and ineffectual. All the various fittings come with manufacturers' instructions which should be helpful when placing them.

The lights can be used in various ways, depending on the intended effect. Wall washing is the term used when the whole wall, from floor to ceiling, is illuminated with an even and completely uniform wash of light. It is often used for a photomural or for a display covering a whole wall. It can be most successfully achieved with a group of evenly space track lights or with a row of recessed lights placed near the wall.

In addition to track and recessed lighting there are spotlights and floodlights which can be attached to the ceiling or to a wall. A spotlight casts an oval of concentrated light on an individual picture or on small groups of pictures, highlighting the area against its surroundings. A floodlight casts a wider, more diffused beam of light than a spotlight and can illuminate a larger group of pictures and some of the wall behind them. It is sometimes possible to fit frame projectors to the lights. Such a projector will cast a square or rectangular pattern of light which will fit a picture exactly and make it appear luminous.

Whichever system you choose, bear in mind that a good lighting scheme should provide enough light to carry out normal everyday activities in comfort, and also allow the best kind of emphasis on the photo display. The lighting of pictures in a home, like the pictures themselves, should enhance surroundings without either excluding or dominating the lives of the occupants. Aim for an attractive home, not a peopled gallery.

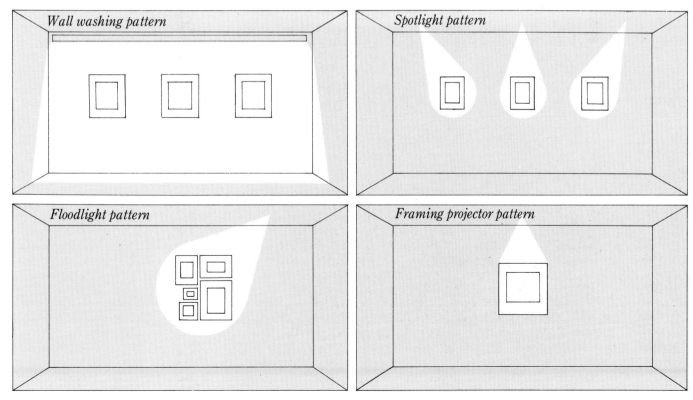

Wall washing pattern

Spotlight pattern

Floodlight pattern

Framing projector pattern

Pictures for Tabletops

In our rushed world, tabletops often become something like secular altars, or what the Japanese call *toko-no-ma,* alcoves where flowers or works of art are displayed for contemplation. They are a place for small human pieties, reminders of precious times, people, or places, a home for objects which act as charms or talismans against the world's inroads upon our often precarious equilibrium. They become a natural surface on which to display photographs that carry some of that quality for us.

Tabletop arrangements can be intimate and informal, or take on the austere remote beauty of ikonostases. They are perfect for the quick reassuring glance in passing while turning on a lamp. On the other hand, one picture on an otherwise empty table can create a small space for sustained meditation in an otherwise busy life. While tabletop arrangements can of course be permanent, they are perhaps most appropriate to more transitory, changeable decorative ideas. And since the frames do not

have to be fixed to a wall, there is room for considerable improvisation. Tabletop frames can be accordion-pleated, freestanding, or even cubical, and they can be made of a wide variety of unusual materials.

Pictures on a table are greatly affected by the quality of the lighting they are near or under. Bright light is appropriate for contemporary pictures, while softer lighting will gently illuminate old photographs or more contemplative, meditative arrangements.

The two transparent plastic cubes, left, provide an intriguing way to display four photographs. Because of the way light is refracted in the cubes, the pictures appear to be three-dimensional, creating an interesting and lively effect.

The simple but charming frames on the right are made from inexpensive plastic shaving mirrors. The mirrors were removed and the photographs most effectively matted in gold. The bases of the frames swivel so the pictures can also be hung on a wall.

Because it is printed on lith film, the photograph on the table left has an almost holographic effect. Lith film is perfect for a portrait, since nothing interferes with the purity of the image. Mounted in clear plastic, the photograph stands boldly clear, sharp, and absolutely contemporary.

35

Tabletop Arrangements

Some photographs seem to look better in freestanding frames rather than hanging. Displays of photographs on tables, on the mantelpiece, and even on window sills can become a whole new avenue of exploration in decor. Whether you opt for the clean, unusual simplicity of a picture on lith film in an almost invisible acrylic frame, or prefer the sculpturesque solidity of heavier, more baroque frames, or the tactile pleasures of fanciful and inventive home-made frames of leather or fabric, you will find that many of your photographs will acquire a new brightness and life once you establish one or two special surface areas as places for photographic display.

Framed photographs alone are fine, but your displays can become even richer and more exciting, more interesting as unified displays if you begin to think in terms of integrating photographs with other objects—whether they be bits of sculpture, rocks, shells, even a treasured ginger jar. Such displays encourage the viewer to look more closely, to be brought into far more intimate contact with them than mere observation would allow. They also give you the incentive to explore your photographs thematically and to make all kinds of unexpected connections evoked by skillful and imaginative juxtapositions.

There are basically three types of extended tabletop arrangements. The first kind is composed only of photographs, but with careful attention not only to the relation of the photographs to each other, but to the relation of the sizes, shapes, and styles of the frames. The second is an arrangement of photos as the dominant element together with other objects which, either thematically or through colour or mood, amplify, highlight, or reflect upon, the photographs. In these displays, the objects may be interesting in themselves, but acquire their life and their rationale for being where they are from their proximity and relation to the photographs. The third kind of display might be called a three-dimensional collage. In such an arrangement, the photographs are only one element in a composition dominated and integrated by an idea, a preference, or a collector's passion of some kind. The theme might be inspired by a love of antiquities and ancient places, an event, historical or contemporary, a place you love, or even a completely abstract concept, provided it can be visualized in photographs and realized, somehow, by and in a collection of related objects.

There are a few simple guidelines to bear in mind in relation to any kind of tabletop arrangement. Considerations of stability, proportion, and harmony underlie everything else.

Often the way to begin making a display is to think about what kind of mood various sorts of surfaces evoke in you. Glass-topped tables, stripped pine, and polished mahogany all have associations unique to them and certainly different, again, from surfaces of marble or Jacobean oak.

Bear in mind that your arrangement will exist not in a vacuum, but in a room, and in relation to the existing decor and feeling of the room.

There are also general questions of perspective. Will people be standing up to see your arrangement, or sitting down? Will it be glanced at in passing, or contemplated at leisure? Will it be seen, as a rule, from a distance, or close up? It is important that all the elements of the composition, perhaps especially the photographs, should be fully visible, both separately and in relation to each other, from whatever perspective they are likely to be looked at most frequently. In an arrangement that is all photographs, it might be interesting to have the photographs not only of different sizes and shapes but at different elevations, raised on appropriate blocks at various heights. You could aim at a sort of mini-amphitheatre effect, or a mini-mountain range, or city skyline so that the edges of the frames themselves become an element in the composition.

Once you begin to integrate other objects into your arrangements, the sky's the limit in terms of what is possible. With a clear eye and an imagination for what will make a striking ensemble, use almost anything you find appropriate and personally pleasing. You will be surprised to discover that in the right circumstances apparently unlikely photographs, together with the most disparate things of different periods and places and qualities, junk and *objets d'art,* old bronzes and dried flowers, will work together and will not only enrich each other, but will bring out unexpected facets to your appreciation of each item.

Suppose, as a possibility, you had a photograph of someone you loved. Suppose, as well, that you had walked on a beach with this person and found some beautiful shells and rocks, which subsequently always reminded you of that person. Or perhaps he or she reminds you of a certain period of history, and seems to have been born slightly out of the proper time. In those two simple associations lie the germs of two elegant, and even potentially eloquent, arrangements. The photograph, or photographs, appropriately framed in relation to the rest of the composition, can always, and very concretely, remind you of the person you love.

In a totally different vein, there are many possibilities in an arrangement of vacation photographs integrated with craft objects from the locale you visited. Folk craft, wherever it is from, is almost always exciting and beautiful, and certainly evocative of its place of origin. If, on the other hand, you are fond of birds, or cats, or horses, some good photographs, together with various styles of sculptural representations of the animals in as many media and styles as you like or can afford, and from as many historical periods as possible, would almost certainly be a charming and personal arrangement.

As à final thought, the possibilities for abstract designs exist even for tabletops. Some strong, clear, and probably colourful photographic images, of bits of buildings or even the branches of a tree, would find themselves very at home among some pieces of small, abstract sculpture or a collection of brightly coloured plastic boxes. It's all up to you, and your developing eye.

Displaying Transparencies

The special quality of colour transparencies—their brilliance when light shines through them—is seldom exploited to the full, if at all, in home displays. Transparencies tend to be kept in boxes and taken out only for slide shows at family gatherings. Permanent displays are usually reserved for prints.

There are several good reasons for this. The large, backlighted displays seen in office reception rooms or shops are seldom practical to set up in the home. A light box is unwieldy to keep on a table or hang on a wall and, most important, large colour transparencies are prohibitively expensive. In any case, even if the transparencies are sprayed with a varnish which absorbs ultraviolet light, the colours will still fade quickly.

It is, however, practical and effective to use black and white transparencies in photo decor. They will not fade and can be displayed simply and inexpensively. A black and white negative can be enlarged on sheet film, slipped into a freestanding acrylic frame, and displayed on a tabletop, placed where the light will shine through it.

Either ordinary continuous tone film or line film can be used for making the transparencies. Since transparencies appear brilliant only when they are very contrasty, a photograph which is just right as a print may appear flat and dull as a transparency. For this reason, the high contrast images produced on lith or line film tend to be most effective in displays.

Full instructions for using lith film are given right. If some half tones are desired, process the film in normal print developer (page 134). When a stark black and white effect is most desirable, use a high contrast developer.

Choose a negative with a good range of tones. The picture can be presented in several ways. It can be vignetted, as explained on page 57. To create a black border, make a card mask the appropriate size and hold it over the image when exposing it. To make a borderless picture, enlarge the negative so it overlaps the edges of the sheet of film. Colour can be added to black and white transparencies by slipping a sheet of coloured gel or acetate into the frame with it.

Lith Film

An extremely high contrast film, lith film, if processed correctly, will produce a negative or positive with only two tones — black and white. Ordinary continuous tone negatives or slides, if they are printed on lith film, can be converted into high contrast line images.

Lith film is produced in sheets and in 35 mm bulk rolls. It is either orthochromatic or panchromatic and must be processed in red or very dark green safelighting.

Negatives or slides can be either contact printed or enlarged directly on sheet film in exactly the same way as paper prints. To ensure a rich, dense black and clear highlights, test strips should be made.

Lith film should be processed in a high contrast developer. There are a number of these on the market and you should, of course, follow the manufacturer's instructions carefully. Sheet film can be developed in a dish and inspected as it develops. Load 35 mm lith film into a develop-

ing tank reel and process it in the lidless tank. The developer should be kept at a temperature of 68°F (20°C).

After immersing the film in the developer, agitate it continuously, either by rocking the dish or by rotating and lifting the film spiral in the tank. Certain developers need agitation for the first half minute

only and should then be allowed to settle for the rest of the processing time. Development is complete in about two and a half to three and a half minutes. The film should be inspected to ascertain whether it has developed fully.

The next stage, rinsing, should take place in an indicator stop bath. Agitation is important at this stage. About ten to fifteen seconds in the bath is sufficient.

It is best to fix the lith film in a rapid fixer, although any film fixer can be used. Fix for about twice the time the film takes to clear. Again, agitation is important.

Wash in running water for about ten to fifteen minutes. For the final rinse, use Photo-flo solution, then hang the film up to dry in a dust-free place.

Albums—for Changing Displays

Albums ... what an incredibly nostalgic word, evoking Jane Austen novels, young ladies in the provinces gazing wistfully at fashion plates, and callow young men inscribing wretched but heartfelt verses. Photograph albums are direct descendents of these early collections. Their basic virtue is that they are cumulative, and can be either leafed through all at once or displayed page by page. They can of course be used merely for reference, but that seems a shame when, on the one hand, the album itself can so easily be lovely and, on the other, it provides such an unparalleled opportunity for a continually changing but always unified display of photographs. You put the whole album together, set it on a table, and then all you have to do is turn a page occasionally.

Since albums have been around for such a long time, style of albums and of what kind of photographs you want to display is very much a matter of taste. Flea markets are good hunting grounds for old albums that may need a bit of repairing, but will reward any work you put into them as they regain their original charm.

This old Chinese album, with delicately water-coloured pages, makes an ideal setting for precious family photographs. The cover is lacquered wood veneer, and the album pages are exquisite.

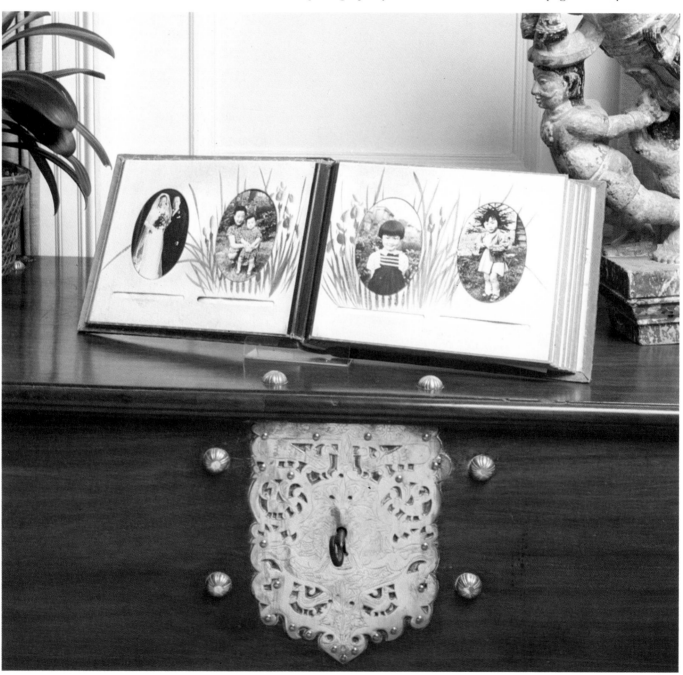

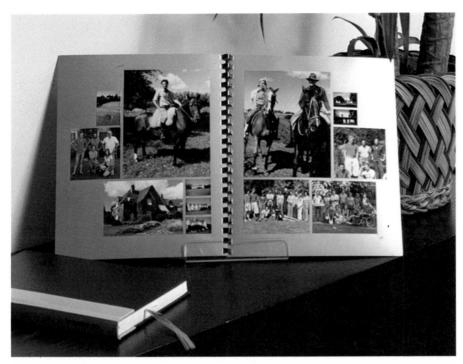

The striking album on the left was not bought but made. It clearly demonstrates that in an album you can make excellent use of all kinds of photographs, from contact prints to colour enlargements.

The simple contemporary album below provides a place to display a bright and witty arrangement of vacation photographs. Notice how the coastline follows on from one photo to another, backed, as it is in reality, by the town.

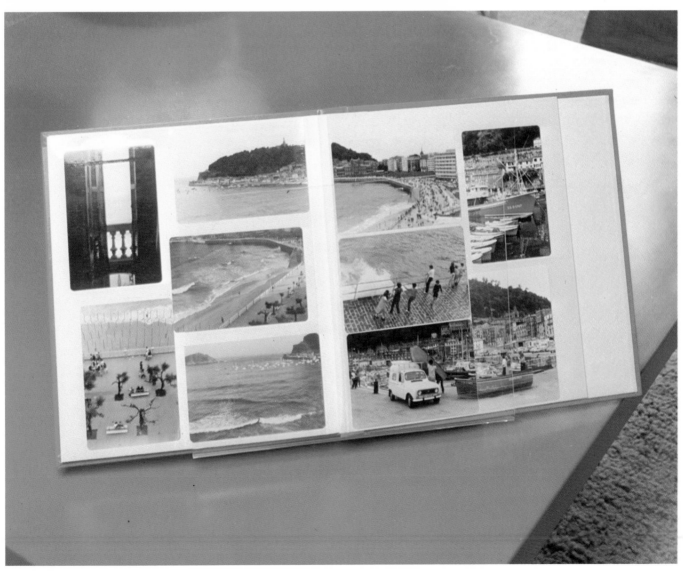

Make Your Own Album

The days of putting together a photograph album with snapshots of nearly identical size and using those little stick-on corners are long gone. It is now well within the capacity of anyone to design an elegant album, working with a few of the same principles and techniques as those used by designers of illustrated books and magazines.

In an album, like a book or magazine, the page is the basic unit of design. The design challenge is, initially, to organize the space on the page so that it works creatively, not merely as background but as part of the design concept. If you can begin to think like a graphic designer, you will be well on your way to creating a successful album.

Most designers work with some kind of grid. This is neither a formidable technical term nor something you have to buy. A grid is simply a variable division of a page, or of two facing pages, into symmetrically or asymmetrically divided units of space, so that you then have some elementary structure within which to begin placing your

photographs. A grid can be drawn on a sheet of tracing paper which you then place over the album page, or you can draw it lightly, in pencil, on the page itself.

The best way to begin is to decide on the margin, and how wide it should be. There is also the question of whether you want the margin equal all around. It may sometimes look better to have a wider margin at the bottom of the page, or at one of the sides. Once you decide that, and until you do you can experiment on sheets of scrap paper the same size as the album pages, draw in the margin.

Whatever grid you decide to use will go within the borders of the margin. An extremely simple grid to begin with, but a useful one, would be to divide the page space within the margin into thirds, both horizontally and vertically. Then, rather than placing nine identical pictures into the nine spaces, you can play with the number of units a given picture should take up.

There are many, many permutations.

All you have to do is use your eye for balance. If you want to work with something a bit more complex, try a design based on the Japanese tatami mat's double square proportion. Or you could try a two-and-a-half column grid, or a grid with a great many small units, either of which would allow you to make use of contact prints as well as enlargements. By alternating the grid throughout the album you can achieve an interesting change of pace. All you need for working out a grid is a ruler, a pencil, an eraser, and some paper the same size as your album pages.

You can, of course, buy blank photograph albums in a large range of shapes, sizes, and styles. It may be more interesting and rewarding, however, to make your own album, with heavy paper of your choice, and the kind of spiral binding that is by now an ordinary service of many small printing shops. The album could even be a looseleaf book of some kind, with a cover you make or design yourself, held together with metal rings.

A two-and-a-half column grid

A six-column grid

A tatami-like grid

A three-column grid

Restoring Old Photographs

When restoring an old photograph it is best to copy the original (page 130) and to carry out the restoration work on the new print. This makes it possible to experiment without any danger of ruining the original. Some problems, however, can be dealt with on the original print, or when it is being copied.

First examine the old photograph carefully to determine the nature and severity of the damage. There are several categories into which the damage will probably fall—tears, creases, and folds, scratches and missing patches of emulsion, stains and dirt, fading, writing on the print.

Tears can be dealt with in a number of ways, depending on their nature. In some cases, transparent tape can be placed on the back of a print and the small, ragged edges of the tear can be drawn carefully

together and pressed down on the tape from the front. When pieces of the print are missing, patches made from ordinary paper, tinted with watercolour to match the surrounding areas of the print, can be taped to the back of the original and retouched on the copy. Retouching techniques are described in Spotting (page 49) and Hand Tinting (page 77).

Creases and folds can be carefully ironed. Place silicone release paper between the iron and the print to protect the surface of the photograph. Ironing will remove the larger

marks. The remaining lines can be eradicated with good lighting when copying the photograph. A print mounted on board will have become brittle with age and should never be ironed.

Sometimes small pieces of emulsion come off when the corner of a print is unfolded. These can be glued on using a tiny amount of adhesive.

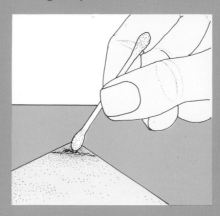

Scratches are best removed by spotting the copy print. If the original is not too precious, it can be retouched and disguised to some extent before being copied, but it is usually difficult to match the exact colours and tones of an old print.

Missing patches of emulsion are best treated when doing final spotting.

Some stains and dirty marks can be removed by the gentle use of a very soft eraser. Spots caused by dead insects can be lifted off carefully with a knife blade.

The most effective way to deal

with a stain, however, is to use a filter of the same colour as the blemish when copying the print. Any sign of the stain left on the final print can be removed by hand colouring or by spotting.

Some old photographs were extensively retouched at the time the original print was made, to remove wrinkles, add brilliance to the colour of the eyes or hair, or reshape a double chin. The pigments which were used to do this often discolour with age. These colour changes, too, can be corrected with a coloured filter.

Fading is a difficult problem, because it causes much of the detail, especially in the lighter areas of the print, to disappear. A contrast filter will help to replace some of the tonal vitality of the old print, but it obviously cannot replace what is no longer in the original. Use a pale blue filter when dealing with old sepia prints, and filters of various shades of yellow for faded black and white prints. As a general rule, the more faded the black and white print, the stronger the yellow needed, but it is necessary to experiment.

Writing on an old print can be partially removed with an eraser, if it is in pencil, or with ink eradicator, if it is in ink. Sometimes the pressure used by the writer leaves indentations on the print. These can be minimized by careful lighting when copying. Any remaining evidence can be retouched by spotting on the final print.

Mounting, Matting, and Framing

Frames, mats, and mounts are crucial elements in photo decor. They are integral to the structure of arrangements, and link photographs to the style and tone of a room. The wrong frame and mat can destroy even the most superb photograph, while the right frame and mat can make even an ordinary snapshot quite exciting, either alone or as part of a larger arrangement. Whether the end result is conservative and traditional, wildly daring, or a piquant and idiosyncratic combination which just happens to work, the taste and skill of the designer or decorator are most in evidence here.

Framing is an oddly attractive craft, evoking images of small workshops, simple tools, careful and painstaking work. Today there is a kind of nostalgia attached to working with wood. Although modern frames can be, and often are, made of almost any material, some of that nostalgia and charm still attaches to framing as a craft.

If you are interested in crafts, but have been hesitant about embarking on projects that seem too complex, involve learning too much at once, or entail too much initial expense, then framing could be an opening into a new world of working with your hands, and with sturdy, attractive materials. It does not require a large initial outlay, a lot of space, or elaborate equipment. The first trials can be extremely simple, yet produce effective, even beautiful, results. Then, as you acquire confidence, more subtle techniques and a bolder range of ideas can transform those first diffident steps into a lifelong adventure with a venerable yet always new craft.

All About Mounting

A photograph which is to be framed must first be securely fixed to a piece of stiff backing so that it lies flat and remains in position. There are several ways to do this. The most common methods of mounting photographic prints at home are adhesive mounting and wet mounting. Dry mounting, the most reliable method and one of the easiest, requires a dry-mounting press which, although expensive, many amateur photographers consider a worthwhile investment.

Once mounted, a photograph usually cannot be removed from the backing board, so if an original has considerable nostalgic or monetary value it is advisable to make a copy of it (see page 130) and mount and display this.

Mounting Board

A variety of mounting materials, including many types of cardboard, plastic foam board, wood, and hardboard, are available. It's a good idea, therefore, to look around an art supply shop to find the mounting material best suited to the size of your photograph and the manner in which you plan to display it. There are, however, a few general guidelines.

A photograph which is to be framed and is less than twenty inches (50 cm) in height or width should be mounted on triple-weight mounting board. The board should be cut slightly smaller than the rebate, or channel, of the frame so it will slide in easily.

When a photograph is more than twenty inches (50 cm) in height or width or is to be hung without a frame, a stiffer mounting material, such as hardboard or chipboard, should be used.

For an extremely light frame, or for a photograph which is going to be transported for exhibition displays, light, but strong, plastic foam mounting board is a good choice.

Adhesive Mounting

The simplest method of mounting a photographic print at home is to glue it to the mounting board.

The Equipment

For adhesive mounting you will need a sheet of glass, slightly larger than the mount, which is used as a weight on top of the mounted print while it is drying, a soft cloth, a rubber roller, four to six inches (10 to 15 cm) wide, and a wide brush to smooth the surface of the print. Also required is adhesive and a brush with which to apply it.

Most of the adhesives made for home use are suitable for mounting. Rubber solution, however, should be avoided because it tends to lose its adhesive properties when it dries.

There are several spray adhesives on the market. These are easy to use and effective, providing the manufacturer's instructions are followed exactly. Some types dry instantly, others more slowly, thus allowing time to reposition the print. The first spray from the can often results in a heavy application of adhesive which will subsequently spread out from under the edges of the print, so it is advisable to begin spraying to one side of the photograph on a piece of scrap paper.

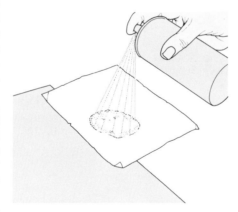

Plastic film sheets with adhesive on both sides can also be used, but most brands stick instantly and make it almost impossible to reposition a print if it's not exactly right on the first try. The way these adhesive sheets work is that the protective backing is peeled off one side, which is then placed on the back of the photograph and smoothed down. The second protective backing sheet is then removed. Another sheet is placed on the mounting board in the same way. The print is positioned on the mounting board, covered with a clean piece of paper, and rubbed with a cloth or roller to bond the two surfaces.

Tape is useful for temporary mounting, but it will disintegrate in time and is therefore not recommended for permanent use. Double-sided tape can be used, but once put down with this a picture cannot be repositioned. So unless you are perfectly confident, don't try to use it.

How to Do It

Following the manufacturer's instructions, apply the adhesive to the back of the photographic print. Position the print on the mounting board and smooth out wrinkles and air bubbles by rubbing the surface of the photograph gently with a soft cloth or brush and then by using a roller. Work outwards from the centre so that no air is trapped between the picture and the mounting board.

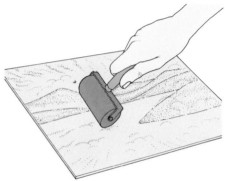

Since the mount will tend to warp as the adhesive dries, a photograph should always be countermounted. To do this, cut a piece of heavy, brown, kraft paper to the same size as the mounting board. Dampen one side of the paper with a moist sponge. Apply adhesive to the other side and stick this to the back of the mounting board. As the paper dries it will counteract the pull of the drying photograph.

After mounting and countermounting, place the print under the sheet of glass until it has dried thoroughly.

Wet Mounting

This is a variation on adhesive mounting and is recommended when a photograph is curled, badly creased, or torn, since the damage can often be disguised or repaired. Wet mounting is a bit tricky because a wet photograph is rather fragile and requires careful handling, but it is worth the effort.

To begin, immerse the photograph in clean water, then place it face down on the sheet of glass. Carefully smooth the surface using a brush or roller.

When the surface is smooth, apply a thin coat of adhesive over the back of the photograph and of the mounting board. Position the print on the board and press out any air bubbles. Then stick a countermount to the back of the mounting board.

Turn the board over and examine the photograph for any imperfections, which can still be smoothed out. Let the adhesive dry until it is barely moist, then place the mounted picture under the sheet of glass to dry thoroughly.

Dry Mounting

This is the most efficient, and probably the neatest, way to attach a photograph to mounting board. An electrically heated mounting press is necessary and a tacking iron should be used, although it is possible to use a domestic iron.

A sheet of tissue, coated with dry adhesive, is placed between the photograph and the mounting board. When heated under pressure in the press it bonds the two surfaces together. A special dry-mounting tissue, which requires less heat and allows the print

to be removed from the board if desired, has recently become available. It is intended for use with colour prints, particularly those on resin-coated paper.

No damaging chemicals are involved in the dry-mounting process, so it is the best way to mount photographs for almost archival permanence. Framing and do-it-yourself shops will often do dry mounting inexpensively.

The Equipment

Besides a dry-mounting press and a tacking iron, you will need a rotary trimmer or a straight edge and a very sharp craft knife, sheets of clean paper, and dry-mounting tissue.

How to Do It

When dry mounting at home, the first step, before beginning to mount the photograph, is to preheat the mounting board in the press to remove the moisture in it.

The instructions included in the dry-mounting tissue pack give precise temperatures for various types of photographic paper. The thermostat on the press should be set to the temperature that suits the paper used.

Lay the untrimmed print face down on clean paper. Position a sheet of dry-mounting tissue, at least as large as the print, over the back of the photograph.

Gently run the tacking iron in a cross over the tissue, following the direction of the arrows in the diagram, so that it adheres to the print.

Using a rotary trimmer or a straight edge and knife, trim the print and the tissue to the desired finished size.

Position the print and tissue on the mounting board with a gentle touch of the iron.

Cover the print and the mount with clean, uncreased paper. Silicone release paper is best because it will not stick to the print or leave a texture. Place the mounted print in the press for about ten seconds. After removing it, bend the mounted print slightly to be sure that the print has adhered to the board.

The Wall is Frame Enough

This is a dramatic, technically simple way to make photographs a lasting and integral part of decor. Nothing interferes with the impact of the image. The uncluttered look need not be stark. Block mounting is extremely versatile. Solid yet graceful, block-mounted photographs fit easily into any decorative style and, by contrasting or harmonizing, can be as at home with antiques as with the most contemporary furniture. Some block-mounted photographs, when cut into sections, have the same flowing tranquility as certain oriental screens.

A great advantage of block mounting is flexibility of shape. The only limitations are imposed by the material on which the photograph is mounted. Squares, rectangles, circles, polygons—any or all of these are available to the

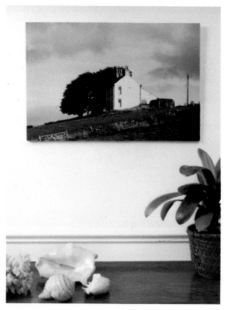

imaginative decorator. There is no limit, either, to the kind of photographs suitable for block mounting. Anything goes, from a tree to a face to the most abstract pattern, a baby, a blade of grass, or an oil rig.

The rural landscape left is as cool and serene as the shells and plant on the table under it. The bone whites and deep greens echo each other; the blue sky seems to belong to both.

The poppies glowing on the right show block mounting in an opulent setting. The block-mounted sections have been remounted on a soft green background and the colours echo those of the couch and cushions.

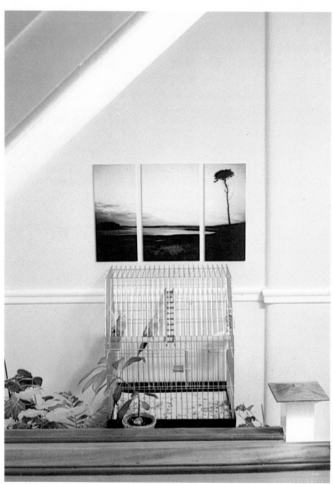

This landscape has been block mounted in sections. The impact is similar to that of a Japanese screen.

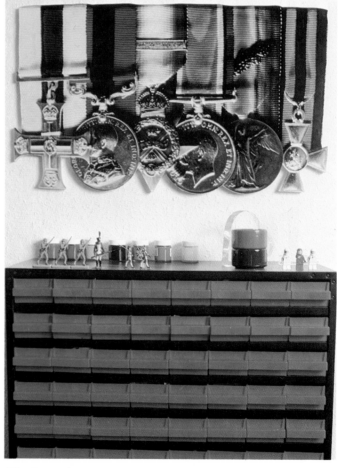

The inventive medals have been enlarged as a poster print, cut to shape, and mounted on plastic foam board.

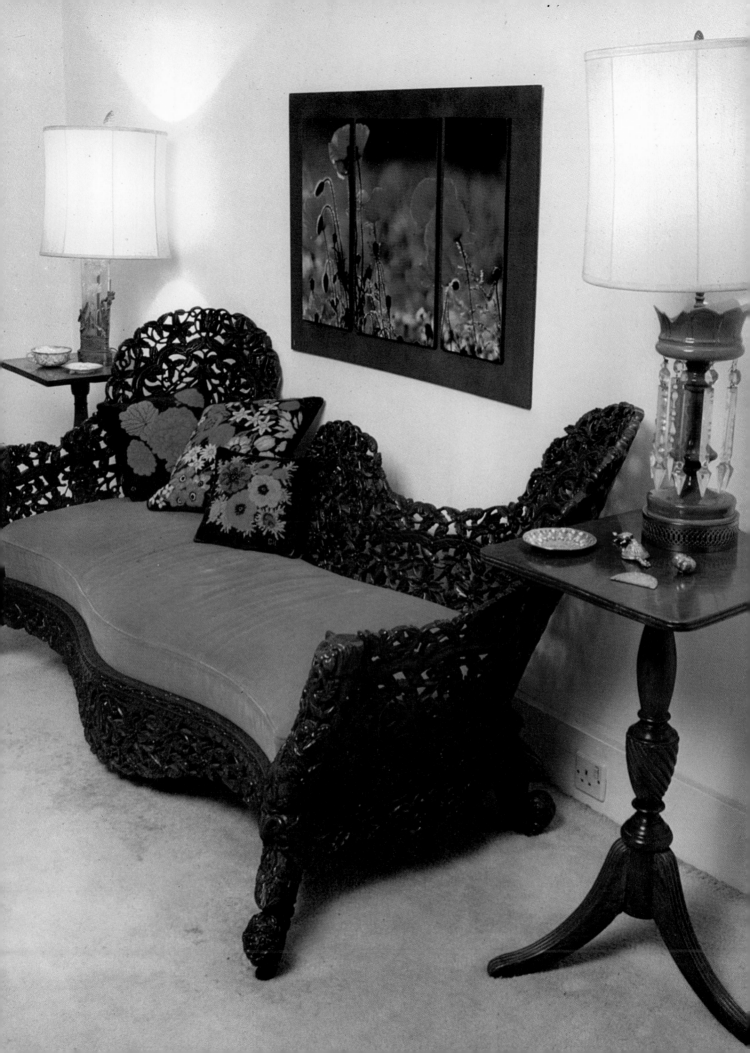

All About Block Mounting

Many large photographs are suitable for block mounting. A picture thus mounted requires no frame and no glass and can be hung quite easily with screws or even with a suitable adhesive. There are processing companies which will produce very large colour prints—photoposters—from transparencies. These are quite inexpensive and when they are block mounted are exciting and highly decorative. At even less cost, but a little effort, giant black and white prints can be made at home (see page 124) and mounted in the same way.

Mounting Board

Self-adhesive block mounts are available in standard photographic print sizes. They are beautifully finished, but are, of course, more expensive than home-made mounts.

A block mount is quite easy to make at home using plastic foam board, chipboard, fibreboard, hardboard, or even wood of the required thickness. The minimum width should be five-eighths of an inch (1.5 mm).

Equipment

To block mount a photograph, a piece of mounting board is needed which is about three-eighths of an inch (9 mm) smaller than the print on all sides. Also required is cellulose adhesive, a brush to apply it, lots of newspaper, a soft cloth or rubber roller, a large piece of card, a very sharp craft knife, a cutting mat, and a piece of fine sandpaper.

How to Do It

Mix sufficient cellulose adhesive to cover the back of the print and the mounting board. The board may absorb the first few coats, so quite a bit of adhesive will be needed.

Soak the print in clean water for about twenty minutes. If the print is very large it may be necessary to do this in the bathtub.

Place several layers of newspaper on a large work surface and place the mounting board on it. Apply the adhesive to the board, paying particular attention to the edges. It will be necessary to give it at least two applications.

Remove the print from the water and let the excess drip off. Place the print picture-side down on the work surface and cover the back with adhesive.

Turn the print over and position it carefully on the mounting board. Working from the centre outwards, smooth the print carefully to remove all the air bubbles. This is best done with a soft cloth or a rubber roller.

When the surface of the print is dry, lay the board picture-side down on a piece of clean card. (Don't use paper which tends to wrinkle and spoil the surface of the print.) Pile books or other heavy objects on top of the board. The adhesive must be permitted to dry thoroughly. This can take up to two days, so patience is necessary.

When the adhesive has dried completely, remove the weights and put the board face down on a cutting mat. Using a sharp craft knife, carefully trim the print to the edge of the board.

Adhesive will almost certainly have oozed out from between the print and board, but it should be dry and quite hard and the knife will cut through it cleanly.

If necessary, use a piece of fine sandpaper to smooth the edges of the board. Be careful not to touch the edge of the print with the sandpaper.

The edges of the board can either be painted or left their natural colour. Most commercially produced block mounts have matt black edges which set the pictures off very well, but a colour can be chosen which complements the print or the colour of the wall on which it will be hung. When painting the edges, put masking tape on the edges of the print to protect them from paint.

Wraparound Block Mounting

An interesting effect is created when a picture is continued around the edges of the mount. The mounting board should be at least one-half inch (1.25 cm) thick.

Cut the mount so that it is at least one inch (2.50 cm) smaller than the print all around. Glue the print to the board as for block mounting.

When the adhesive has dried, cut the corners of the edges of the print as shown below.

Apply adhesive to the edges of the board and to the edges of the print. Smooth the print around the edges of the mount, taking particular care at the corners, so that they will be neat.

Let the adhesive dry with the print face down. When it has dried completely, trim the edges of the print.

Multiple Block Mounting

Block-mounted photographic prints are effective if several are grouped together. They can either be hung separately on a wall or several can be attached to a single, large piece of mounting board and hung as one picture. According to taste, spaces of varying widths are left between the prints, revealing the wall or the colour of the mounting board.

A single large photograph can be treated in the same way. A picture with strong graphic content is especially dramatic when it is cut into sections and reassembled on a wall or mounting board, with spaces between the sections.

Attaching Blocks to a Mounting Board

Prints which are block mounted on plastic foam board can be glued to a mounting board. When they are block mounted on board they will have to be secured with small screws, countersunk and inserted from the back of the mounting board.

Make pilot holes for the screws using a push drill with a one-sixteenth of an inch (1.6 mm) bit. Position the holes two inches (5 cm) in from each corner of the board, with another one in the centre.

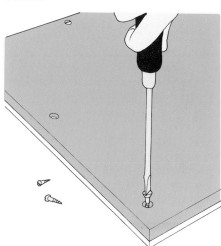

Spotting

No matter how carefully they have been developed, prints almost always have a few blemishes. To retain the impact of the picture, these can and should be removed by the retouching technique known as spotting. Much retouching is a complex and difficult process, requiring professional skill and equipment, but spotting can be done at home with a minimum of tools.

Spotting entails dotting tone on the surface of the print with pencils or with the tip of a fine brush dipped in spotting medium or retouching dye. It is used for removing black and white specks, but larger areas can also be filled in by using this technique.

It is easier to spot successfully on the surface of a matt print than on a glossy one, which shows every mark.

Mixing the spotting medium with a little gum arabic will, however, make it shinier so that it shows up less on a glazed glossy surface. If retouching dye is being used for spotting, the print can be glazed afterwards, disguising the retouching.

The tools needed for spotting are: fine sable brushes, numbers 0 to 00, a palette—an old saucer will do—a sharp craft knife, spotting medium or dyes, tissues for blotting brushes, HB and B or 2B pencils, and a magnifying glass.

Work in a good light and begin on the dark spots first. Using a magnifying glass, gently scrape the emulsion surface with the knife until the tone of the spots matches that of the surrounding area. This is called knifing. It may be necessary to

scrape down to the white base and then use spotting medium to achieve the right tone. The medium should be diluted on the palette to the correct tone and then applied with the tip of a fine sable brush.

Dust spots, which appear as white marks on a print, can be dealt with by applying spotting medium in the same way. It is best to begin with the darker areas and dilute a small amount of the medium progressively.

On matt prints, it may prove easiest to work with pencils.

The Difference a Mat Makes

Even the simplest photograph, the most ordinary portrait, can be transformed by surrounding it with a simple mat. When the mat is well-proportioned, the photograph will immediately achieve a certain depth and distinction. But a simple, conventionally proportioned mat, although undeniably attractive, is the least of what can be done once you consider the potential of mats.

Mats are usually made of thin cardboard or heavy paper. These are good materials to use when you begin to make mats for your photographs.

A mat is the setting for a photograph, and will strongly affect the tone, style, and mood of the picture. The elements to consider are the size, shape, and proportion of the mat in relation to the photograph, the texture and colour of the matting material, and, possibly, the degree of ornamentation. Such accents as fine ink lines drawn close to the photograph can add definition or create the illusion of a double mat. Sometimes a double, or even a triple, mat, can be strikingly effective, but it must be cut with extreme care, since the inner mat is usually much narrower than the outer one and the two edges are very close together.

You may never realize the potential of your photographs until you begin to experiment with matting them. A photo of a family group may suddenly leap into life when the basically circular shape of the composition is emphasized by a mat's circular aperture. Or an old vignetted portrait may be highlighted by an oval aperture in a mat of antiqued parchment. A colour photograph that seems rather undistinguished in its naked state often gains luminosity and depth surrounded by a mat that picks up one of the dominant colours in the picture. Abstract photographs of industrial scenes or patterns in an urban landscape can achieve a kind of austere drama matted in stark black or in a mat covered with paper that has the sheen of burnished chrome. And there is always the intriguing possibility of assembling a group of small photographs that you think might belong together, and unifying them into an integrated composition by arranging them within an appropriately coloured and textured multiple mat.

The picture above is unmatted. It is quite an attractive photograph, but it is rather innocuous and boring in its unadorned, simple acrylic frame. In the subsequent illustrations, you can see exactly how much difference a mat makes to the same photograph, even before a frame has been added.

The white printed paper mat above, picks up the white of the flower and gives the picture a rather conventional, but charming, almost bridal, air. The small print on the paper provides just enough emphasis to lift the mat off the wall, so that the photo seems to be almost, but not quite, floating.

Notice how the lilac of the mat above brings out all the pale tones in the photograph, echoes the mauve in the woman's scarf, and gives the whole picture a soft quality.

By contrast, a deep brown mat of exactly the same dimension completely changes the mood of the photograph, giving it an autumnal feeling, and a kind of velvety richness.

On the left are four variations on double and triple mats. The dimensions of all are the same. The change in effect created by each change in the mat is remarkably striking. There is the quiet elegance of the green mat, in which the effect of a double mat has been achieved by painting thick and thin lines close to the photograph. The brown mat with its cream inner fillet is simple and, at the same time, striking. And compare the rather classically dignified brown, black, and ivory triple mat with the ombré triple mat in shades of pink. The mats seem to change the character of the woman. It is like stepping from an academic gallery into the bright world of high fashion.

The common denominator of the three prints above is that the apertures all crop close into the face in the photograph. The colours bring out different qualities in the portrait. The heart-shaped mat above makes the woman look young and pretty.

This pale grey mat makes the woman's face a study in ethereality, and the grey seems to evoke all the softness and lyricism in her face.

This dark green mat is charming, and the colour, combined with the oval aperture, give the impression that the woman might be peering out of a woody clearing.

All About Matting

A mat creates a link between the photograph itself, the frame, and the decor of the room in which the picture is hung. It also protects the picture. Consequently, a mat is one of the most important elements in the framing process and great care is required in choosing the right colour, material, and width of the mat and precision when measuring and cutting it.

Matting Materials

A mat is usually made from cardboard, which is available in a wide range of colours and textures. Matboard covered with gold foil, cork, and fabric is also available, but can be difficult to cut and it is often easier to cut a cardboard mat to size and then cover it with the material desired. When choosing a matting material, it is important that the colour and texture enhance the picture, rather than overwhelm it.

Equipment

The equipment needed for cutting a mat is simple, but should be of first-class quality. It includes a very sharp craft knife, a metal ruler and steel tape, a marking gauge with a pencil lead in place of a scriber, a large square or set square, a cutting mat, and a sharp pencil.

Cutting paper blunts the edges of blades quickly, so a knife must be sharpened frequently or the blade changed often.

A special cutting tool for mats is available which makes cutting a bevelled edge particularly easy, although a sharp craft knife and straight edge work well.

Measuring the Mat

Check the dimensions of the mat board and be sure that it is square. If it is irregular, the aperture cannot be measured or cut accurately and the whole mat will be distorted.

Check the right angles at the corners of the board with the square or straight edge. They should be exactly 90 degrees.

Never assume that your photographic print is square. Measure it as well as the mat board across the diagonals from corner to corner, from side to side and from top to bottom.

To trim an irregular mat board, place the straight edge along the side of the board and draw a pencil line on the board to give an absolutely straight line from which to work.

Place the large set square against the straight edge and draw a line at right angles to the first.

Measure the line AB. Place the square on B and draw a line BC, at right angles to AB. AD and BC can now be measured and the points DC connected.

When trimmed along these lines, the mat will be absolutely square and ready for the aperture to be cut.

Scaling and Cropping

Sometimes, when a print is to form part of a multiple display in which the mats are all of a uniform size and shape, it has to be cropped to match the proportions of the mat. There is a simple way to do this.

Place the print in the bottom right-hand corner of the mat. Place a straight edge in a diagonal from one corner of the mat to the corner opposite. Draw a line AB. Where this line crosses the print, at C, is where the print should be cropped. Measure the distance from C to D and make B to E the same length. Draw the lines CD and CE and crop the print. It will now be the same shape as the mat.

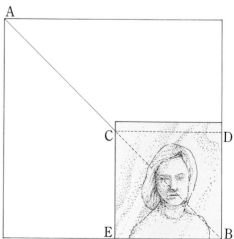

The same method in reverse provides a quick way to crop a mat to make it the same shape as a print.

Place the print in the corner of the mat. Place a straight edge diagonally across the corners of the print. The point where the straight edge touches the edge of the mat is where the mat should be cropped. It will now be in the same proportion as the print. Before cutting, carefully measure the sides of the mat to be sure they are equal.

Cutting the Aperture

After the mat board has been checked and trimmed, use a marking gauge to mark the position of the aperture. The aperture should overlap the print by about one-eighth of an inch (3 mm) all around. The aperture can be drawn in lightly with pencil, or the corners can be marked with tiny pinholes. If pencil is used, it is best to draw the lines on the back of the mat board and to cut the board on that side so no marks show on the front.

The edges of the aperture can be cut either vertically or bevelled. A vertical edge is more unobtrusive and is often used for double or triple mats. It tends, however, to cast distracting shadows. The bevelled edge, on the other hand, makes the mat look more finished, casts no shadow on the print, and gives a greater feeling of depth to the picture.

To avoid ruining matting board and to get accustomed to the tools, it is a good idea to practise cutting on scrap pieces of cardboard before cutting the mat itself. Cutting the corners in particular may take time to master.

Lay the blade of the craft knife against either the 90-degree or the 45-degree edge of the straight edge, depending on the cut required. Cut as smoothly as possible, at a steady pace, from corner to corner. Do not stop in the middle of a side or slow down at the corners because this may change the appearance of the cut. Be careful, too, not to overcut the corners. The tip of the blade should just penetrate the mat board.

Keep a steady pressure on the knife at all times, and be careful to keep the angle at which you are cutting consistent. Pretend your wrist is rigid.

When all four sides have been cut, the centre piece of card should lift out easily. A sharp razor blade can be used for neatening the corners and a piece of fine sandpaper or a fine emery board to smooth the edges of the cut.

Double and Triple Mats

A single aperture with the edges of two, or even three, mats showing can create an interesting effect. The aperture in the upper mat is cut slightly wider to reveal a narrow strip, called a fillet, of the lower mat around the picture. Three mats can be used in the same way to make a triple aperture. The fillet focuses attention on the print by outlining it against the mat. It can be darker or lighter than the mat, or can pick out one of the colours in the photograph or in the surrounding room.

When the edges of the apertures are bevelled, showing two or three thin white lines, the effect can be very striking.

When making a double mat, instead of using mat board for the narrow inner mat it can be made from a piece of heavy coloured paper and left unbevelled.

To avoid monotony, it is important with double and triple mats to make the fillets, frame and mat all different widths.

Instead of cutting the apertures before fastening the mats together, it may be easiest to cut the largest aperture first. Then attach the two mats together with double-sided tape and cut the second aperture through the first. If a third mat is to be used, attach it next and cut through the other apertures.

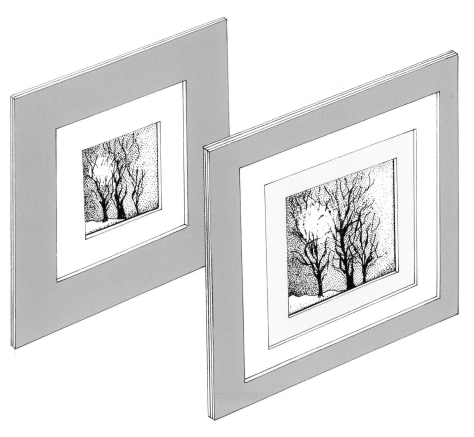

Bringing Images Together

Multiple matting is a simple and economical way to create a variety of photographic arrangements. The term means either that several apertures are cut in the same mat or that the photographs are glued to the same piece of backing. The arrangement is then treated as a whole, covered with a single piece of glass, and hung as if it were one image. There is great flexibility; the photographs can be brought together because of their subject matter, history, common location, colour values, personal interest of the designer, or even because they share a common style or just look good together. The principle of selection is only that the photographs came together in some sort of coherent group and are enhanced by each other's presence. The economy of multiple matting can be of great help to people whose good taste continually outruns their finances.

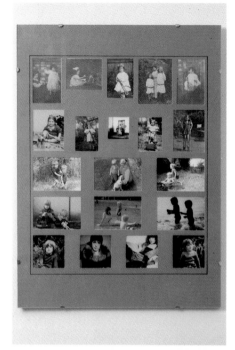

Mothers and children of several generations of the same family is the theme of the colourful display on the left. All the apertures were cut into the same mat, whose neutral tone easily accommodates many photographic styles.

By contrast, the sharp, clear colours of the flowers and fields in the photographs at the right strike a more contemporary note. The white mat enhances their brightness and blends with the white wall.

The charming ladies below have been brought together in a multiple mat the same tone as the photographs, but several shades darker so that attention is concentrated upon the old-fashioned grace of the portraits which harmonizes so well with the wallpaper.

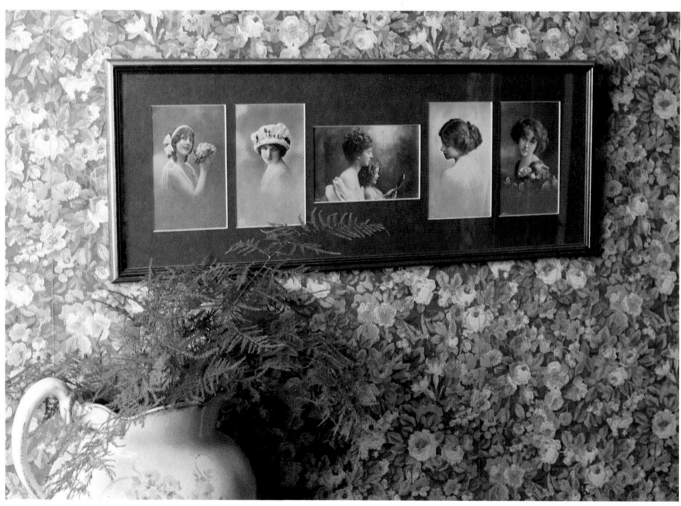

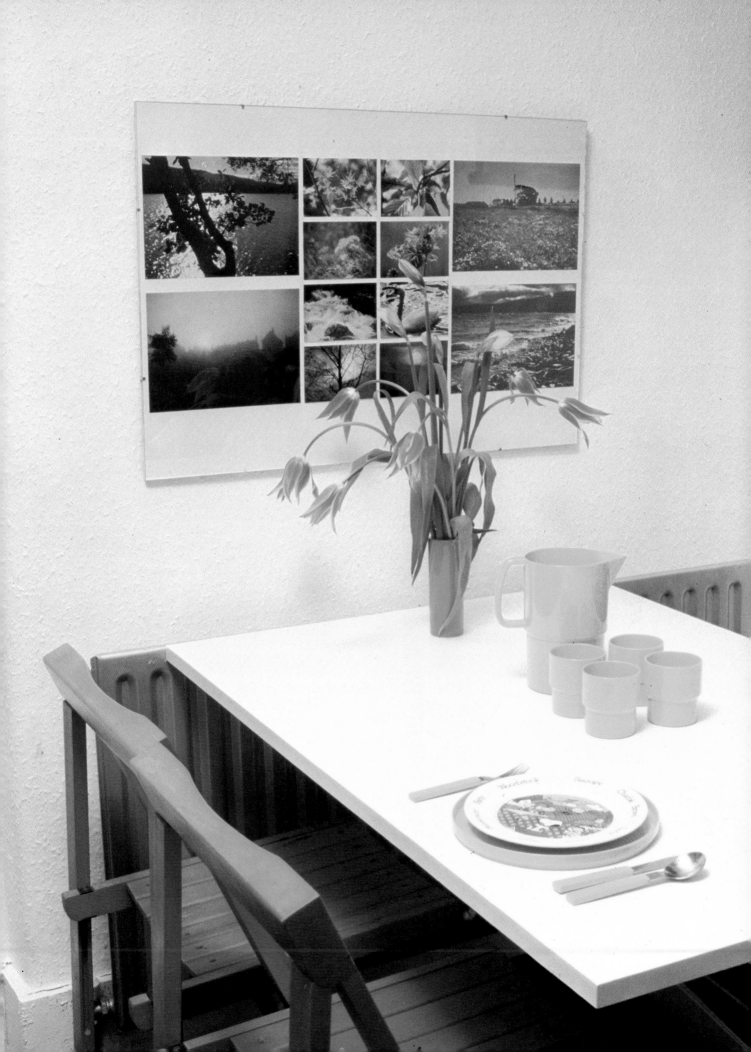

Multiple Matting

A collection of family photographs, a group of vacation snapshots, a series of nature studies, are the kinds of picture which lend themselves to display in one frame. After the theme of the multiple display has been decided, select the pictures you want to use and examine them carefully.

If the photographs are of different sizes, decide whether they should be cropped to a uniform size and shape or left in their original format. If the assembly includes old photographs, these may be sepia toned or vignetted. For the sake of uniformity, the other photographs can be copied (page 130), sepia toned (page 25), or vignetted (page 57) to match, although sepia toned pictures can be successfully combined in one frame with black and white photographs and colour prints.

Choose a mat colour which will enhance all the photographs. It is usually best to stay in a fairly neutral range and use a black, white, or creamy beige mat, although if there is a dominant or common colour in the pictures a mat which matches it or contrasts effectively can be used.

Group the pictures on the mounting board to decide on the right arrangement and spacing. Pay particular attention to the way the compositional lines

of the individual pictures relate to each other and try each picture in several different positions. Experiment with the spacing. A good rule is to make the border around the assembly wider than the spaces between the individual pictures.

Decide on the size and shape of the final assembly in relation to the format of the photographs. A row of vertical pictures, for example, might look most

dramatic in a long, low, horizontal frame. For a large assembly, it may not be possible to buy mat board of the required size. In this case, two pieces of mat board can be butted together and covered with fabric, or hardboard which is one-eighth of an inch (3 mm) thick, can be used.

When the photographs have been arranged, check to be sure that the vertical spaces between the photographs are equal, even if the horizontal spaces are irregular. Do this first by eye, then check the space with a ruler or a pair of dividers.

When the spacing is satisfactory, mark the mounting board clearly at the corners of each print. These marks will not show after the mat is put on.

Stick the prints to the mounting board, beginning at one end of the assembly and working across.

With masking tape, attach a piece of tracing paper the same size as the mat to the top of the mounting board, covering the prints and the board. With a straight edge and pencil trace the photographs, making the tracing one-sixteenth of an inch (1.6 mm) smaller

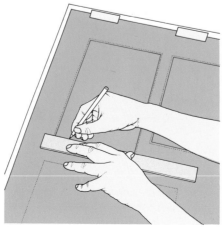

on all sides than the prints. Remove the tracing paper and tape it to the mat board, making sure it is absolutely square.

With a sharp craft knife and a straight edge, cut out the apertures in the mat, cutting through both tracing paper and board. It is easiest to cut all the vertical lines first, then all the horizontal lines.

After the apertures have been cut, remove the tracing paper, turn the mat over and apply adhesive to the back.

Lower the mat carefully over the mounting board, lining up the apertures with the prints. Cover with a piece of card and weights, such as heavy books, or with a sheet of glass and leave until the adhesive is dry.

After the adhesive has dried, it may be necessary to trim the mat and mounting board.

As a final touch, to unify the assembly, a thin black line can be ruled around the outside of each print with a fine-pointed pen and black ink.

Covering a Mat With Fabric

Sometimes a photograph seems to demand a fabric mat. An elegant portrait might seem best set off by a mat of natural linen. A beach scene might be most attractive against a grass-cloth mat. And a little girl's picture might be charming matted with a Liberty print.

For the mat board which is to be covered, choose a colour close to but not darker than the fabric.

Measure and cut the mat. Cut a piece of fabric at least one inch (2.50 cm) larger than the outside dimensions of the mat.

Spread an appropriate adhesive evenly on the front of the mat.

Press the adhesive-covered surface to the back of the fabric.

Turn the mat over and press the fabric on the mat with your hands until it is smooth.

Turn the mat over again and, using a sharp craft knife, carefully trim the fabric along the edge of the mat.

Make a diagonal cut in the fabric out from each corner. Cut out the centre aperture leaving one inch (2.50 cm) along the inner edge.

Apply adhesive to the inner edge of the back of the mat. Pull the fabric around the inner edge and press it into the adhesive on the mat.

Vignetting and Shading

A vignette is a picture whose edges fade gradually into the background, although the term is often broadened to encompass picture shapes with hard edges. The technique used to obtain a dark picture surround is called shading.

Vignetting

The technique of vignetting is almost as old as photography itself and is simple to carry out in a home darkroom. It has a number of practical uses, for it makes it possible to remove a cluttered background or unwanted detail, and to isolate the subject. Vignetting is particularly useful for picking out one individual from a group photograph. When, for example, the only picture of a relative is in an old army or team group, by combining copying with vignetting that person can be singled out. The technique can, however, be used in as many creative ways as imagination suggests. The oval shown here is not the only shape which can be used for vignettes; different shapes, perhaps related to subject matter, are equally successful.

To vignette, place the negative in the enlarger and focus. Make a test strip (see page 134) to determine the print exposure time. Take a piece of matt black card or paper about the same size as the print and, to establish the size of hole required, hold the card between two and five inches (5

and 12 cm) above the baseboard, in the light path of the enlarger. With a white pencil crayon, draw an oval of the required size and shape on the card. Absolute accuracy is not essential at this stage.

Draw the oval again, accurately. Place a cutting mat or board under the card and cut out the oval carefully with a sharp craft knife.

Take the piece of card with the hole in it and hold it under the enlarger lens, about three inches (7.50 cm) above the baseboard of the enlarger. Print the negative, using the exposure time determined previously, moving the card slightly in a circular manner, to soften the edges of the image which is printing. This will result in a picture with a gentle oval shape and a white border. To produce a vignette with a hard edge, cut the hole accurately to size and lay the card on top of the paper while printing the photograph.

Develop the print in the usual way.

Shading

To produce a picture with a black surround, use an oval, or other shape, cut from a piece of matt black card or paper as explained above. Expose the whole print in the usual manner, then switch off the enlarger and remove the negative.

Tape the oval piece of card to a piece of thin wire; this will serve as a handle by which to hold the card in the light path of the enlarger.

Switch on the enlarger and hold the card over the centre of the print for fifteen to twenty seconds, until the border of the paper turns black. Remember to move the card gently to soften the edges of the image and eliminate the shadow cast by the wire.

Framing Without Frames

Everyone who has been to a museum has experienced the horror of seeing some lovely work of art surrounded by a hideously encrusted frame. While framing can be tasteful, appropriate, even enhancing, contemporary taste has turned increasingly towards permitting paintings, prints, and certainly photographs to speak for themselves, presenting them with a minimum of fuss. Just as the Victorians were so concerned with covering up that even piano legs often had skirts, so the twentieth century has been concerned with stripping away covering, ornament, excess. Out of this has developed a contemporary passion, of which there are many attractive and dramatically effective examples, for exposing the working parts of things, as well as for a kind of minimalism—reducing things to the simplest shapes and the cleanest possible lines.

The concept of framing without frames is very much in the contemporary mood. Photographs speak for themselves, and the methods by which they are mounted are either nearly invisible or frankly and attractively functional. If there is a visible background, it is likely to have a touch of sophisticated humour or even to unabashedly incorporate the photographic process as part of the design.

Framing without a frame is a particularly appropriate mode of display for a photograph in which the image is in itself so dramatic, powerful, or sensuous that anything around it would only detract from its inherent qualities. Strong natural images, of surf, or rocks, or fields, where the shapes are bold and the textures vivid, are ideal for this kind of treatment. A portrait of a striking face, too, is often even more impressive against the stark background of a white wall. While the whole issue of whether to use frames or not remains largely a matter of taste, it is worthwhile to consider all the possible options.

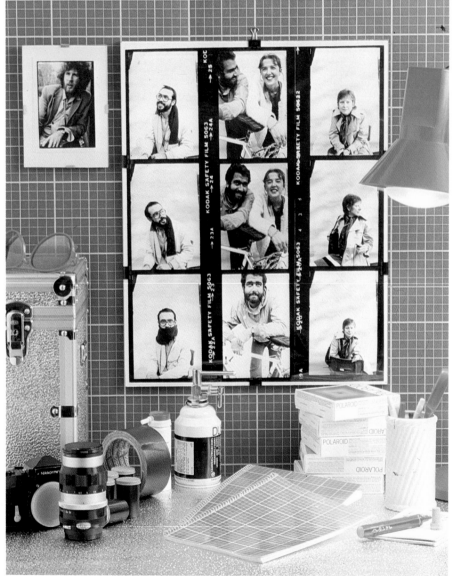

The blow-up of contact strips on the left shows a bold incorporation of process into a finished work. Because the photographs are in sequence there is a strong sense of movement and spontaneity. The picture is held between mount and glass with ordinary fold back clips, a classic example of the functional becoming decorative. The clips fit in perfectly with the technical apparatus on the desk and the general atmosphere of the room as workshop.

Nothing distracts the eye from the photograph above. Grass, trees, and sky emerge sharply on the white background. The discreet metal clips which hold the picture elements together add only a note of modernism and efficiency.

The solarized photograph of a sailboat floats serenely on its wraparound background of photographed cloudscape. The glass is held by transparent plastic clips, so the effects of lightness and clarity are almost entirely undisturbed.

Making Frameless Frames

A frame is not always essential. Some photographs look best when they are displayed in unobtrusive, simple frameless frames. This method also has the great advantage of being relatively inexpensive and of making it possible to change the picture quickly and easily if desired.

In a frameless frame, the components —the mounting board, photograph, mat, and glass or acrylic—are held together by clips or brackets. A great deal of variation is possible. The photograph can be floated on top of the mat, or behind it. Some systems will accommodate more than one mat. The photograph can be mounted on heavy board without glass or it can be put between two sheets of glass or acrylic. If glass is used, it is important that the edges be smoothed with an oilstone.

A great variety of clips and brackets are available at framing and art supply shops. Some are included in kits with the glass and mounting board cut to size. These are simple to assemble, but are only useful if the sizes available are right for your photographs. They are also somewhat more expensive than

buying clips and other components separately.

Brackets and Clips

Here is a guide to some of the clips and brackets available for frameless framing. **Corner brackets** are made of metal and fit over the corners of the assembled mounting board, mat, and glass with relatively little of the bracket visible on

the front. They are held in place by metal bands or string-tightened cords in the back. Some are designed to go around the back of the picture. Others

cross over diagonally in the back, thus easing the strain on the glass. The ties, in either design, should not be overtightened, for this can distort the assembly.

Edge brackets are wider than corner brackets and only two of them are used on the top and bottom edges of each picture. They are held in place by a tie which is threaded between them. Although edge brackets are somewhat less obtrusive than corner brackets, the design puts some strain on the assembly and they are, therefore, most suitable for small, light pictures.

Swiss clips are quite easy to use. Four or eight of these clips must be used, however, depending on the size and weight of the assembly. Rather than being tied together, each spring-loaded clip is pushed over the assembly, or, in some types, has a tooth that pierces the back of the mounting board. Another version, illustrated below, is held in place by a nail driven into the mounting

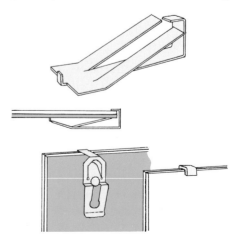

board and is very secure. The clips that can be seen over the edges of the glass are quite unobtrusive.

Plastic clips can only be used with a heavy mounting board of at least one-half inch (1.25 cm) thick. These clips, which are almost invisible from the front of the picture, are attached to the sides of the mounting board with small metal screws. Eight are needed for each picture.

Paper clips with wire handles, available from office suppliers and stationers make simple and inexpensive clips. After they have been clipped on the pictures the handles are removed. One handle can, however, be used as a hanger. Conceal a piece of rubber band between the clip and the mounting board to keep the clip from slipping. The clips, which are black, can be painted, if desired, with brightly coloured or white enamel.

Solarization

When photographic film is exposed to an unsafe light during development, the result is a partially reversed image. This can be fixed, washed, and printed to give an exciting, if somewhat unpredictable, picture. Originally called the Sabattier effect, after the man who discovered it, this technique is now usually called solarization. It is used deliberately by photographers to vary their results and to achieve strong and sometimes exotic visual effects.

Sharp images with strong graphic content respond best to solarization, but because this is a one-off process it is worth experimenting. This technique is unpredictable, therefore, for effective results, it is necessary to try different types of film and developer and to vary the timing and length of exposure. If the film or print is exposed too early, the half tones will become too dense and if this is done too late, it will not have much effect. Usually, the film or print is exposed halfway through development.

There are two types of solarization—print and film. Film solarization is often more effective and has the advantage that the image can be repeated. When producing solarized prints, it is advisable to use paper a grade harder than that used for conventional printing.

Print Solarization
Set up the enlarger as for any print and make a test strip (page 134).

Expose the print. Develop it for half the usual development time.

Expose the print evenly to white light for about one second. Complete development, then fix and wash the print. The finished print can, of course, be printed on single weight paper and used as a negative for contact printing (see page 134).

Film Solarization
This process is unpredictable, so to avoid ruining the original, it is advisable to contact print the negative onto such sheet film as Ilford line film, and solarize this. Alternatively, develop the sheet film in the usual way, contact print it on a second sheet of film, and solarize the resultant negative. That negative can then be used for making an enlarged print. If 35 mm is being used, a number of negatives can be produced on the same sheet of line film.

Place the original negative on line film and hold it flat with a sheet of clean glass. (To produce an enlarged positive at this stage, just project the negative on the film from the enlarger.)

Make a number of test exposures as for print making (see page 134) and develop fully. Make the contact exposure. Develop for half the normal development time. Expose, using the same exposure time as when contacting and keep the film in the development tray. Develop fully. This will produce a solarized positive. To obtain a negative, contact on another sheet of film. The film may have to be cut to fit the enlarger when making the final prints.

The solarized black and white negative can also be used to produce a colour solarization. The negative is printed three times on a sheet of colour printing paper, using a different filter—red, blue, and green—for each exposure. Test strips must be made every time the filter is changed because each filter requires a different exposure. Process as usual.

Colour transparencies can also be solarized by subjecting the film to coloured light halfway through the first stage of development. The solarized transparency is then printed on Cibachrome paper.

Designing With Mats and Frames

A well-framed photograph is an aesthetic unit, a composition, with several elements poised in careful relation to each other. Much of the interest and balance of the composition is created by the mat. Usually, but not necessarily, lighter in colour than the frame and the photograph, the mat provides the photograph with an area of space distinctly its own, a kind of habitat, while at the same time providing a decorative continuum with the frame and the rest of the room.

The choice of mat goes a long way towards establishing the ambiance of the photograph, and can push the photograph in different, unforeseen, even startling directions.

Like frames, mats can be bought or found or made. Since mats are usually made from cardboard, available in an exciting range of colours and textures, and the only necessary tools are a metal straight edge and a sharp craft knife, making mats is a simple and satisfying way to begin exploring your potential skills. After the initial discovery that you can cut a straight line with precision, there is a lot of experimentation to be done, with covered mats, perhaps, or with double mats of contrasting colours and textures. Old photograph albums, found in almost any flea market, and fairly inexpensive, are a good source of mats.

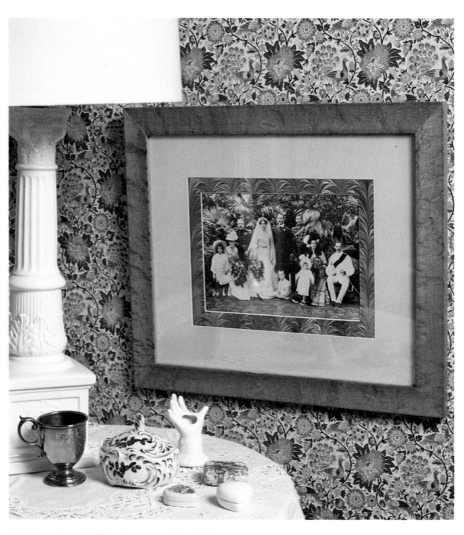

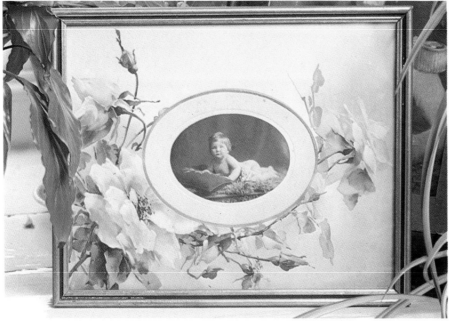

The photograph above, of a wedding in India, has been interestingly double-matted. The innermost mat is of feathered paper, which picks up, in an abstract way, the old-fashioned atmosphere and the luxuriant foliage in the photograph. The outer mat is cream-coloured and the frame is burl maple.

The charming baby picture left, has been matted with a page from an old photograph album and framed quite simply with a gilt wood frame.

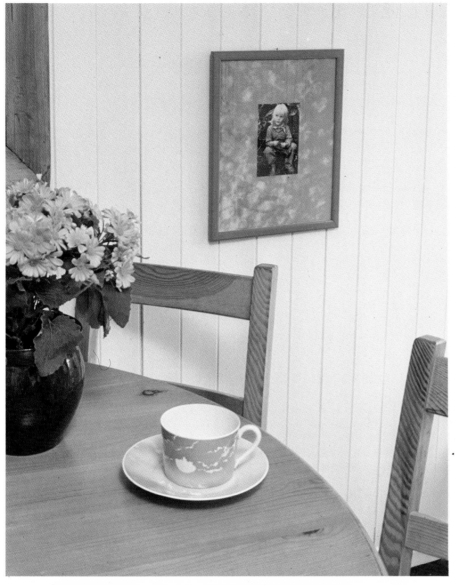

The two photographs of children, left and below, make a study in contrasts. The modern colour picture has been matted on a photo cloudscape and framed in bright red, conveying something of the freedom of the contemporary child. The old photograph has been double-matted in pale brown and grey-blue, with pen lines drawn delicately around both mats. The austere loveliness of the composition seems to emphasize the child's charming but constrained pose.

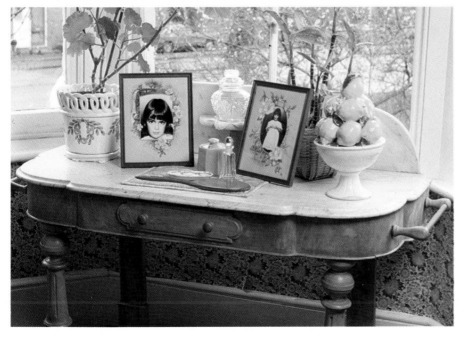

The photographs on the left have also been matted with the pages from old photograph albums. The simple wooden frames modify, yet harmonize with, the appropriate but rather sentimental flower wreaths that become part of the shape of the apertures.

All About Framing

A frame should not be chosen in isolation from the photograph, mat, and setting in which the finished picture is to hang. Each of these elements influences the other and all should be considered together. Only then should the frame be bought or made.

Kits to make frames of wood, metal, and plastic are commercially available. A traditional frame of wooden moulding can be made to order by a custom framer, or the moulding and glass can be cut professionally and the pieces then assembled at home. When a number of pictures are to be framed it is usually least expensive and most satisfying to make frames at home.

Equipment

An adequate work surface is a necessity. It should be large and sturdy, in a good light, and, preferably, away from the wall so that you can walk around it. It should be high enough to work comfortably standing up.

A few tools are necessary for making frames. Others are helpful, but are not a necessity. When buying tools it is best to invest in those which are in a medium-priced or expensive range and are made by a reputable manufacturer. Buying cheap tools from an unknown manufacturer is a false economy. They can result in a poor and inaccurate finish so the frame looks amateurish and the money spent on materials is wasted.

A mitre box is useful when the moulding is being cut. It supports the saw blade at the correct angle so that the mitre joints are uniform and fit together snugly when the frame is assembled. Mitre boxes are available in various materials. Those made of hardwood are adequate and inexpensive, but wear out quickly. Boxes made of metal or a combination of wood and metal, although they are more expensive, last much longer.

Mitre clamps hold the mitre joints together while the glue is drying. It is possible to use an ordinary woodworker's vice or even masking tape for this purpose, but mitre clamps are infinitely superior. Some clamps are equipped with saw guides so that they can be used instead of a mitre box. Moulding wider than three inches (7.50

cm) may require a special clamping device. Although it is possible to make a frame using only one clamp, it is not recommended.

A mitre saw has a reinforced back which prevents the blade from bending. A tenon or back saw, provided it is at least sixteen inches (40 cm) long and has a fine cut, is, however, adequate.

Other tools. A ruler is a necessity. Whatever type is used, it must be accurate to one-sixteenth of an inch (1.6 mm). Also needed are a tack hammer, a push drill or small hand drill, G-clamps, try square, a nail punch or nail set, masking tape, white glue, and a glue brush. There are also a number of specialist tools on the market which are worth investigation if frame-making is going to be a serious hobby. They rapidly pay for themselves in increased accuracy and time saved.

Moulding

Many styles of moulding are available at framing shops or through mail order firms. Choose the style and size which best suit the photograph, the mat, and the decor of the room in which the photograph will be displayed. Check the height of the rebate, or rabbet, the recess under the lip of the moulding, to be sure that it will accommodate snugly the glass, mat, mount, and backing board.

Moulding can also be made at home by gluing together strips of the moulding used by carpenters and home builders to finish doors and windows. The strips can be glued, then held in place with masking tape until the glue dries. When buying strips of moulding, check carefully to be sure there are no defects.

To Make a Simple Frame

The first step is to estimate the amount of moulding needed to make the frame. Measure the matted and mounted picture, adding one-eighth of an inch (3 mm) to each dimension to allow for expansion of the mount due to moisture.

Add the width of the moulding for each mitre cut and about one inch (2.50 cm) overall for the kerfs, or saw cuts. Buy a little extra moulding to allow for imperfections.

The moulding may vary slightly in colour or shape along its length, or the grain of the wood may show in the finished frame, therefore the pieces of frame should be cut in the same sequence as they are to be assembled.

Before a length of moulding can be measured, a mitre must be cut at the right-hand end. To do this, clamp the mitre box firmly to the work top. If there is a saw guide, adjust it for cutting a mitre at the right-hand end. Make a light kerf, or saw mark, on the bottom of the mitre box to act as a guideline for sawing.

Place the moulding on the mitre box with the rebated end towards you. The moulding can be held by hand or clamped to the box using a G-clamp and a block of wood.

Place the blade of the saw in the guide. Using light, steady pressure, cut the first corner. Remove the moulding

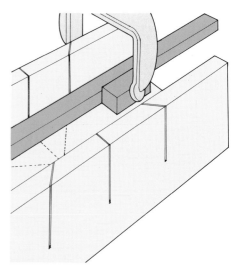

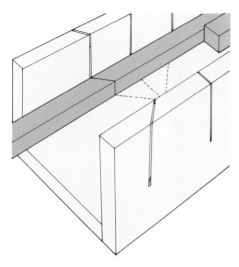

and adjust the saw guide for a left-hand saw cut.

Lay the ruler along the rebate of the moulding and measure from the mitre cut. Mark the first measurement with a sharp pencil, replace the moulding in the mitre box, and cut the second mitre, sawing on the waste side of the pencil line. Repeat the procedure until all four sides of the frame have been cut, numbering them on the ends as you proceed to prevent confusion later when they are being assembled.

After the four sides have been cut, lay the opposite sides back to back to check that they are the same length. If one is slightly longer, it can be shortened by sandpapering, but care must be taken not to distort the 45-degree angle of the mitre.

Gluing and Clamping

Choose a glue suitable for wood and follow the manufacturer's directions for its use. A white household glue is usually the easiest to use and the most effective. Lay the pieces of the frame on the work surface in their right order. Assemble the frame in the clamps and check that the mitre joints fit together neatly. Remove the clamps from two of the corners and take away one side of the frame. Apply the glue, and replace the moulding and the clamps. Repeat until all four corners are glued and clamped.

Wipe the excess glue immediately from the mitre joints and rebates. Do not wait until the glue has dried.

Nailing

For large and heavy frames and when glass will be used, nails add additional strength. The nails or brads should be long enough to reach across the mitre joint. They should be inserted only from the top and bottom outside edges

of the frame, where they will be least conspicuous.

Drill holes for the nails through the first mitre and a little way into the second. This will prevent the moulding from splitting when the nail is inserted. The holes should be 25 per cent smaller in diameter than the nails. Tap the nails into the holes, driving them about one-sixteenth of an inch (1.6 mm) below the surface.

Use a burnishing tool to press protruding nail points back into the frame. To hide nail marks use frame repair putty or repair sticks of the same colour as the frame. For bare wood frames, use wood dough or putty which can be stained later if desired.

Finishing

After the frame has been assembled and the glue is thoroughly dry the wood should be lightly sanded. It can be painted, highlighted with gold or silver wax, or toned down with an antiquing glaze. A bare wood frame can be stained, varnished, gilded, or painted.

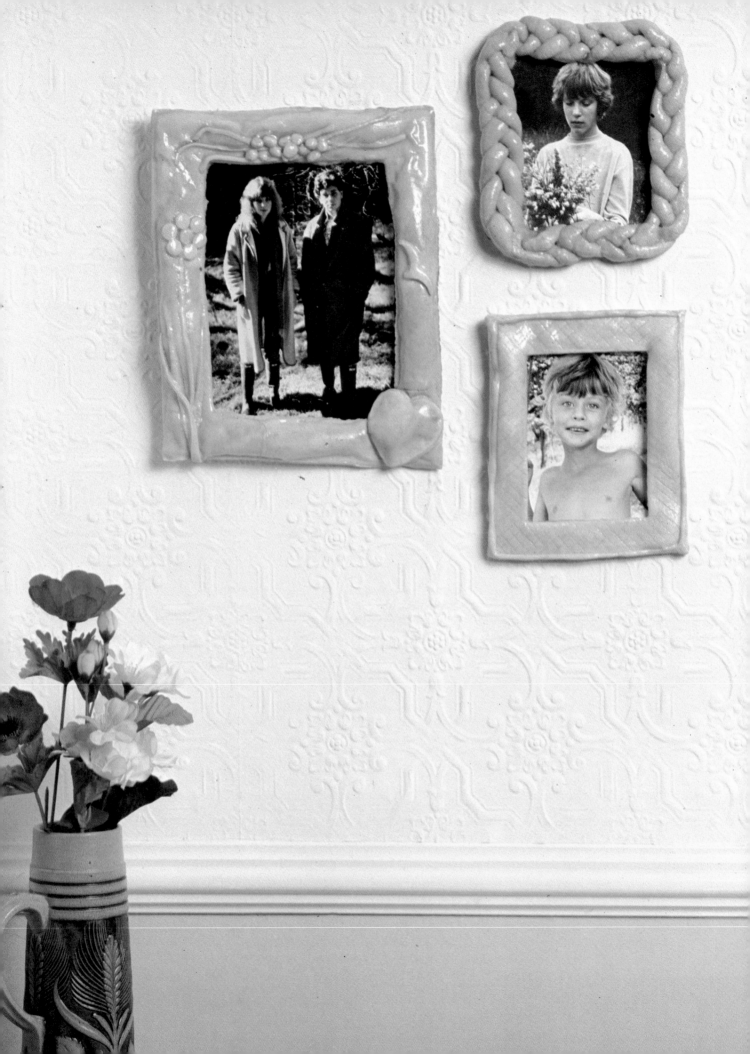

Unexpected Frames

Frames of wood or metal are all very well, and often beautiful, but frames of stamped leather, or fabric, or even bread are quite something else again. They are unusual, and will be uniquely yours. Indeed, the very idea is a challenge to your decorative sense. These frames are not difficult to make, and while they can be very lovely, their real charm probably lies in their sheer unexpectedness, and in how much fun they are to create in an impromptu way.

Any of these frames could be suitable anywhere in the house, but it might be amusing to suit the material to the environment. A display of family snapshots in bread frames could be delightful in the kitchen. An arrangement of photographs in stamped leather frames would be quite elegant in a study or office. Fabric frames could be coordinated anywhere in the house.

The beautifully punched leather frames below look extremely distinguished on the polished wood table. While the rectangular one is handsome and dignified, it is the lovely elliptical frame that catches the eye most since it is such an unusual shape.

The light warm colours and the chunky look of the bread frames on the left make a delightful setting for the photographs of children. The frames also lighten up the wall and create a bright spot where before there was nothing.

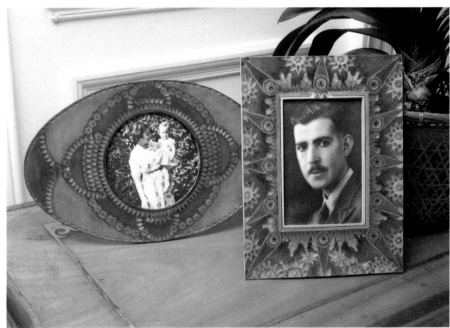

Fabric frames are perfect—simple bright, and cheerful—as a setting for black and white photographs of children. The small pattern of the fabric above and right acts almost as a solid background and in no way detracts from the potential impact of the pictures.

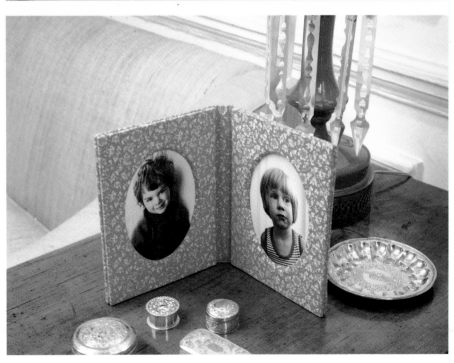

Making Special Frames

Here are the basic methods for making frames of bread, fabric and leather. As you become more confident you can improvise more of your own designs.

Bread Frames

The charming bread frames shown on page 66 are easy to make, durable, and very unusual. Dough seems an unlikely material to use for making frames, but it is extremely malleable and can be moulded and textured to almost any design. You can colour the dough with food colouring or just glaze it with egg and milk before baking to give it an attractive golden sheen. After it bakes the dough dries rock hard to produce a light, but strong, picture frame.

To make two small bread frames measuring approximately six by eight inches (15 by 20 cm), you will need:

1 lb (3¾ cups) flour
8 oz (¾ cup) salt
12 fl oz (1½ cups) water

Combine all the ingredients and mix by hand. Add more flour or water if necessary so that the dough is very stiff and dry. Add food colouring if you like.

Turn the dough on a lightly floured surface and knead it for five minutes.

Divide the dough in half. Roll each half out into a rectangle of the size needed for the frame and about one-quarter inch (6 mm) thick.

With a kitchen knife, cut the apertures for the pictures out of each frame.

The dough will not change size when baked, so cut the apertures to the exact size required.

Roll out the dough cut from the centre of the frames as thinly as possible and cut decorations from this. You may also use cooked pasta shapes to decorate the frames.

Stick the decorations to the frames with water. If you prefer, press or cut

textures into the frames with a kitchen knife, or with the tines of a fork. Keep the decorations simple because detail tends to get lost after baking.

Alternatively, after kneading divide the dough for one frame into three pieces. Using your hands, roll each piece into a long sausage. Using water, glue the three pieces together at one end. Then, working quickly, braid the three pieces together. Form the braid into a frame and stick the two ends

together with water.

Lay the frames on a lightly greased backing sheet. Glaze with a little beaten egg and milk.

Bake in a warm oven, 325°F (Gas Mark 3) for one hour, or until the frames are dry.

Leave on the baking sheet in a dry place for twenty-four hours to harden.

Seal the frames with clear polyurethane varnish, back and front, to protect and preserve them.

Cut a piece of heavy mounting board to the size of the frame. Mount the photograph on this. Glue the mounting board to the frame. Tape a hook for hanging the picture on the mounting board. Although bread frames are light and durable, they will crack if they fall and must, therefore, be handled with a certain degree of care.

Fabric Frames

The enormous range of fabrics available, with their great variety of colour and texture, makes them ideal for framing. They can create any mood and fit in with any decor.

Scraps of material left over from dressmaking are useful, or remnants from your furnishings, which will ensure that the frame matches the rest of the decor. Sunfilter fabric, hessian, felt, tweed, lurex, velvet, satin, quilted cotton, to name but a few, can all be used to make attractive and arresting frames.

There are two main ways to make fabric frames. One is, very simply, to cut a base out of thick card to the exact size and shape you need, and glue the fabric on it, using a latex-based adhesive. Paint the edges of the fabric with non-fray glue. Thicker, textured fabrics tend to be most suitable for this method.

The second method is somewhat more complicated, but the result is very finished and effective.

Draw a mount of the appropriate size and shape on a sheet of thick card.

Draw the aperture on the mount. To draw an oval, either buy a template at an art supply shop, or draw a rectangle on the mount where the aperture is to go and construct an oval using a compass.

Cut the card carefully with a sharp craft knife, first scoring the surface, then cutting deeper.

Lay the fabric out on a flat surface and centre the card on top of it. Draw around the aperture onto the fabric and cut it out.

Cross-stitch the fabric around the inner edge of the aperture.

Lay the fabric over the mount, matching the apertures exactly.

Fold the fabric around the frame. There should be enough to overlap the edges of the aperture. If you wish, pad the fabric with cotton to give the frame more dimension.

Lay the frame flat. Trim the edges of the aperture again, this time neatening the fabric from the back. Trim the edges with a knife or mark them with a pencil and cut with scissors.

Turn the corners of the fabric over and stitch.

Overstitch the edges of the aperture on the back, joining it with the fabric on

the front at the same time.

If the fabric frays, paint it with a non-fray glue.

Make a sleeve to contain the picture by stitching a felt backing on the back of the frame, attached on three sides only.

A cord or thin strip of fabric can be stitched on the back from which to hang the picture.

Leather Frames

Leather makes unusual and distinctive frames, as can be seen on page 67. It is a flexible medium, allows a wide range of effects, and is simple to use. You need only simple tools, some of which can be made at home. You can punch patterns into the frame, or use the suede side and paint patterns on it with suede paints available in many colours from shoe shops.

To make a leather frame you will need: a piece of hide, about one-eighth of an inch (3 mm) thick and fairly supple, (although you should try to find scraps at a warehouse or factory, because it is difficult to buy small pieces from ordinary dealers); a strong, sharp, craft knife; a metal straight edge; compass and dividers; a hammer; anniline dyes in powdered form, available from leather shops; dubbin, a leather conditioner, available from hardware stores or leather shops; rubber solution; rubber gloves; cotton balls or brushes; a soft pencil; heavy cardboard; and a piece of felt. Punches are available in an extensive range of patterns from any good leather shop. You can also make your own from long steel nails, by sawing them in half and filing patterns into the heads.

Using a sharp craft knife, cut the leather to the size of the frame you want to make and cut the aperture from the centre. Draw your pattern in soft pencil on the leather.

If you dye the leather first, the punched patterns will be the same colour as the rest of the frame. If you punch first, you can wash the dye lightly over the surface, missing the indentations and leaving them the original colour.

Punch the pattern into the leather with the hammer and punch, giving one strong blow, rather than lots of little ones, otherwise you may move the punch and distort the pattern.

Wearing rubber gloves to protect your hands, mix the powdered dye carefully following the manufacturer's directions. Apply the dye with a cotton ball in even strokes, or wash it on with a brush. Work into small areas with a smaller brush. Different strengths of the dye result in different tones.

Cut out a piece of heavy cardboard to the shape of the frame.

Stick the leather to the frame with rubber solution.

When the glue has dried, trim the

leather around the mount.

Apply dubbin to the leather to seal and condition it. Dubbin also enriches the colour.

Glue a sleeve of felt on the back, attached at three edges, to allow the print to slide in and out.

A Flourish of Frames

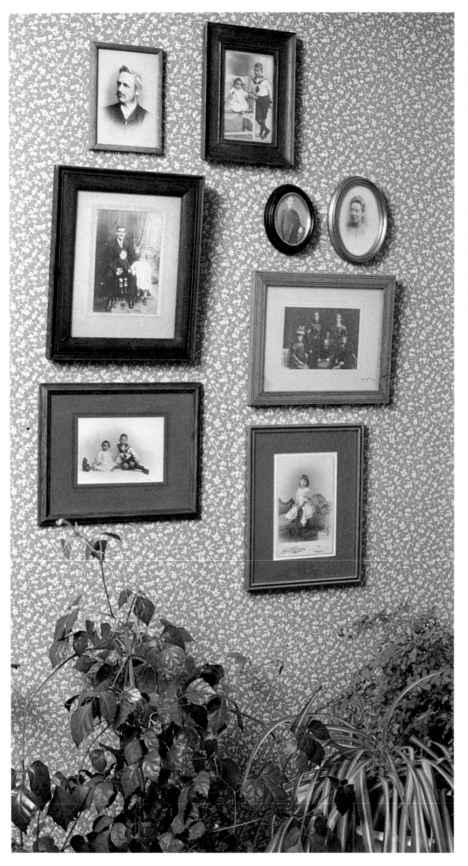

Finding or making precisely the right frame for a favourite old—or new, or unusual—photograph is a simple pleasure, but a lasting one. It is, of course, possible to work with a professional framer, and have the benefit of years of experience and expertise, but that is likely to be expensive. It is far more fun to spend some time leisurely browsing through antique shops and local flea markets, in a pleasant, intent search for old frames, odd frames, frames that will be just right for your photographs. It is amazing what a bit of shrewd looking can turn up—old picture frames, frames from mirrors, interesting frames on appalling paintings. Flea markets still have a kind of romance, a substratum of folklore of their own. They are full of bustle and colour. There is always the illusion, and sometimes the reality, of a true bargain, and the more and more satisfying pleasure of recycling things which may yet, either as they are or with a little care and attention, have a lifetime's use left in them. Old wood stripped and stained, old brass polished—there is the excitement of the revelation of mellow charm under old paint or dirt.

Another possibility, and one with the potential for real joy, is to learn an old, honoured craft and make your own frames. There is no need to be an expert to achieve good, even beautiful, results. Imagine being surrounded by bits of wood with elegant curves, the bracing smell of fresh sawdust, and a few simple tools. Imagine the deep satisfaction of doing a piece of work with your own hands which will permanently enhance not only your photographs but your home.

In the arrangement on the left, a number of old photographs have been set in a variety of frames, and hung in balanced profusion, creating an informal but distinguished grouping.

This curious but serene photograph of a spoon literally resting on its chunky green frame has humour as well as the feeling of a work of abstract art.

These pink velvet frames, an integral part of the tabletop arrangement, softly surround two sepia-toned family photographs. The effect is gentle and endearing.

A rich, old, gold-stamped, ebony frame, with its antique patina, provides the perfect surround for an interesting old family photograph.

Although it is modern, the bamboo frame is completely appropriate for this old sepia-toned photograph of a dapper gentleman.

This vignetted, sepia-toned portrait of a young woman of an earlier generation is dramatized by the dark mat and simple, deep, gilded wood frame.

The photograph and the extremely plain, almost severe, wooden frame are enhanced by the arched white mat which adds depth and distinction.

71

Putting Everything Together

After the photograph has been mounted and the mat and the frame have been made, it only remains to put all the elements together, to add glass and the backing board and, if desired, a dust seal.

Glazing

Glass protects the photograph and will also enhance its appearance. Colours have greater richness under glass and the tonal range and contrast of a black and white photograph seem to be increased. Glass also creates the illusion of greater space, since it reflects some of the colour and light of the surrounding room. The only disadvantage to glazing a photograph is that it makes the picture heavier and more fragile and, when a frame is not properly sealed, condensation can form behind glass.

Non-reflecting glass, although it eliminates all reflections, tends, surprisingly perhaps, to flatten the appearance of a print and, because it transmits less light, reduces visibility. It may spoil the enjoyment of a favourite photograph which has been printed with great care.

For glazing, either picture glass or window glass can be used. Picture glass, which is only about one-sixteenth of an inch (1.6 mm) thick and free of the flaws sometimes found in window glass, is usually used for this purpose. For a very large picture, however, it will not be strong enough and single, or even double, weight window glass may have to be used. It will, of course, make the picture very heavy and, therefore, unless the frame is exceptionally sturdy, it may be best to use acrylic.

Using Acrylic

Although acrylic has many of the same characteristics as glass and the advantages that it is lighter and condensation is less of a problem, there are drawbacks to using it. It is softer than glass and, therefore, scratches more easily—even gentle dusting can leave marks.

Acrylic is not always flat and, because it holds more static electricity, it attracts dust. For extremely large pictures, however, when glass might be too heavy, or for pictures in frames which are not very strong, acrylic is often the best solution.

How to Glaze

Although a framing or hardware shop will cut glass to measure, it is not difficult to do at home. The only equipment needed is a glass cutter, a square, a ruler, a felt-tip pen, masking tape, and an oilstone. (The cutting end of the glass cutter should always be kept lubricated with turpentine to protect it.)

Measure the frame between the rebates. Subtract one-eighth of an inch (3 mm) from each measurement to allow for clearance between the glass and the frame.

With a square and a felt-tip pen, draw the cutting line on the glass. Lay the straight edge along the line, secured with masking tape, and hold the glass cutter upright so that the wheel is on the line.

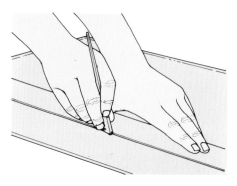

Run the glass cutter along the full length of the line once. Rather than flexing your elbow as you cut, keep it stiff and step backwards. If the glass is being cut correctly, the glass cutter will make a steady hiss as it cuts. When the glass has been cut, run the straight edge under the glass, to the right of the cut line, and firmly press the overhanging piece. It should snap apart cleanly.

The cut edges of the glass will be dangerously sharp and must be smoothed with the oilstone. When buying the glass ready cut from a shop, ask that the edges be bevelled and polished.

Acrylic is measured, marked, and cut in much the same way as glass. A plastic cutter is used, however, rather than a glass cutter. Instead of one cut, several have to be made, each one deeper than those made previously. It is possible to cut acrylic with a power saw fitted with a blade with fine teeth. Put a few drops of turpentine on the cut and use the saw at slow speed, since high speed might melt the plastic. A handsaw is not suitable for it can split the acrylic.

Backing the Picture

A sheet of double-faced corrugated cardboard placed behind the mounted photograph will add stiffening. It will also protect the picture from possible knocks or falls. Sometimes an extra sheet or two of cardboard must be used so that the elements fit snugly in the rebates of the frame.

Assembling the Picture

Before putting all the elements together, be sure that they are clean. Check that the rebate is smooth and that there is no dried glue to prevent the glass from fitting neatly. Gently clean any stains or fingerprints from the mat with an eraser. (Remember to test the eraser on scrap mat board first.) Clean the glass thoroughly and use a photographers' aerosol dust blower to clean the print.

Lay the frame face down. Carefully put in the glass, followed by the mat, the mounted photograph, and the backing board. Press lightly, but do not try to expel all the air. Some room is necessary to permit the card to contract and expand in response to changes in temperature and environmental moisture.

Press a small brad (it should be five-eighths of an inch — 1.5 cm) about half-way down each vertical inside edge of the moulding. Pliers, a special brad pusher, or a tack hammer can be used to do this. If pliers are used, insert some padding between the pliers and the

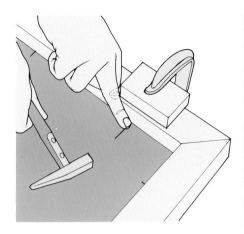

outside edge of the moulding to protect the frame. if you are using a hammer, clamp a block of wood to the work surface and support the frame against this while tapping the nails in.

Inspect the frame and, if everything is correctly positioned, insert the other brads abour four inches (10 cm) apart, working from the centre of each side towards the corners.

The Dust Seal

Even after the picture has been nailed together, dust and dirt can still enter the frame from the back. A dust seal will prevent this from happening.

To make an effective dust seal, cut a sheet of heavy brown kraft paper a little larger than the frame. Lay the paper on the work surface and dampen it on one side. Use a strip of double-sided tape, set about one-sixteenth of an inch (1.6 mm) in from the outer edge or run a continuous thread of thin glue along the back edge of the frame. Press the frame down on the dampened side of the paper. As the paper dries, it will shrink and form a taut dust seal. After the paper has dried turn the frame face down and trim off the excess paper.

Moulding Shapes

Here are some examples of the types of moulding available from frame shops and building supply firms.

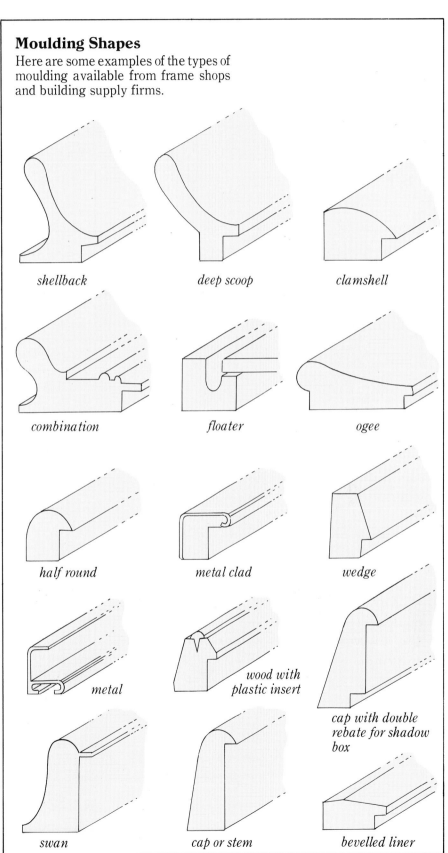

shellback *deep scoop* *clamshell*

combination *floater* *ogee*

half round *metal clad* *wedge*

metal *wood with plastic insert* *cap with double rebate for shadow box*

swan *cap or stem* *bevelled liner*

Using Pictures in Unusual Ways

The most astounding thing about photographs and photographic processes is their versatility. A century ago it was a wonder that an image could even be mechanically reproduced. Today, the real potential of photography—for design, for decor, for art, for the exploration and exploitation of a whole world of visual images—probably exceeds most of our imaginations. Until recently, people thought that technology would be the death of art, and that photography, seen as it was as merely mechanical, would certainly be one of the killers in the field of visual art. Art, although it may have become peculiar and subject to various aberrations, is, however, far from dead. Moreover, photography, through an explosion of technological advances in filming and processing, long ago transcended its origins as a gimmick and became itself an art.

The basic technology of photography is relatively easy, and skill can be acquired by anyone who is patient and prepared to learn to see anew. Particularly in the area of photo decor, photography is therefore wide open to the kind of amateur experiment that simply requires imagination, not genius, to achieve felicitous results. Today, screens, cushions, plates, mugs, and even window blinds can be thought of in connection with photography. With the proviso that only black and white photographs are suitable for printing on certain substances, all of these things—and many more—can be individualized with photography.

It requires only a little ingenuity in working with commercially available chemical substances and easily learned techniques to make a commemorative plate and mug for a couple's anniversary, or to create a photographic analogue of a beautiful Japanese screen, or a sofa cushion on which an image of your favourite cat can sit in perpetuity. At last the photographic image is not confined to paper.

Using Pictures in Unusual Ways

Finding the right pictures to use in unusual ways—that is, other than hanging straightforward black and white prints on a wall—requires first of all developing a new, more flexible, and more selective way of seeing. Finding suitable pictures for various projects is interesting work in itself, as is learning about the capacities of various materials to receive photographic images and of what kind.

The most important factor to bear in mind is the quality of the image in relation to the finished project. Just as different kinds of photographic papers are suitable for different kinds of reproduction, so such materials as linen, metal, and china have unique properties in relation to the kind of photographic image each can accept. For such special types of processing as silkscreen, hand-tinting, posterization, and solarization, other considerations come into play.

The basic principle is to look critically at your photographs, either in terms of the three-dimensional objects they will eventually become, or to try to visualize them in their transformed state. Obviously, a different kind of image will be appropriate for a plate than for a cushion or a place mat. And the right picture for a mirror will be very different from the one you would choose for a screen.

All these objects have, however, one thing in common. They are all most effective when the image used is strong and clear and, usually, fairly simple. Amateur photographs are often quite cluttered, or at least crowded. On the other hand, they often conceal a wealth of interesting detail not immediately apparent from looking at the whole photograph. Therefore, when you begin to look at your photographs, instead of simply examining each one as a whole, begin to look for salient details—a few branches, or a good head, or a kitten fallen into a particularly winsome pose at somebody's feet. Remember that you, or a photographic laboratory, can easily isolate the detail or details you want and enlarge them to the appropriate size. It is not difficult either to block out the background or clarify it. Once you begin to look at your photographs in this way, you will see how often images spring into much more graphic life in isolation, even when they seem relatively insignificant as part of a more or less accidental composition. Browsing through your photographs using an ordinary magnifying glass is a good way to begin to get into the habit of looking for interesting details.

When choosing a picture for a special use, you will also have to consider how well a given image will fit into a particular shape or whether an image is appropriate to a particular shape or would be enhanced by it. A sitting cat or dog, for example, seems almost destined to become a contour cushion, so appropriate is the image to the object, yet the original picture of the pet might come from a hitherto disregarded corner of a snapshot of something else. It is an open, thoughtful, imaginative eye that becomes aware of such possibilities. For such objects as plates and coasters, on the other hand, obviously you want images that either are already or can be made circular.

There is also the question of proportion. A contour cat cushion, if done life-size, would look rather puny. Having the wit to do it somewhat larger makes the difference, and gives such a cushion its charm, along with, of course, the expression on the face of the cat. By the same token, making an image smaller can often sharpen it and eliminate graininess. Once you can begin to think of photographic images as variable in size, you will develop a stronger sense of the potential of any given image.

When printing on metal or glass it is important to use strongly contrasted images, with clear blacks and whites. What you will be looking for will be almost line images, so the reflective qualities of the glass or the metal can shine through. If you are printing on Photo Linen, you will need strong blacks, because greys will kill the contrast if you decide later to dye or tint the image. On most surfaces other than paper only black and white can be printed, but that is not quite all there is to it, since the print can then, if you like, be sepia-toned or hand-tinted, techniques which have a softening effect and look most appropriate with antique or "cottagey" decor.

For such techniques as posterization, silkscreen, and teleidoscopic images, look for photographs, or parts of photographs, with strong design elements—bold curves, striking blocks of colour, and rhythmic lines, since all of these techniques tend towards abstraction, and work best when naturalistic accuracy is not an issue. You will really have a free rein here, since even bits of detail, like the mouldings on buildings or scaffolding, or a bend in a river, can be turned to immense advantage.

Bearing all these considerations in mind, drag out that old box of photographs. You never know what you may find.

Hand Tinting Prints

This technique provides a rewarding and creative way to alter the appearance of black and white prints. Hand tinting may be done so that the effect is natural or, with imagination and a degree of lateral thinking, it can be extended to produce pictures which are bizarre and surreal. Used in combination with other toning techniques, hand tinting can achieve striking results and, for the individualist, gives the satisfaction of reflecting a personal view of the world.

The materials needed for simple hand tinting are photo-tint dyes, brushes, preferably sable, fine (0) to broad(8), cotton balls, blotting paper, water jar, an extra print for testing colours, and a plastic palette for mixing the colours.

To be coloured successfully, a print should have a matt surface and no extremes of tone. It is best to work on a print which has fairly light tones. Some people prefer to work on a sepia-toned print, but this is not essential as long as very dark areas of a black and white print are avoided when colouring.

Dry mount the print (see page 45). Work in good light, preferably daylight. Dampen the surface of the picture with a cotton ball soaked in water. This is an important step for it permits the emulsion to absorb the dyes. Don't forget also to dampen the extra print for testing.

The large areas of colour must be applied evenly and with as few strokes as possible. Tinted areas will not respond well to repeated colouring so aim for the required tone at the first application.

Practise on the extra print before attempting to work on the actual picture. When the largest areas are completed, work on the smaller solid areas.

Leave the fine details until last, for they must be done extremely carefully with a very fine brush.

Care and patience will produce a print in which the colours, although they may not correspond exactly to the original scene, will have a character all their own and can be as natural or imaginative as desired.

Colour can also be applied more selectively, increasing its effectiveness. To do this, photographic strip mask is applied to those areas of the print which are to be left uncoloured.

remain untinted. (the brush with which the strip mask is applied should be thoroughly cleaned in strip-mask cleaning solution or in thinners.)

When the coloured surface is dry, carefully lift the strip mask with the edge of a sharp knife and peel it off.

Prints can also be coloured by

an enormous range of toners of all colours made by various manufacturers. They come with instruction leaflets, which should be followed exactly. The process is exactly the same as for sepia toning (page 25).

The complete print can be coloured in the bath or it can be toned selectively by using strip mask as described above. The same print can also be toned in successive baths of different colours, by protecting different areas with the strip mask for each bath.

The effects that can be achieved by tinting prints are limited only by imagination and skill. Experimentation is the keynote and patience is the prime requirement.

When the mask has dried, the exposed areas of the print surface can be coloured without fear of smudging the parts of the image which are to

All the colours should be mixed on the palette before being applied to the print.

Images on Cloth

This is a technique of somewhat limited application, but with a lot of potential for humour and dramatic impact. It involves printing on a linen-like fabric which is commercially coated with photographic emulsion. Photo Linen cannot replace the vast range of wonderful furnishing fabrics, but it does create opportunities for using photography in unexpected and highly personal ways. After the Photo Linen is printed, it is washed in a glycerine solution and becomes softened—not pliable enough for clothing, but sufficiently supple for incorporation into such soft furnishings as window blinds, wall hangings, cushions, and curtains. In these areas Photo Linen comes into its own and can be exploited for all kinds of amusing and interesting purposes.

Photo Linen can only be printed in black and white. It is best to think in terms of clear, sharp, fairly high-contrast images, although the fabric does accept a continuous tone well. The confinement to black and white need not be seen as a limitation. A touch of black and white makes a wonderfully striking accent even amidst the most flaring colours, and stands out dramatically in a context of more sober, neutral tones. If desired, however, the fabric can be dyed after it is printed. A little imagination will lead you to see all sorts of possibilities for using Photo Linen in your own home. A contour cushion could as easily be a dog as a cat. A window blind could be a close-up of a favourite waterfall rather than a detail of Stonehenge.

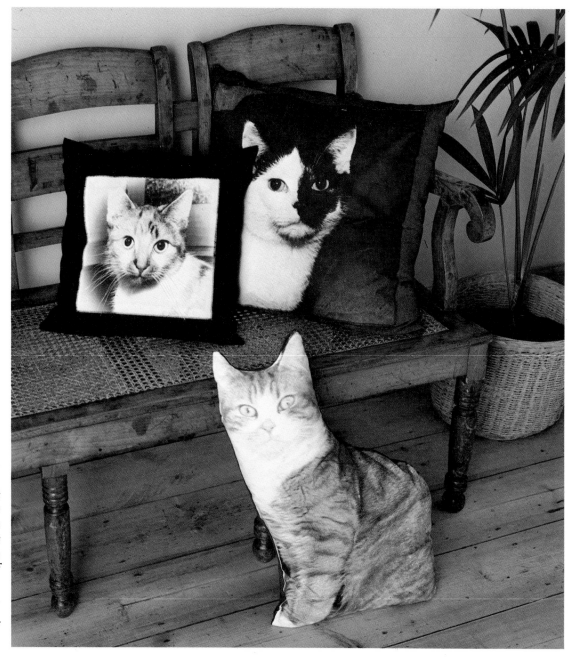

It is difficult to imagine a better, more amusing gift for someone who loves cats than one of these cushions especially if the portrait could be of his or her own cat. The contour cushion, particularly, seems to be a kind of quintessence of cat.

The window blind below has a strong dramatic effect. The capacity of Photo Linen to accept a continuous tone image is more than adequately demonstrated by the excellent reproduction of the texture of the stone.

This photographic reproduction of an Indian statue makes an extremely effective wall hanging, and could well be the solution for someone who loves the art but can't afford the object.

Printing on Photo Linen

White fabric coated with light-sensitive emulsion, known commercially as Photo Linen, can be used in the same way as bromide paper for printing black and white photographs. Available in sheets the same sizes as bromide paper and in large rolls, Photo Linen is easy to process in a home darkroom, using the same equipment and chemicals as for printing on bromide paper.

Good continuous tone negatives and high contrast negatives reproduce extremely well on this cloth and striking effects can be achieved. The material is fairly stiff, however, and it is therefore most suitable for making sunblinds, cushions, and other household items, rather than clothing.

Processing Photo Linen

The cloth is exposed in the same way as a black and white print. A small piece can be placed in the masking frame, while a large sheet can be pinned to the wall and the enlarger head adjusted in the same way as for making a giant print (see page 124). When a large piece of cloth is being processed it must be stretched absolutely flat. If there are any ripples, wrinkles, or bulges in the fabric, areas of the print will be out of focus. When making a print, remember to allow for a hem or seams if required.

Photo Linen can be processed in the same chemicals suitable for bromide paper. When developing a large print, increase the developer dilution and prolong the developing time correspondingly. Even for large pieces of cloth, relatively small dishes can be used. The linen becomes pliable when it is wet and can be gently folded into the developer and submerged. Wear rubber gloves and gently press the cloth into the developer.

After being developed and fixed, the cloth must be washed thoroughly. With a large piece of cloth, this is most efficiently done in the bathtub. To the final rinse add one part glycerine to two parts water. This will make the material more flexible.

Photo Linen should be air dried whenever possible. A large piece of cloth can be pegged to a clothesline, weighted with film clips or with ordinary clothes pegs. Small pieces of cloth can be smoothed out on a flat surface and left to dry.

Photo Linen has a tendency to curl after it dries. It should be ironed only on the reverse side, with a heat-controlled, domestic iron. It can, of course, be sewn by hand or with a machine like any fabric. It can also be mounted with glue. A white household glue is ideal.

Although it only prints in black and white, the cloth can be dyed after it has been processed. Cold water dyes or the usual photographic toning processes can be used for an overall colour effect and photographic emulsion dyes, if carefully handled, can be used for selective colouring.

Multiple Printing

This technique has been traditionally used to print a cloudy sky on a picture that has a clear sky, either because no filter was used during the original camera exposure or because there were no clouds on that day. There are many other uses for multiple printing. These include adding figures and combining two negatives of the same subject at different magnifications. Another use for this technique, which has become popular with wedding photographers, is the superimposition of different, but complementary, subject matter. This has resulted in pictures of the bride and groom inside a champagne glass or wedding bouquet, or even in a close-up, double portrait superimposed on the stained glass window of the church in which the wedding took place.

A multiple print can be made at the printing stage, either by sandwiching two negatives in the enlarger or by double printing.

For the sandwiching method simply place both negatives in the enlarger at the same time. Make a test strip to discover the exposure needed and print in the usual way. Whenever possible the negatives should be placed emulsion to emulsion, although negatives with lettering or subject matter that is not reversible will have to be placed in the negative carrier in the usual way. Since both negatives are printed together it is not possible to enlarge one more than the other. If it is desirable to vary the size of the subjects in each negative in relationship to each other, this will have to be done when the picture is taken.

An important consideration in multiple printing is that each negative should have clear areas through which the image from the other negative can print. This means that each picture must have quite large areas of dark tone for the technique to work well. Fairly hard printing paper should be used for greatest effectiveness.

The double printing method involves printing two negatives successively on one sheet of bromide

paper. Although it is more complex, this method is capable of more flexibility as a creative tool, particularly when the images need to be printed at different magnifications. The two negatives used for double printing often include details which are not wanted in the final print. These unwanted areas can be masked off during printing with hard masking, which produces a hard edge, or with soft masking, which results in an image with a soft, blurred edge. Both methods are simple and need little extra preparation.

For hard masking, place the first negative in the enlarger and focus to the size required for the finished multiple print. Make a test strip to determine the printing exposure. Mark the position of the enlarger head on the column or make a note of the number on the column scale. Remove the first negative and replace it with the second.

Place a piece of thin card in the masking frame and focus the second negative in the enlarger to the size required. Mark the position of the enlarger head. With a pencil trace carefully around the figure or object which is to be printed in. Remove

the card from the frame, replace it with a piece of bromide paper, and make a test strip for the second exposure. Using a sharp knife cut the outline of the figure from the card. Retain both pieces of card for masking.

Replace the first negative in the enlarger and return the enlarger head to the first position marked on the column. Focus, swing the red

filter over the lens of the enlarger, and place a piece of bromide paper in the masking frame. Put the two pieces of card, fitted together, on the paper. Remove the card covering the area of the first negative which is to be printed and leave in position the cutout shape of the figure from the second negative. Be careful not to move it.

Swing the red filter from the lens and make the first exposure. Replace the filter and remove the first negative. Swing the red filter back over the lens, and replace the first piece of card.

Put the second negative in the enlarger and move the enlarger head to the second position marked on the column. Remove the cutout shape, taking care again not to dislodge the first card. Focus the enlarger and swing the red filter away to make the second exposure.

Process the doubly exposed print. If there are slight gaps between the images, either white or black, some spotting (see page 49) will be necessary.

To avoid repeating the masking for additional prints, copy the first print and produce a master negative, so straight prints can be made when desired.

For soft masking, the mask is held away from the bromide paper. Decide on the size the two images are to be and make test strips to determine the exposure required for each negative. Place a piece of thick cartridge paper in the masking frame, project the first negative on the paper and make a tracing of it. Only the important areas are needed, so the entire

picture does not have to be traced. Remove the negative.

Place the second negative in the enlarger and project the image to the size required in the final print.

Support a piece of clean glass about two and a half inches (6 cm) above the print and place a piece of thin card on the glass. The second negative will now appear out of focus on the card. Trace on the card the image which is to appear in the final print. Cut it out with a sharp knife and replace both pieces of card on

the glass in the correct position.

Switch off the enlarger and remove the cutout figure from the card on the glass.

Remove the cartridge paper from the masking frame and replace it with a piece of bromide paper. Expose the second negative. Replace the cutout figure on the glass. Remove the bromide paper after lightly marking it with pencil to indicate the top. Store it away from the light.

Place the first negative in the enlarger and the cartridge paper tracing in the masking frame. Remove the background card from the glass without moving the cutout figure. Focus the enlarger to the size of the tracing in the masking frame.

Replace the tracing with your already exposed bromide paper, making sure it is the right way up. Make the exposure for the time determined by the test strip. Process.

The distance between the masks and the print will blur the edges of both images and should result in a combined print with very little evidence of a join.

Images on Other Surfaces

Printing a photograph on glass or metal or china may seem a rather esoteric thing to do, but considering the flexibility of modern photographic emulsions and the possibilities for amusing, lovely, and even distinguished results, it is a project well worth bearing in mind when you are thinking of original and highly personal ways to make your home more distinctive and more uniquely yours. Finding photographic images in unexpected places creates a kind of aesthetic surprise, and if the printing is done well and appropriately, the surprise will turn almost instantly into a happy sense of satisfaction.

Often photographs on surfaces other than paper can be functional as well as decorative, and serve as a kind of superlative label, identifying the contents of a box or chest while enhancing the object at the same time. Sometimes they can be sentimental, commemorative, like family portraits on interestingly shaped plates. Or they can be quite frankly a joke, as in a series of "mug shots" around a shaving mirror. The only restriction is that only black and white photographs are suitable for such printing, and to be effective the images must be clear and high contrast. On the other hand, once printed a photograph can be toned with other colours, or hand tinted, so the restriction to black and white is not absolute.

The sepia-toned family portraits printed on plates above, harmonize delightfully with the old wood and the earthenware pottery around them and provide a note of originality that enhances the decor without jarring.

The quite ordinary shaving mirror on the left has been transformed into a delightful joke by the strips of "mug shots" printed all around it. Such a mirror would be the perfect gift for someone whose vanity was the subject of some humour.

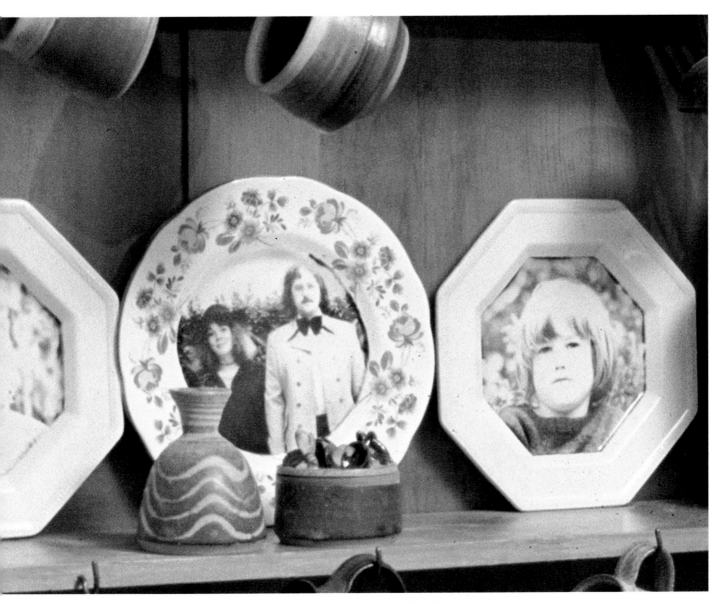

On the left, the close-up photograph of chessmen printed on the metal plate on a chess box functions not only as a label, but makes the simple wooden box look truly distinguished.

83

Printing on Other Surfaces

Black and white photographic images can easily be printed on a variety of surfaces, including glass, metal, wood, china, canvas, and leather, using a special emulsion which is available from photographic suppliers. A gel which becomes liquid when it is heated, the emulsion is brushed on the surface. The photograph can then be contact printed or enlarged on the surface in the usual way and processed with the same chemicals that are used for printing on paper.

Although the variety of surfaces which can be coated with the emulsion is wide, it is nevertheless limited by the use to which the finished object will be put. The emulsion can withstand little heat or abrasion and the photographic image will, therefore, only survive on surfaces which will be used decoratively rather than on those objects that are subjected to practical everyday use. It is particularly effective, however, when it is used to create decorative plates, tiles, and mugs.

Some surfaces need special preparation before the emulsion is applied. Nonporous materials, including enamelware, china, and glass, must be scrubbed thoroughly with a hot solution of washing soda and treated with the subbing solution supplied with the emulsion. Brick, unfired ceramic, plaster, shells, and metal require a base coat of oil-based polyurethane varnish. Primed canvas must be prepared with acrylic gesso or white cellulose primer. Wood, leather, unprimed canvas, and cloth need no preparation, although cloth should be washed before the emulsion is applied. The backing on mirrors is particularly sensitive to scratching, which can mar the mirror's appearance. Prior to coating and processing, therefore, it is advisable to cover the back surface with transparent adhesive film or to spray varnish it.

The emulsion comes with complete instructions from the manufacturer, but there are some points worth noting. The emulsion is solid at room temperature and must be warmed to become a liquid. To do this, place the bottle of emulsion in a container of hot water—hot enough to be uncomfortable to the touch—and it will melt quickly. It is not necessary to liquefy the entire contents

of the bottle; when enough emulsion has melted, remove the bottle from the hot water.

In safelight conditions, in a well-ventilated room, pour the required amount of emulsion into a container of glass, plastic, or stainless steel or directly on the surface of the material or object on which the photograph is to be printed. At the same time, coat two strips of paper to use as test strips.

The emulsion can be spread with a soft brush or, if it is being applied to a plate, tile, mug, or mirror, by gently rolling or tilting the object. If there are any air bubbles in the emulsion put the object down with a slight jolt; this

should dispel them. Pour the excess emulsion back into the bottle before it hardens.

It is best to coat irregular surfaces, such as rocks or shells, by dipping them into the emulsion, allowing them to dry until they are sticky and then

dipping them a second time. Three-dimensional objects are easiest to coat if the emulsion is allowed to set slightly before being applied. For large flat surfaces, a wallpaper brush can be used, or two thin coats can be applied with a fine-bristled brush, the second coat at right angles to the first.

If the emulsion is setting too rapidly, the addition of up to 20 per cent water will delay it.

The emulsion-coated object should be left to dry flat in complete darkness, but there must be ample circulation of air. Although on most surfaces the emulsion takes about twenty minutes to harden, in very damp weather and in cases where the emulsion is put on too thickly, it can take as long as one week to dry completely.

Two test strips must be made, one to check the emulsion and one to ascertain the exposure time. The first strip, to check the emulsion, is not exposed, but developed immediately, for the minimum time recommended by the manufacturer. It is then rinsed, fixed for five minutes, and examined in white light. If there are any grey areas, use the anti-fogging agent which is supplied with the emulsion.

The second test strip is exposed in the usual way (page 134). The method of exposure for any emulsion-coated surface is the same as for a paper print and is described on page 134. The negative can be contact printed by placing it directly on the object or it can be enlarged. When enlarging, choose a small aperture on the enlarger lens to ensure a sharp picture, particularly if you are printing on a three-dimensional object.

Processing is quite simple. Chemicals can be applied with a soft natural sponge or poured on the object. Small, three-dimensional objects should be immersed in the chemicals—plastic containers are ideal for this, but film developing tanks or paper processing trays can be used.

The same developer can be used as for paper prints. Be sure the temperature does not exceed 70°F (21°C). If it is higher the emulsion may melt. Leave the object in the developer for three times as long as it takes for the image to appear. It should be left in the stop bath for the same amount of time as it was in the developer. Ordinary white vinegar, diluted one to one, is the best stop bath to use because indicator short-stop may stain the emulsion.

Rinse, then fix for twice the length of time it takes for the emulsion to become transparent. Use a hardening fixer or a rapid fix with hardener added.

After using a hypo cleaning agent, wash gently but thoroughly. The manufacturer's instructions will tell you how long each material should be washed.

Leave the object to dry naturally in a dust-free atmosphere.

A finished object which is likely to be exposed to sunlight for long periods of time—if it is destined for display, for example, on a window sill—should be protected with a coat of ultraviolet varnish, available from photographic supply shops.

Since the emulsion must be kept dry, if the article is to be displayed outdoors or in the kitchen or bathroom, coat it with dilute polyurethane varnish.

Printing on a Plate

A good example of the use of photo emulsion is the decoration of a china plate for display on a wall or shelf. Since china is highly glazed, it will be necessary to use the subbing base before coating the plate with emulsion.

The plate should be slightly warmed before a small amount of the melted emulsion is poured on the centre. The emulsion can be spread by gently tilting

the plate to achieve an even coat. Let the emulsion harden completely in a dark, well-ventilated place.

After making the test strip, swing the red filter over the enlarger lens, position the image on the plate, and focus. Stop down the lens to the exposure aperture determined by the test strip. Remove the red filter and expose.

Immerse the plate in print developer, or pour developer on and roll it around the plate until the image reaches the required density.

Pour off the excess developer. Immerse the plate in stop bath and then

in hardening fixer for the required fixing period. Wash the plate gently and thoroughly, then allow it to dry naturally.

Printing on Metal

Printing a photograph on metal sounds impossible, but it is really not difficult. You could easily embellish a cigarette case, make a personalized name plate, or create a special and sophisticated label for the contents of a box, like the chess box on page 83.

A photograph can be printed on metal by coating it with a special emulsion, but Metone, a photosensitized aluminium, is made for the purpose and is available from photographic suppliers in sheets of various thicknesses, with a matt or brushed surface and in sizes from three and a half by four and three-quarter inches (9 by 12 cm) to nineteen by twenty-three inches (48 by 59 cm).

Metone is sensitized with hard orthochromatic emulsion and can be used with either continuous tone or line black and white prints. Either contact print the negatives or enlarge them on the metal plates in exactly the same way as when using bromide paper. Process the Metone in any developer suitable for bromide paper, as long as it does not contain caustic soda. Do not use an acid hardening fixer because this can harm the metal.

Fix for the minimum time and transfer the Metone to a wash tray immediately. This is important, particularly if you intend to do a lot of printing on metal in one session and must transfer the sheets to another room for the final wash.

Let the Metone dry on a draining rack.

The image on the Metone can be protected from peeling or scratching by coating it with a special spray-on varnish, made by the manufacturers.

As with prints made on bromide paper, prints made on Metone can be hand tinted (page 77) or sepia toned or toned with other colours (page 25). There is no difference in the techniques used except that special care must be taken not to scratch the surface or dissolve the emulsion. Colouring or toning must be done before varnishing.

With a Contemporary Air

There are many intriguing things to do with photographic negatives, aside from developing them straightforwardly. Often, creating these special effects can become a way of playing with moods, even with the sense of time. Working with photographic images to create extra-photographic effects is one of the most dynamic and subtle ways of using applied science in the service of taste and sensibility. The results of such techniques as hand tinting (an old technique which has been recently revived and extended), solarization, posterization, and silkscreen can expand your perceptions of the images you are working with and of the realities they reflect.

Hand tinting was used long before colour photography and, when it is used today, the effect is often pleasantly old-fashioned, the colours soft, imbuing the whole photograph with an air of charming nostalgia. On the other hand, it is a flexible medium, so the effects can extend into the macabre or even the surreal. Posterization and solarization often create a more futuristic effect, with strange, flaring colours and dramatic distortions. We are projected into the excitement of an unknown future that is nevertheless already flooding towards us, or reminded that the world we live in now is already more saturated with the future than we realize. Our vision expands with a rapidly growing technology of light. Perhaps within the forseeable future we will have holograms in our homes.

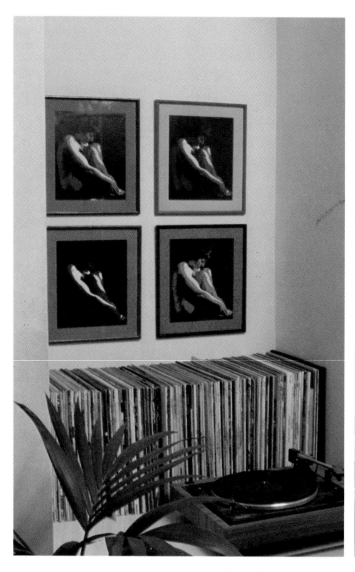

The four prints above left, identical except for the backgrounds and frames, were created by posterization, then printed on paper of various colours to create an interesting pattern.

The photograph of the house in which it is hung above right has been hand tinted, giving it an old-fashioned charm completely in harmony with the exposed brick wall and the iron stove.

The silkscreen of a black and white photograph, right, adds a note of abstract serenity to the room, its cool greyness contrasting with the warm tones of the furniture.

86

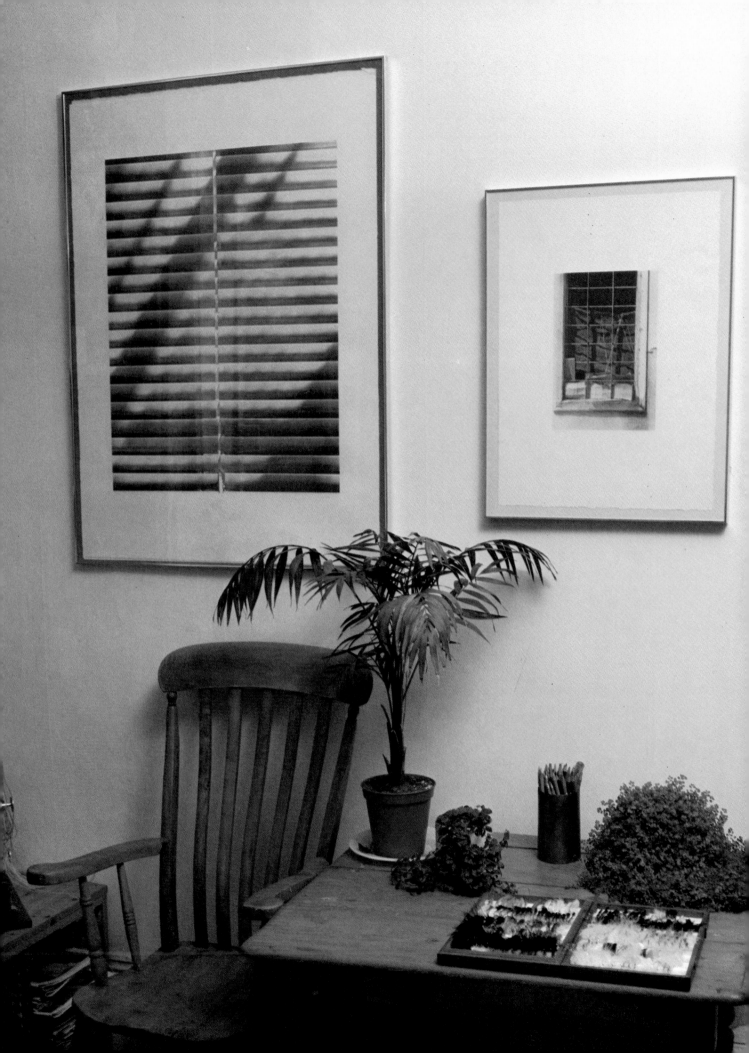

Photosilkscreening

One of the most striking ways to create art with a contemporary look from a photographic image is with silkscreen printing. This technique makes it possible to print a photograph on almost any surface, using ink of any colour.

Silkscreening is a sophisticated method of stencilling. The screen itself is a rectangular wooden frame over which a fine mesh fabric (this originally was silk) is stretched taut. The stencil is created on this mesh. As in an ordinary stencil the spaces form the design. Colour is forced—squeegeed—across the mesh and goes through the spaces on to the surface being printed.

With photosilkscreen printing the dominant lines of the photographic image are converted into a stencil, which is then used to create the final picture. The effects that can be achieved range from a simple two-colour picture—a photograph printed in one colour on a background of a second colour—to a complex and sophisticated image involving several colours.

The Ink

Silkscreen inks suitable for printing on various surfaces are available in a wide range of colours from art supply shops and silkscreen printers' suppliers. There are even special inks for silkscreening on pottery before it is fired. Washable inks, which will stand up to reasonable use, are available for printing on cloth. These are particularly good for printing motifs on table linen. Be sure to buy the appropriate solvent for cleaning up after printing and also to thin the ink if necessary.

The Screen

Commercially made frames are available from art shops or silkscreen printers' suppliers, but it is not difficult to make one yourself. The frame can be used to print different designs because when you have taken all the prints you require from the first design the stencil may be removed leaving the mesh clear. Then another stencil can be applied.

To decide the size to make the frame, measure your design and add two inches (5 cm) to the short dimension and eight inches (20 cm) to the long dimension. This gives you the inside

measurement of the frame. The extra four inches (10 cm) at the top and the bottom allow room for the printing ink and the squeegee. If you intend to buy a squeegee this should be one inch (2.50 cm) wider than the design and one inch (2.50 cm) narrower than the inside of the frame. For a small screen a piece of heavy card or a strip of hardboard makes an improvised squeegee.

Use planed softwood for the frame. Mitre the corners. A quick corner joint can be made by first gluing the mitred ends and then hammering in a corrugated fastener. Sealing the wood with

polyurethane varnish is recommended.

The silkscreen printers' supplier sells nylon or polyester screen fabric in various mesh sizes. The finer the mesh, the greater the detail of the finished picture. You will require a rectangle of screen fabric which is four inches (10 cm) longer and four inches (10 cm) wider than the outside measurement of the frame.

To attach the fabric to the frame lay it out over the frame. The weave must be parallel to the edges of the frame. Be

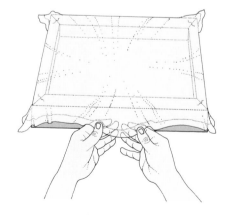

sure an equal amount of fabric hangs down over each side. It is best to use a

heavy duty staple gun to attach it. Start by turning the fabric under once along one of the long sides. Doubling the material makes it stronger. Insert a couple of staples vertically—this also gives extra strength—at the centre of this side on the outer wall of the frame. Double turn the fabric on the opposite long side and pull it as hard as you can across the frame. Staple it to the centre point of the opposite outer wall. Do the same thing on the two shorter sides. Now stretch and staple either side of each centre point, methodically working your way all around the frame. Pull and

turn the corners under as if wrapping a parcel and staple them down.

Making the Stencil

Line or half-tone images can be printed from a silkscreen. Line images record only the very dark and very light areas of a photograph and result in a picture which has the quality of a silhouette or a line drawing. Half-tone pictures, on the other hand, record the full range of tones of the photograph.

To transform a black and white photograph into a line image, the negative is enlarged on lith film (page 37). To make a half-tone image, a bromide print is copied on autoscreen film and then enlarged. Autoscreen is a kind of lith film with a screen incorporated into it, which translates the tones into a coarse pattern of dots, like a photograph reproduced in a newspaper. In both cases you end up with a positive on film. There are two ways to make a stencil from this positive. For the direct method you coat the screen mesh with a light-sensitive emulsion in liquid form. Alternatively you can use photostencil film which is a transparent material with a presensitized coating. Both

methods should be undertaken in safe-light conditions.

For either method first make sure the screen mesh is clean and free of grease by washing it in detergent and rinsing it thoroughly. Dry it—a hand-held hair dryer can be useful here.

Liquid light-sensitive emulsion must be applied in an even film. The simplest way to do this is to use a length of a V-shaped aluminium cut one and a half

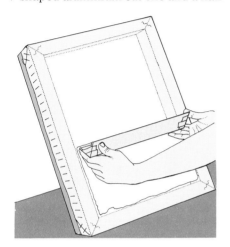

inches (4 cm) shorter than the inside measurement of the short side of the screen. Seal each end of this aluminium trough with masking tape. Lean the screen against the wall, mesh facing out. Fill the trough with the emulsion and, starting at the bottom edge, tip it towards the mesh. Pressing firmly, slide it up to the top of the screen. Turn the screen around and repeat this on the inside. Let the screen dry. When dry hold it up to the safelight to check for any pinholes. These, together with any blank areas at the sides, may be touched in with a brush. Clean the brush in water.

Photostencil film is ready for use. Simply unroll it and cut off the required amount.

Expose the emulsion-coated fabric or the film beneath your positive to a bright light source, such as sunlight or a photofloodlight. Manufacturers give instructions on exposure times.

Prepare for the exposure of either type of stencil by first piling up several books. On this pile put a board which will fit snugly inside the screen. Cover the board with a piece of thick, uncreased cloth. Now fit the screen over the top of

this, with the back of the screen facing upwards. Position the positive on the screen, face down. Keep it in place with pieces of transparent tape. Lay a sheet of glass over the positive so that it and the screen are in close contact. Expose for the recommended time.

Spray wash the screen, first in cold water and then in lukewarm water. The unhardened, unexposed emulsion will wash away leaving the areas which are to be printed as open mesh.

The dried screen must be sealed to prevent the ink seeping out at the edges. Do this with paper tape. Cut two lengths for each long inside wall. Fold one lengthwise, dampen it well, and

apply it to seal the angle between the mesh and the wall. Stick the second piece alongside on the mesh to seal the area between the design and the wall. Do this on the short sides of the screen, too. Here, in addition, build up a flat area of tape on the mesh about four inches (10 cm) wide to accommodate the squeegee and the ink.

Printing

Place the screen face down on the paper on which you will print. Either fix the frame to the table with clamps or get someone to hold it secure while you print. Apply a liberal line of silkscreen ink to the tape area at the top of the screen. Pull the squeegee firmly towards you, scraping the ink across the entire design. This forces it through the unblocked sections. Carefully raise the

screen, put the printed image some-where safe to dry, and repeat the procedure as many times as you wish.

When you have taken all the prints you need, scrape any excess ink back into the can and thoroughly clean the screen and squeegee.

Special decoating agents are available to remove the stencil from the screen mesh when that design is no longer required.

Many variations are possible when printing with a silkscreen. A two-tone effect can be achieved by using a light colour first and then a stronger colour on top, slightly out of register. Detail from one screen can be superimposed on another to vary the effect. Strong graphic images can be achieved with black ink, especially if it is used on a vivid base colour.

Photomontage

Montage means putting together, assembling, connecting, and, in film, editing. For someone beginning to explore the use of photography as decor, this technique can provide an exhilarating opening up of possibilities, a chance to play with emotion, experience, and dream, like a child or an artist. Historically, the most powerful use of montage has been in the cinema. Eisenstein's famous films, for example, were edited down to sequence after sequence of monumentally composed images. In the beginning of *Que Viva Mexico,* the real but sculpturesque heads of Indians emerge from behind the carved Mayan heads on an ancient pyramid. Their identical features convey a sense of continuity over unimaginable stretches of time. In *Potemkin,* a row of fixed bayonets, a woman's face screaming, and a baby carriage hurtling down a flight of steps become an ineradicable montage of images of massacre.

The Surrealists, like Salvadore Dali, brought their bizarre images up from dreams, and from the reservoir of the unconscious. *Le Chien Andalou,* the film made by Dali and Luis Buñuel in the 1920s, contains an unforgettable instance of photomontage — the shot of ants crawling out of a man's open palm. These are perhaps more dramatic examples than anyone might want in a home, but they do convey the potential range and power of montage techniques.

In a domestic setting, elements of photographs already on hand can be cut up and reassembled to answer almost any mood or purpose: humorous exaggeration, personal symbolism, an idiosyncratic sense of the absurd, or simply a desire to collect favourite faces or images into one harmonious whole.

The most unlikely, startling, and beautiful images can be combined, created, with the exercise of a little ingenuity, scissors, and glue.

The friendly cluster of faces in the montage on the right adds a note of cheerful busyness to an already charming kitchen — like having all the family in to dinner at once, without the bother. At the same time, the patchwork effect of the montage is entirely in harmony with the farmhouse decor of the room.

The photomontage below has the three-dimensional quality of a bas-relief. The photograph, taken in sections, has been block mounted on plastic foam board. The sections have then been overlapped and mounted at different levels to create an effect of maximum movement and depth.

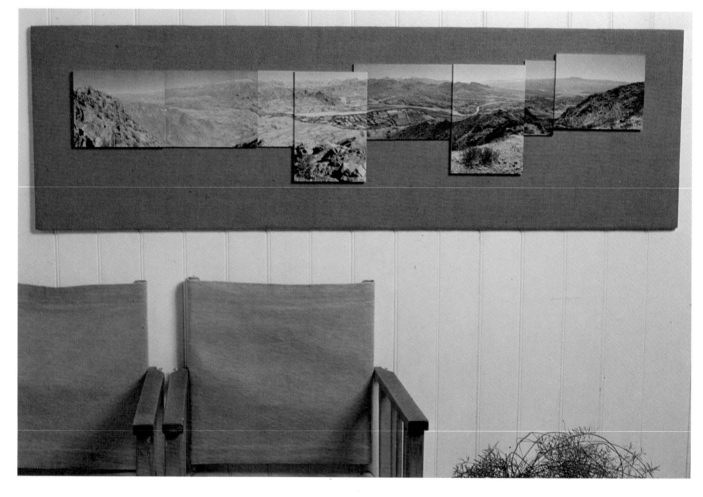

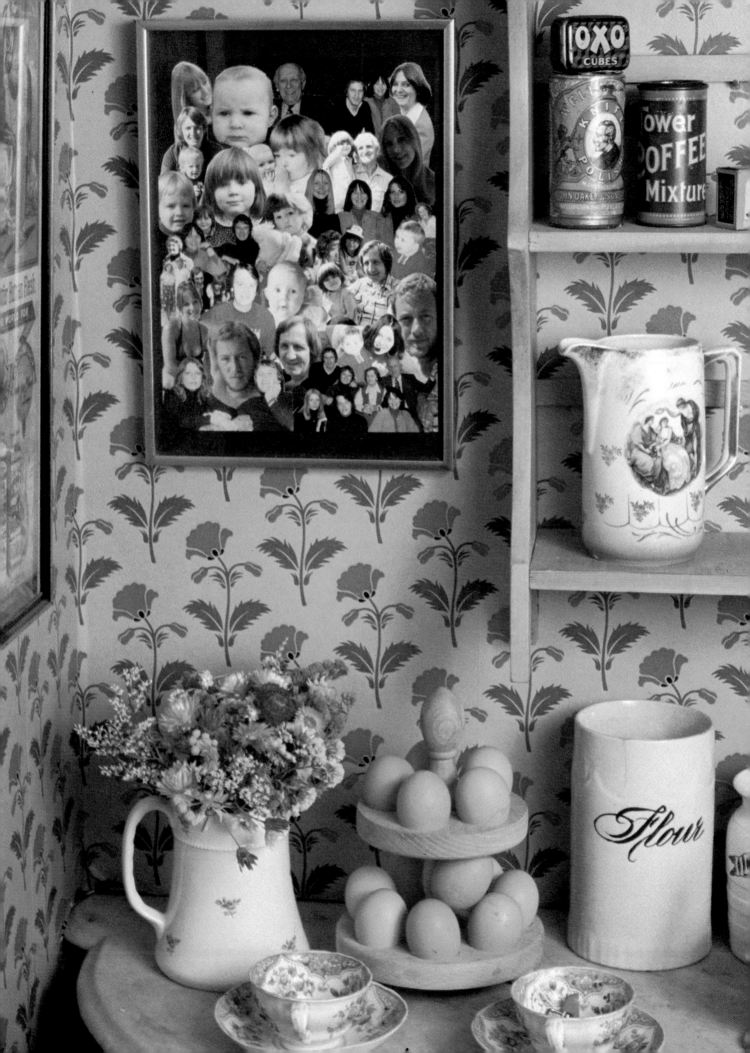

Create a Photomontage

A photomontage is a composite picture made from parts of one or more different photographs. In its simplest form, a photomontage consists of one photograph used as a background with portions of another photograph cut out and glued to it.

Quite complex pictures can be created from this basic principle. It is an easily mastered technique, and, with a little imagination, unusual images can emerge. Construct a photographic family tree, perhaps, or an individual life history. Combine a favourite landscape with close-ups of local plants and animals. But photomontage really allows most scope for highly expressive images — witty, poignant, dream-like, surreal, even bizarre, but always unique to their creator.

The Equipment

The necessary equipment is simple. For montages made of existing photographs, you will need a sharp craft knife and spare blades, a good large cutting board, suitable glue or a thermal mountant (a simple adhesive activated by the application of heat), silicone release paper (paper with a nonstick silicone coating on one side), a domestic iron, fine sandpaper, and dry-mounting equipment, or ordinary, good-quality mounting board.

How to Do It

Print the background photograph on double weight paper and carefully dry mount it. Leave excess mounting board on all sides so that there is no chance of getting fingermarks on the print. Work with extra prints to allow for mistakes. It is best if the prints to be glued on this surface are on single weight paper, but prints on double weight paper can be used if the cut edges are roughened on the back with fine sandpaper before the adhesive is applied.

Roughly cut out the appropriate figure or subject from the print to be superimposed. Coat the back with a thermal mountant. Allow it to dry thoroughly and only then cut out the subject precisely. Position it on the background. Cover it with a sheet of silicone release paper. Tack or weight the paper to keep the image firmly in place. Then, using a household iron set on a low

temperature, iron it on. The heat from the iron will release the adhesive. Leave the montage under pressure (a heavy book will do) until the adhesive dries. Using a thermal mountant results in a neat finish, but some people nevertheless prefer to use simple adhesives or spray mount.

Rephotograph the combined print and print it to a size appropriate for framing and hanging. Usually a photomontage is printed slightly smaller than the original to get rid of unsightly joins. When rephotographing, light the montage evenly to avoid showing up any cut edges in the work.

Photomontage Variations

There are several ways to extend the photomontage technique. Colour prints can be combined with black and white photographs to great effect. The same subject can be reintroduced repeatedly, using images from different photographs. Relationships of size, subject, and scale can be manipulated with dramatic results. Photomontage can also easily be combined with selective toning and colouring effects. It is possible, as well, to create montages with an uncannily three-dimensional effect. Cut out the images which will make up the elements of the composition and mount them separately. Set them up in different vertical planes, propped by little wooden blocks or cardboard and adhesive tape. They will now look like a page from a child's pop-up book. Photograph the assembled images through a large aperture and focus on one of the cutouts to strengthen the illusion of depth.

Taking Pictures for Photomontage

If the possibilities for making montages from existing prints are exhausted, or if you have gained confidence and interest and want to experiment further, it is time to take some pictures specifically to use in montages. Skies, textures, empty rooms, or uncluttered landscapes are always useful for backgrounds. The negatives need not be printed until they're wanted; simply file them with the contact sheets for easy retrieval.

When taking pictures for a pre-designed montage, you have to plan all the stages carefully. To create an illusion of reality, for example, the lighting and perspective must be consistent in all the photographs used. This sounds difficult, but with a large format or view camera, and careful use of tracings so that the planes of the montage can be precisely aligned, there will be little trouble.

If the camera being used has a separate viewing lens (as in a twin lens reflex) a tracing of one picture can be put over the viewfinder and the second shot can be composed and taken in relation to the first. Use small pieces of transparent acetate, precut to the size of the screen and near

This complicated photomontage was achieved by combining hands, two portraits, a banknote, and a background of contact prints.

at hand, and fine felt-tip markers. If the camera is a single lens reflex, attach a waist level viewfinder or remove the pentaprism.

Compose the first picture through the focusing screen in the camera, and expose. Without moving either the camera or the subject, place a piece of acetate on the screen. With the felt-tip pen, trace the portion of the picture which is going to be used in the montage, then wind on the film. The procedure may seem to require at least three hands, but with a little practice you will find that two are sufficient. Leave the acetate in place and, looking through the tracing, compose the second picture

in relation to the first, and at the size desired. Expose. This can be done several times before the acetate sheet becomes too crowded. If the lighting and perspective have been consistent, the pictures should be ready for use directly in the montage.

Making Prints for a Photomontage

Negatives can be printed to the right size for use in a predesigned photomontage.

Place a piece of tracing paper the

same size as the finished montage on the enlarger baseboard, and project each of the negatives in turn on it, tracing the elements which are to appear in the final print. Make these the size they are to be in the montage.

To make individual prints of each element, lay the tracing over a piece of printing paper of the necessary size and, under the safelight, project the image on the tracing paper and adjust it to the required size. Switch off the enlarger, remove the red filter and tracing paper, and make the exposure.

By working in this way, size and subject relationships can be manipulated to produce the most bizarre results. Insects or animals can dominate whole towns and cities. The family pet can engulf the home. Enlarged, the benign can appear horrific and the threatening, reduced, becomes simply comic. This theatrical mode of presenting photographic images will probably appeal at some time to any photographer with some skill and plenty of imagination.

In this photomontage the elements have been assembled and pasted down on the background. Retouching of the outlines remains to be done.

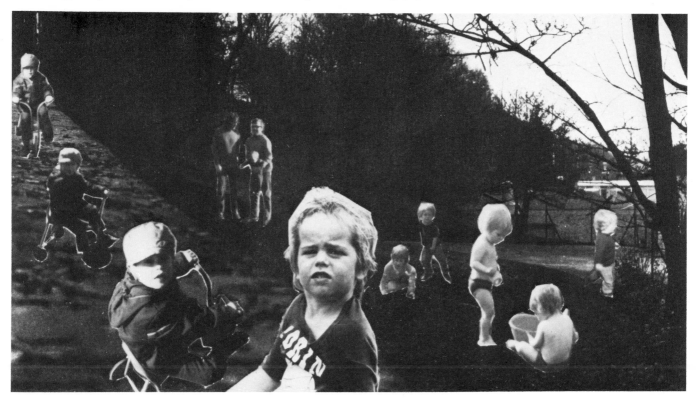

Collages With Photographs

Another way to use photographs in an imaginatively decorative way is collage, a centuries-old art form. The principle and the methods are simple. The kindergarten Valentine, made of bits of lace and coloured paper, may be everyone's original experience of collage. The materials are even simpler—anything, potentially, that can be cut, glued, and assembled on a flat surface. Collage is a highly personal medium, unhampered by conventional materials or formal techniques. Exploratory, serendipitous, it is an adventure in combining colours, forms, textures.

When used in a collage, photographs become simply another element, often no more important than the others. But what better way to tell a story or evoke a mood than to surround photographs with bits and pieces belonging to their time and place—some dried grasses from a vacation perhaps, or a fragment of shell, combined with a restaurant menu or a scrap of a foreign newspaper. The more remote past, too, can become a rich source of materials.

Most people have a box, or a trunk, full of the most diverse oddments, neglected, but for obscure reasons kept. Part of this mysterious hoard is usually a collection of photographs, sometimes going back for generations, tucked in among old postcards, greeting cards, ancient magazines and ephemera. Rainy afternoons spent brooding among these cast-off treasures can yield substantial creative pleasure, as one picture is added to another, and a bit of cloth to both. Perhaps an old ornament is exhumed, and transforms the whole composition, so that slowly, musingly, an idea for a finished work begins to grow, and where it will hang becomes clear. Something beautiful will happen where before there was only an idea.

Using cloth, lace, photographs, paper, dried flowers, paper doilies, and various bits of memorabilia, the collage at the right is a charming and sentimental tribute to the designer's young family.

The child's collage below is a wonderfully imaginative combination of photographs, drawing with felt-tip pens, and cut out, painted paper figures. The figures superimposed on the photographs and the painstaking continuations of gates, fences, and bits of landscape from the photographs to the background are a continual source of delight.

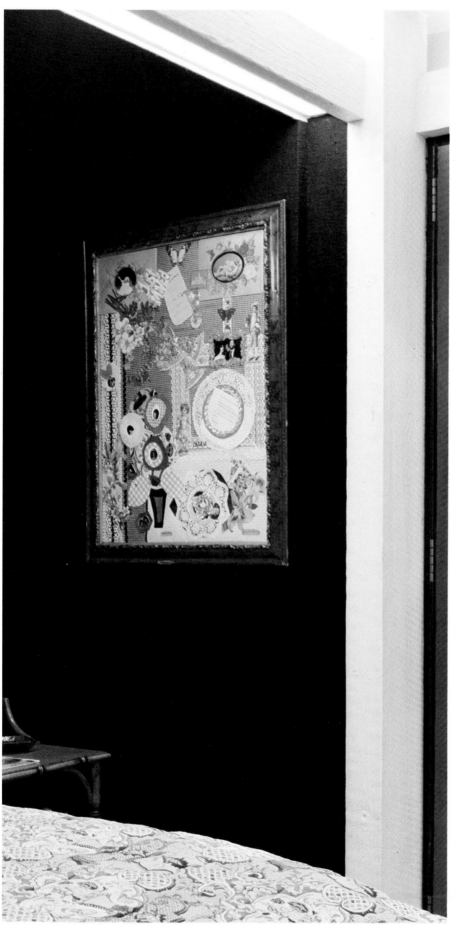

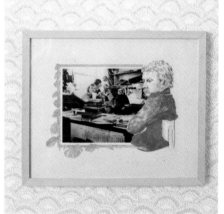

A painted, somewhat stylized portrait and the floral border are interestingly superimposed on the photograph below It is easy to tell who the relevant person in the photograph is.

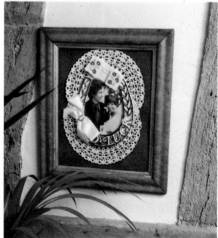

The wedding collage above has been made quite simply by combining memorabilia from the wedding—the lace doily, the decorative horseshoe, and the invitation—with the wedding photograph.

Making a Photo-collage

Given the simplest equipment—a piece of mounting board, glue, a sharp knife, a pair of scissors, some photographs which are not too valuable to cut up, and scraps of different materials—you can assure yourself of hours of unmitigated and exploratory fun by beginning to make photo-collages. Most photo-collages are of one or two types, those which are built up around a photograph, so that it remains the dominant element, and those in which the photographic image, or images, may be a small but essential part. The second kind, particularly, gives you the freedom to cut up photographs and use only salient images. This has great and obvious advantages for the amateur photographer whose level of technical proficiency may be uneven.

Portraits respond well to being integrated with collage techniques. Sometimes a decorative border is most appropriate, made of seeds or shells or, in a more sentimental vein, a wreath of dried flowers. More ambitious projects can be fascinating, and you can use collage techniques to project, illuminate, and round out the personality and interests of the portrait subject. Several snapshots, or a single posed photograph, of a child, for example, would look wonderful interspersed with or surrounded by kids' paraphernalia—bits of comic books, pictures of the child's heroes, chewing gum wrappers, favourite small toys (if they can be glued in place), the odd school report—anything, in fact, that is a small and treasured part of the child's life. Such a collage would create an amusing and enduring image to look back on as the child grows up.

The same idea would be equally appealing as, say, a gift for a person in middle life. A photo-collage that would reflect his or her life and interests, from bits of a concert programme to half an old tennis ball or a piece of fabric from a treasured but discarded garment to an astrological chart. What the bits and pieces are doesn't matter, so long as they are connected to the person, can become part of an entertaining and integrated image, and can be glued to a flat surface. The lives of elderly people are of course splendid hunting grounds for photo-collage portraits. Old people

have long histories, and much experience. They will have collected memorabilia. Old and new photographs would harmonize admirably in this context, along with everything from old theatre tickets and dance cards to bits of lace or an old-fashioned tie.

Nature photography is another area in which photo-collage comes into its own. Landscapes and seascapes can be combined with bits of bark, pebbles, grasses, dried flowers or anything else of this kind from the area where the photographs were taken. You can recreate the texture and substance of the area to expand your photographic image. If the photographs were taken on a vacation, use photographs of your family and friends along with snapshots of the local people and pictures of where you stayed, along with leaves, flowers, and other natural substances to create a memorable composition that combines the techniques of montage and collage and will remind you forever of an enjoyable few weeks. You can evoke a vacation at the seaside with equal ease and pleasure. Countless mementos are associated with such holidays—seaweed, sand, driftwood, shells, and, if you stayed in a seaside town, you probably have a few silly postcards and other nostalgic trivia that abound in such places.

For people who are interested in social history, or costume, or the history of fashion, photo-collage can be an excellent learning tool as well as a source of pleasure and artistic expression. Photographs of people in a given milieu combine happily with indigenous materials, small artifacts, bits of clothing, anything which concretely evokes the place and period of the photograph. Students learning about the theatre or about sumptuary laws, or even, say, World War II, would learn a great deal from combining photography with fragments of actual substance.

An exciting range of photo-collage falls into the area of purely abstract design that incorporates photographic images. You may find that the most unlikely bits of ordinary snapshots, a section of gate, or moulding, or brick wall, or half of someone's face, or a rock or a branch, is exactly what you want for a given design. Anything

from a patch of cloud to a section of wall can become unexpectedly exciting in the right context. The image need not even be recognizable for what it is in a naturalistic sense so long as it can become part of the design. Here is the area in which to really experiment to your heart's content, to while away rainy afternoons, or perhaps discover a new and absorbing avocation.

Equipment

Mounting board is the first thing you need to make a collage. Any flat surface which will not warp will do. Heavy card is fine for collages consisting of paper or fabric, but if you include heavier three-dimensional objects the mount should be hardboard, masonite, plywood, or chipboard.

Adhesives. For the preliminary and experimental pasting, use rubber solution. Spread on one surface only, it allows the materials to be moved around at any stage. The glue can be removed by rubbing with a finger.

There are many quick-drying glues on the market for permanent adhesion. Use a contact adhesive when gluing thick or heavy materials. It is applied to both surfaces and creates a stronger bond. It is also possible to coat the mounting board with plaster or acrylic paint and press objects and materials on the coating.

Tools. A pair of sharp, pointed scissors for cutting fabric, a second pair for cutting paper and card, a craft knife, an HB pencil, and tailor's chalk for preliminary marking up.

Varnishes. It is a good idea to give the finished collage a protective coating of varnish. This also helps to secure objects and materials to the base. Acrylic polymer

mediums and varnishes, obtainable from art supply shops, are good for this purpose. Milky when first applied, they become clear when dry.

How to Do It

Working methods will vary according to the materials used. Three-dimensional objects, for example, are more tricky to stick down than paper or fabric. Here are suggestions for how to work with some of the most popular collage materials.

Dried flowers and grasses are very fragile and should be handled with care. Only a small amount of glue is necessary for sticking them down, or they can be stitched on the background. If you do not have the opportunity to collect and preserve your own flowers or grasses, florists often sell bunches of dried plants for flower arrangements.

Shells can be fixed to a surface by covering the mounting board with a thin layer (about one-eighth of an inch, 3 mm, thick) of slow drying plaster or self-hardening clay, and embedding the shells in it. Cover a small area of the board at a time and arrange the shells there before going on, so the plaster doesn't dry out.

When the plaster has dried, varnish the shells to restore their natural colours. This method can be used with other small, three-dimensional objects.

Seeds and dried pulses come in many shapes and colours. Parrot seed or pigeon mix, available from pet shops, can be useful in collages. Oily nuts are not suitable because the seeds should be quite dry. Hardboard, used on the rough side, makes a good mount for collages which incorporate seeds. The design can be pencilled on the board, the background colour painted on at

this stage, and the seeds then stuck on with woodworking glue. The glue remains tacky for about twenty minutes,

during which time changes can be made. If the glue is rubbed with a damp cloth before it dries, it is quite easy to remove.

Paper of any kind can be incorporated into a photo-collage—wallpapers, marbled endpapers, art papers, and coloured tissue papers, ordinary brown parcel paper, corrugated cardboard, sandpaper, and even such oddments as bus tickets, cigarette packs, letters, laundry lists, and travel brochures. For the purpose of putting a photo-collage together, photographs count simply as paper.

Use a good quality paper paste. Wallpaper paste can be used for large areas. Press the pieces of paper down on the background with a clean rag so that finger marks will not be left on the surface of the picture.

Place the larger background shapes first, adding the smaller pieces later. Move the pieces around until you are satisfied with the arrangement, then glue them down. Spread the paste thinly. Some papers are quite absorbent and need more paste than others, so experiment with a small sample first.

Acrylic paint or medium can be used to fix tissue paper to a collage.

Fabric can be used to evoke almost any mood or feeling from the luxurious and exotic to the domestic or frivolous. Lamé, satin, lurex, leather, plastic, tweed, felt, linen, cotton, and organdie are only some of the possibilities in a long list. Such trimmings as braid, fringe, rafia, thick wool, sequins, or beads can add accent or brilliance.

The fabric can be either glued or sewn down. Many fabric adhesives are available, so experiment to find the one you prefer. Contact adhesives are also suitable. A toothpick can be used to apply glue to tiny pieces.

Choose the background material first and cut it out, leaving a margin of about one and a half inches (4 cm) all the way around to allow for mounting. The composition can be sketched in with tailor's chalk, which is easy to rub out afterwards.

Your first photo-collages will probably be quite simple, but given the vast possibilities of the medium, it is likely that you will go on to more complex, challenging, and imaginative compositions.

Teleidoscopic Images

The teleidoscope is a relative of the kaleidoscope, and even more fun. It works the same way, but, instead of the coloured fragments inside a kaleidoscope, it has a transparent sphere in the end. It can be focused on anything and the viewer looks directly at whatever is visible through the tube. The potential for ever-changing patterns is limitless. The simplest bit of the real world takes on a mysterious crystalline beauty. With the exercise of care and imagination a similar yet more enchanting effect can be caught and held photographically.

The process involved has been developed to a high level of virtuosity and artistic excellence by the French photographer, Monique Fay. She created the images below by reversing, upending, and juxtaposing identical colour prints of the same photograph. Despite the relative simplicity of the technique, the final images have an impressive meditative power. An imaginative eye and unerring taste, as well as immaculate craftsmanship, combine to turn pleasant, but not necessarily unusual, photographs into works of art of considerable force.

The mandala-like image on the left is made up of four duplicate pictures of an ordinary, tranquil, rural scene. The ox-bow shapes of the water, the fences, and the different colour grasses become sharp design elements.

The jewel glowing behind the Buddha on the right has been created, in the same way as have the other images, from multiple, carefully matched pictures—this one of a desert sunset.

Below, the rocks loom out of the mountains of water like primitive gods and, in the lower half of the image, troughs of water become crests and seem themselves to be ghostly presences.

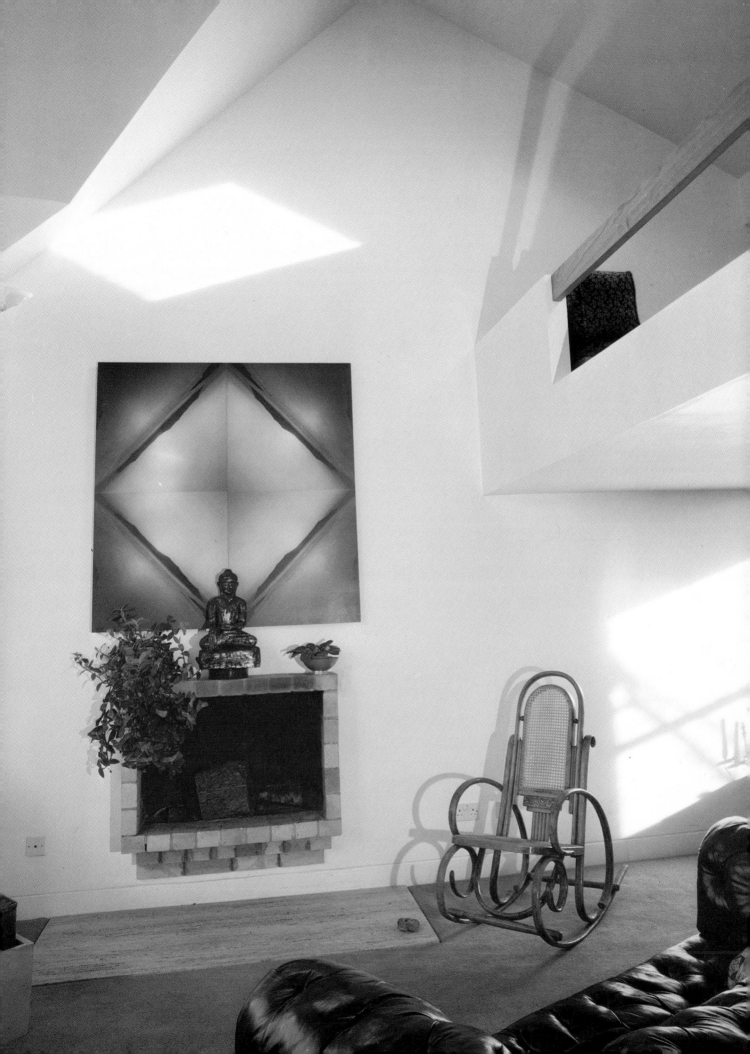

Making Symmetrical Patterns

By combining prints from one negative in various ways even some realistic photographs can be used to create abstract symmetrical patterns similar to those seen through a teleidoscope. To begin you will probably want to experiment with available negatives or transparencies, but as you discover the potential of those techniques you may find yourself taking pictures especially designed to be transformed into these teleidoscopic images.

The simplest approach is to use two prints from one negative. The second print is a mirror image, made by reversing the negative in the enlarger. The two prints must be identical in size, density, and contrast, so it is essential that they are given the same exposure and development time.

If you print a picture of, for example, a line of trees that appear low down in the print, and reverse the negative laterally to make a mirror-image print, the two prints can be mounted together with striking effect. Mounting the prints so that the two sets of roots seem to merge creates an effect rather like the reflection of trees in a lake. There will be sky at the top and bottom of the combined print, and along the centre where the two images of trees meet there will be an interesting play of abstract shapes derived from the bottoms of the trees and the combined ground lines.

These photographic patterns are a sophisticated version of the visual effect achieved by "blot pictures." When blobs of ink are dropped into the crease of a folded piece of paper and both sides of the paper are pressed together, the paper opens out to reveal a perfectly symmetrical double image.

Once the basic technique has been mastered, it is reasonably simple to increase the number of prints and combine them in different ways to create a variety of abstract patterns.

By printing twice from each orientation of the negative, four prints can be arranged to fit together along any of their four edges, to produce four different versions of the combined print. If you decide to experiment you should try to ensure that the prints will at least potentially combine in interesting and aesthetically pleasing ways. One way to do this is to take pictures that make specific use of only two of the edges of the print, and can therefore be matched easily to produce a variety of diamond shapes. The more naturalistic the subject of the print is, the less effective the final result tends to be, so look for simple textures and patterns. The moulding on a building can, for example, translate into striking graphic effects in combined prints.

When choosing from photographs you already have, select pictures with forms and lines which run off the edges of the print. These will be the elements which join in the combined print.

It is possible to visualize the final effect by holding two mirrors together at an angle of about 30 degrees over the print. Many prints which seem unpromising may reveal surprising potential.

When taking photographs specifically for the purpose of making these patterns, forget about all the formal rules of composition you may have learned and move the camera so that the various elements of the subject relate to the four sides of the photograph in unusual ways. A strong linear element, the horizon, for example, or the side of a building, can be made to slant rather than remain horizontal or upright. Pay particular attention to the lines and tones running out of the edges of the viewfinder. The final abstract pattern

created by combining the prints will totally transform the individual picture, so do not be afraid to experiment at this stage.

When dealing with black and white photographs, the whole range of printing techniques can be used to enhance the patterns. Toning the individual photographs (page 25) will produce exciting and sometimes wholly unexpected results. Quite small prints can be assembled into large photomurals. Although obtaining matching colour prints can be difficult, the finished results are well worth the effort.

Pattern Possibilities

Exciting pictures can be made by cutting the prints into different sizes and shapes and rearranging the pieces according to some arbitrary plan that imposes another order on them.

Cut one of the prints into a number of squares. Rotate each square through 90 degrees. Glue the squares on a mounting board in the same order they were in before being cut. This pattern will retain elements of the original scene, but with dislocations that may be amusing or disconcerting, but will always intrigue.

With a straight edge and knife, cut a print into half-inch (1.25 cm) strips. Reassemble them slightly out of register. This pattern can intensify the illusion of movement in action shots in a dramatic and unusual way.

Use a sharp knife to cut the print into undulating strips, and mount these with a slight separation between them.

Use two different prints of exactly the same size and cut into squares of the same size. Mount them on two boards using alternate squares from each original. This can be particularly effective if one print is a negative version of the other.

Black and White Posterization

Also called tone separation, posterization is a process whereby the continuous tones of a conventional black and white photograph are broken down into a number of separate flat tones, usually black, white, and one or more mid-greys. This is done by contact printing the original negative on separate sheets of high-contrast lith film, giving each sheet a different exposure time. If two separations are made, for example, the first sheet is underexposed to record only solid black shadows and the second is exposed to record a mid-grey. Negatives are made from these positives and are printed successively in register on one sheet of bromide paper. The final print, as the name of the technique suggests, has the strong, graphic appearance of a poster.

A few additions to the usual printing equipment and chemicals are needed. These include lith film (five by four inches—12 by 10 cm—or larger), lith developer, usually prepared in two separate solutions which are mixed just before use (if this is not available, undiluted print developer such as D163 can be used), a red safelight or a safelight filter, if this is not already part of the darkroom equipment.

For successful posterization, a negative must have good blacks and whites, together with a range of intermediate tones. Big bold design should be the keynote, because a multitude of detail will be confusing in the final print and simplicity is the desired effect.

When posterizing, the greatest problem is registration. This can be achieved by scratching four crosses

on the rebates of each negative and registering these, or by using a cardboard folder as described in the colour posterization instructions on page 121.

First make a test strip of lith film. It is important to find the exposure time which will give maximum density on development. Place the film on the enlarger baseboard with the negative on top of it and expose by shining the enlarger light through the negative. To judge the exposure,

it should be enough to give the strip three very short exposures in the order of one, three, and six seconds.

Develop the strip in the lith developer to make a positive and assess the three exposures. The one which gives a good dense black and a clear film area is the one to begin with. This will also indicate the areas that will appear black in the final print.

Using the selected exposure time, make a positive on a sheet of five-by-four-inch (12-by-10-cm) lith film, remembering to include the entire negative so that the important crosses on the rebates show. Process the film.

Without moving the enlarger or printing frame, expose a second sheet of lith film for four times the previous exposure, and process as before. Spot out any pinholes in the black areas with photo-opaque.

Contact print these two positive liths on two further sheets of lith film to produce negatives, and process. The exposure time for contacting should be that used for the first, underexposed, lith positive.

When the negatives have been washed and dried, spot out all the pinholes and, if necessary, carefully scrape away minute black specks in the clear areas of film with a knife. This will be easier if done on a light box.

Make a test strip in three-second stages and process. The first exposure, to give good strong black, should be used for printing the shadow, or darkest, negative. The exposure which gives a mid-grey should be used for printing the second negative, which will provide the middle tone on the final print.

Place the shadow negative—the one with the most black on it—in the enlarger. Expose a sheet of bromide paper to the longest of the exposure times chosen. With a fine, black, felt-tip pen, mark on the paper the crosses scratched in the rebates.

Leaving the paper on the baseboard, swing the red filter over the enlarger lens. Place the second negative, which will provide the mid-tones, in the enlarger and register the crosses over those drawn previously on the paper. Give the shorter exposure time. Process the print.

The final result will be a reproduction of the original photograph but in three tones only, white, mid-grey, and black.

The larger liths can also be contact printed in register directly on the bromide paper.

Special Pictures for Special Places

There are some delightful photo decor projects for which you will have to take special pictures. These pictures, usually but not invariably of objects, are well within the range of even an inexperienced amateur photographer. They may possibly require a bounce flash, or a reflector, but probably no equipment more sophisticated than that. The work, and the interest, come from assessing the kind of photograph required, from what angle it should be shot, and what type of print will be most effective for the finished project. You will find that you can fancifully decorate and label everything from cupboard doors to a shoeshine kit, create stunning pop art designs to function as tabletops or decorative motifs, take circular photographs which can then be laminated into beautiful placemats, and create charming screens and room dividers with giant enlargements. You can even create intriguing *trompe l'oeil* effects and transform your home dramatically.

Taking photographs for a particular project allows you to experiment within fairly close and definite limits, and you will even learn a good deal about basic photography in the process. If you have to take the same picture five or six times before you hit on the necessary angle from which to create a certain effect, you will get considerable insight into both viewing and processing in the course of achieving exactly the photograph you need for your project. Taking special pictures can also be a splendid exercise in looking more closely at things, and seeing them more clearly — how things are built, the visual effects of proportion, the way designs and patterns and colours really work. It will be a learning process, and like any learning process approached with openness, a willingness to experiment, and flexibility, taking special pictures can be a source of real enjoyment.

Ordering Colour Prints

An enormous range of services is available to the photographer. You will probably be able to get done whatever you want in the field of colour printing, though the price will vary according to the service.

It is worth finding one competent laboratory and developing a good relationship with the technicians there, especially if fine enlargements are required. A glance through the advertisements of any photographic magazine is a good starting point in the search for a reliable colour laboratory.

The big film and paper manufacturers offer regular processing and printing services which may at times include some worthwhile special offers. In some areas, Kodak, for example, does giant colour enlargements for home decoration. Local photographers have special offers from time to time to increase business, and these are also worth watching for.

Machine colour printing has become an extremely sophisticated and reliable process. The standards of the laboratories offering high-speed mass processing seem to rise all the time. Spoiled pictures will be credited, and many mail order services require no money until you have seen the pictures and are confident of the quality. Incompetent laboratories do not stay in business for long, so cut prices and free film do not necessarily conceal poor processing. Offers appearing in responsible places are on the whole genuine and worth trying.

Most laboratories offer a choice of either standard or exhibition service. Exhibition service is sometimes called professional service and is about three times more expensive.

The standard service offers machine processing, with only limited facilities for colour correction, should it be needed. The exhibition service is nor-mally used only for prints eight by ten inches (20 by 25 cm) or larger. Since the prints are hand finished, the colour, tone, and contrast can be corrected if necessary and the finished print is of a much higher quality.

Services Available

Far more things can be professionally done with colour prints than most people are aware of. Here are some of the services available.

Prints can be made directly from negatives.

C-types are prints made from transparencies by means of an internegative. These are quite expensive but have the advantage that once the internegative has been made any number of prints can be made from it.

R-types are prints made from transparencies directly on reversal paper. They are cheaper than C-types, but since this is a one-off process it is normally used when only one or two prints are required.

Prints can be made from prints, including instant pictures.

Prints can be made from the individual frames of cine film.

Multiple prints can be made by combining several negatives or transparencies. A popular example of this process is a wedding photograph in which the bride and groom are vignetted in a champagne glass.

Prints can be mounted on hardboard and given textured surfaces. Simulated brush marks and canvas or linen texture imitating the appearance of an oil painting, are among the most popular.

Poster prints, twenty by thirty inches (50 by 76 cm), can be made comparatively cheaply from either negatives or transparencies. The colour is quite crude and the print grainy, but with the right picture the overall impact will easily overcome these minor disadvantages.

Most laboratories offer a selective enlargement service, which will extract a chosen detail from a photograph and make it into a complete picture when, as often happens, a group photograph contains an especially good portrait of one particular person.

En-prints are the postcard-sized machine prints obtained from transparencies when these are given to a local shop or sent away to be processed. Prints made from 110 film or 35 mm transparencies measure three by five inches (7.50 by 21 cm), while those made from 120 or 126 film measure three inches (7.50 cm) square.

Remember that mass printing houses have to crop the sides of the picture, so if the subject has been too closely framed in the camera, the intended composition may be spoiled. A moonlit river, for example, is not nearly so melting a scene if the moon is sharply dissected at the top of the picture. Portraits are also obviously vulnerable to partial decapitation.

If there is any particular finish you prefer for the prints, check that the laboratory offers it. Prints can be ordered with or without borders; they can have square or rounded corners, and a matt or glossy finish. Most laboratories now prefer to produce borderless prints on matt paper. These have more picture area per print. The laboratories, unless instructed otherwise, print on matt paper because it tends to disguise any softness in the focus of the picture. This is a point worth remembering when looking through your prints for pictures to enlarge. Sometimes, quite attractive prints will not take kindly to being blown up much larger than five by seven inches (12 by 18 cm). If in doubt, examine the print with a magnifying glass to see how much clear detail there is. If you are lucky, there will be enough detail to justify enlargement.

All About Adhesives

For photo decor, you will probably need several types of adhesive for a variety of uses. Since adhesives vary in strength, purpose, and method of application, you could easily find yourself using up to three types for a single project. A frame that will have to support glass and a heavy mount, for example, will need a much stronger glue than a frame made of balsa wood, and a different glue, again, than you would use for a plastic frame. If a picture will hang in a damp atmosphere, like a bathroom, you'll have to use a glue impervious to moisture, and if it will be in direct sunlight, a glue unaffected by heat will be required.

Here is a guide to the types of adhesives available and their most appropriate uses.

Spray adhesives come in aerosol cans. Excessive adhesive is difficult to remove from a matt surface, so it is important to work neatly. Heat causes the adhesive to soften and a print mounted with it will peel away at the corners. Do not, therefore, place prints mounted with spray adhesive in direct sunlight unless they are framed and glazed.

 Good for card and paper.

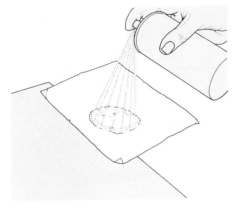

Cellulose wallpaper paste is best for mounting prints on large, flat surfaces. It is extremely inexpensive, but rather messy. The print should be thoroughly soaked first. This method will not work on resin-coated paper prints, which are waterproof, but is good for photoposters. Prime the wall or board first or cover it with a thin coat of adhesive.

 Good for walls, chipboard, and hardboard.

Dry mounting tissue bonds when heat and pressure are applied, either with a dry-mounting press or a household iron.

 Good for card and paper.

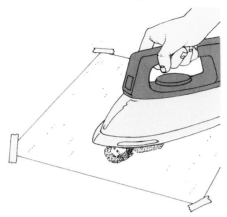

Water soluble contact adhesive is also called impact adhesive. It is diluted and spread thinly and evenly on both surfaces. Most types need to be left to set for about twenty minutes before bringing the two surfaces together. The print must be accurately positioned the first time because once the two surfaces have made contact the bond is immediate and permanent.

 Good for plastic, metal, laminates, wood, hardboard, and Photo Linen, and for objects that get heavy wear.

Superglues are expensive and set instantly and permanently. Use with care.
 Good for gluing almost anything.

Epoxy resins are strong and waterproof. The most efficient types need a long hardening period of up to forty-eight hours. Use sparingly and clean off excess with methylated spirits before the glue hardens.

 Good for gluing almost anything.

Animal-derived glues are also called rabbit or horse glues. Essentially wood glues, they are inexpensive and strong, except in damp conditions. They usually need heating before use. Most have an unpleasant odour. The excess must be removed immediately because these glues can stain natural wood. They also become brittle in the cold.

 Good for wood. When using on frames, however, it may be sensible to supplement the glue with nails.

Casein glue comes in powder form and is mixed with water. It is very strong in dry conditions and does not become brittle in the cold as do some animal glues. The two glued surfaces can be separated by applying water.

 Good for wood, and, if applied thinly, for Photo Linen. For frames and other wooden objects, however, it may be worthwhile to supplement the glue with nails.

Latex-based adhesives are basically fabric glues, and do not stain or show through.

 Good for Photo Linen, for gluing fabric on prints when making collages, or on hardboard or card mounts when making fabric frames.

Rubber solution, or cement, is a good, flexible mounting adhesive. Coating one surface creates a temporary bond, coating both creates a permanent bond. You can remove any excess by rubbing gently with a finger. If you are careful the adhesive won't leave any stains.

 Good for card and paper.

Waterproof adhesives are best used for small prints because they can be difficult to spread over a large, flat area. They set in about thirty minutes, but take longer to dry completely. Clean off any excess with a damp cloth before the adhesive sets.

 Good for damp atmosphere, and unaffected by heat.

Urea formaldehydes have good resistance to moisture. They also double as filler and can be used to fill small spaces in a frame.

Everything in its Place

One of the most frustrating experiences of daily life is the often fruitless search through drawer after drawer, or box after box, looking for the one object, the one small implement, most needed at any given moment in order to complete a job. Perhaps the bottle opener has disappeared, or the only screwdriver that will turn an obstinate screw. Maybe the can opener is missing, or any item whose absence can halt a job or throw a household into chaos. Such situations are exasperating. The mental voice that persists in saying, "I know where everything is, I just have to find it," is stubborn, but unhelpful.

Happily a solution exists that is both decorative and functional. Is that the drawer where the bottle openers and corkscrew should be? A laminated photograph of the contents on the outside of the drawer will make that clear. If the knives and forks should be in one drawer and no other, then identify that drawer similarly. A set of tools will be far more likely to get hung up after they are used, if there is a photogram space for it on a tool board. And on the door of a cabinet full of miscellaneous items, a photograph of the contents in meticulous order would be decorative and might help keep it neat.

Stark white shapes take the place of labels on the tool board in the picture below. This arresting image was very simply made. It is a photogram, which is, curiously, a picture taken without a camera. Here, too, lamination insures washability and durability.

The drawers of the kitchen cabinet on the left have been adorned with photographs of cutlery and equipment shot against a white background, enlarged to fit the size and shape of the drawers, and laminated. This is a project that combines practicality with striking decor.

Laminating and Varnishing

When a photograph is to be used in a kitchen or bathroom, the surface has to be protected from steam and condensation. The safest way to do this is with a well-constructed, sealed frame. But if you want to use a photograph on a table top or on the front of a drawer or as a placemat, then the best way to protect it is by lamination or varnishing.

Lamination

One of the most effective ways to protect a print is to have it laminated. True lamination must be done professionally and can be expensive, especially for larger prints. It involves putting a plastic skin over both sides of the print and sealing the edges. The result is an excellent surface which protects both sides of the print from the effects of water, steam, and fingerprints.

Self-adhesive acetate film can also be used to protect the surface of a print and is a simpler kind of lamination. The film comes in rolls of different widths and has a protective backing which is stripped off before the film is applied to the print surface.

It requires care and patience to use this material successfully, but it is not difficult to master. Cut the film to size with the backing sheet still in place. Allow one inch (2.50 cm) excess all around the print. Lay the film face down on a clean surface and strip off the backing sheet.

Hold the print face down and position one edge one inch (2.50 cm) in from the edge of the film. While holding the opposite edge of the print up in the air, curve the print gently downwards on the film, pressing with your hand to expel the air as you go. Mitre the corners and fold over the edges one at a time.

Another method is to first stick the print, image side up, to a smooth cutting surface with a small piece of masking tape. This will keep the print from moving as you laminate it. Then peel back the backing sheet about one inch (2.50 cm) from the adhesive film and smooth it flat with the palm of your hand so that it stays separate from the film.

Attach the exposed adhesive film to the cutting board so that the line of the folded backing sheet is parallel to the

edge of the print and about one inch (2.50 cm) away from it. Be sure that the film completely covers the print.

Lay the bevelled edge of a set square against the crease. Lift the backing sheet up from underneath, then carefully peel it back about one inch (2.50 cm) from the edge made by the crease. The print is now also held by the

adhesive film.

Hold the set square down firmly and begin sliding it over the print and the film. It will release the backing sheet,

and as it slides across the print, it will simultaneously press the film down flat and peel away the backing sheet.

Finally, cut around the edge of the laminated print and carefully remove it from the cutting board.

Turn the print over and check for air bubbles. If the air has been expelled while positioning the print there should be no problems, but if there are any small bubbles, prick them with a needle and press them out.

Another way to laminate a photographic print is to put it between two sheets of thin acrylic and seal the edges

with thin acrylic adhesive or plastic tape. In this way, the print is sealed in a strong, rigid, transparent plastic container.

Varnishing

The surface of the print can also be protected by coating it with a fine varnish, of which there are several kinds available. For full protection, varnish the back and sides of the print as well as the front.

Photographic shops stock varnishes with mat or glossy finishes, made specially for photographs. Some varnishes also provide protection from ultraviolet rays and prevent the photograph from fading in the sunlight. These photographic varnishes are probably the best ones to use. Fine varnishes of the type used by artists to cover paintings will, however, be quite effective.

The heavier types of polyurethane varnish—available in hardware shops and used on furniture—are not usually suitable for prints. They are not quite colourless and will give a slight yellow tint to the photograph. Such a varnish can be used, however, if it is thinned first and applied in two thin coats rather than one thick one. Use turpentine substitute to thin an oil-based varnish and thinner for the varnish which is alcohol- or spirit-based.

Varnish can either be brushed directly on a print or sprayed on. Be sure to

apply varnish in a well-ventilated room. When spraying lay the print face upwards on newspaper. Begin to spray at the top left-hand corner and spray steadily in parallel lines from left to right down the print. If more than one coat is necessary, allow the first to dry completely before applying the second.

Photograms

A child will often learn the trick of writing his or her name with opaque masking tape on an unripe apple and be rewarded with a rosy red apple, the name on it in green. At its simplest level, a photogram—a photograph made without a camera—works in the same way. Interesting shapes can be recorded by placing objects on bromide paper and switching a light on briefly. When the paper is developed, the shadows of the objects print white against a solid black background. Objects which do not lie flat on the paper will produce a range of greys.

Etched glass, doilies, lace, open knit-work, and macramé can all be used to make interesting photograms, as can such ordinary household objects as scissors, paperclips, and keys, and natural materials like ferns, seeds, and leaves.

To record shapes as positive images, place the objects on sheet film, develop this and use it as a negative in the enlarger. A photogram printed on single weight bromide paper will make a good negative for contact printing (see page 134).

Although a desk lamp can be used, the most convenient light source, particularly for flat shadow shapes, is an enlarger. It is necessary to experiment with exposure, but to begin try ten seconds with the enlarger head at the top of its column, stopped down to about f.11.

To create an unusual effect, objects can be combined with a negative. Using the red filter in the enlarger, position the negative on the paper, surrounding it with the objects chosen. cover with a sheet of glass so that the whole negative is in contact with the paper. Remove the red filter, expose, and develop as usual.

Thin objects can be enlarged dramatically by positioning them between two pieces of slide-mounting glass. The slide is then used as a

negative in the enlarger. Inks will, incidentally, produce exciting, non-figurative images. After the objects have been arranged, tape the pieces of glass together and place the slide in the negative carrier.

Print the photogram in black and white or on reversal paper in colour.

Pictures for Practical Purposes

Modern technology has emancipated photography from the walls, even from an entirely flat surface. Today there is more and more scope for entertaining, humorous, and idiosyncratic uses of photography. Most of the projects can be undertaken in an amateur darkroom or fairly inexpensively by a professional photographic laboratory. Modern techniques for fixing and laminating photographs are reasonable and accessible. Consequently, photographs can now be used to decorate the most unlikely places and things, adding an unsuspected element of surprise and fun to ordinary domestic life, or making something special—personalized—of what might have been an uninteresting gift.

A child's toy chest, for example, could not only be cheered up but given some slight pedagogical point if it were decorated with a photographs of a battery of bright and neatly arranged toys. Perhaps a budding lepidopterist would enjoy a glorious life-size photograph of a luna moth, mounted, cut out, and transformed into a mobile. Most breadboxes are banal objects, but those who bake good bread would no doubt

be pleased with a box, fit to hold the noble thing a good loaf is, decorated with a photograph of one of their own loaves—life-size, in colour, fixed, laminated, washable. The same approach would work for a cake tin, embellished with a photograph of some elegant triumph of the baker's art.

A sepia-toned photograph of old-fashioned apparatus used to cover a chemistry-set box, would make it look like an ancient and arcane treasure. A carefully selected galaxy of other-world creatures, perhaps mounted and freestanding, could find some friendly habitation in strategic places, walking on window ledges, creeping around corners, and lounging around the room of a science-fiction addict.

Once the idea of special pictures for special places takes hold, it is hard to stop, since techniques have become so flexible, and decorative style so eclectic. On the whole, photography is comparatively economical. It is not difficult to be rich in ideas, and relatively simple photographs can, with ingenuity, be processed and used with an originality that bears no relation to their cost.

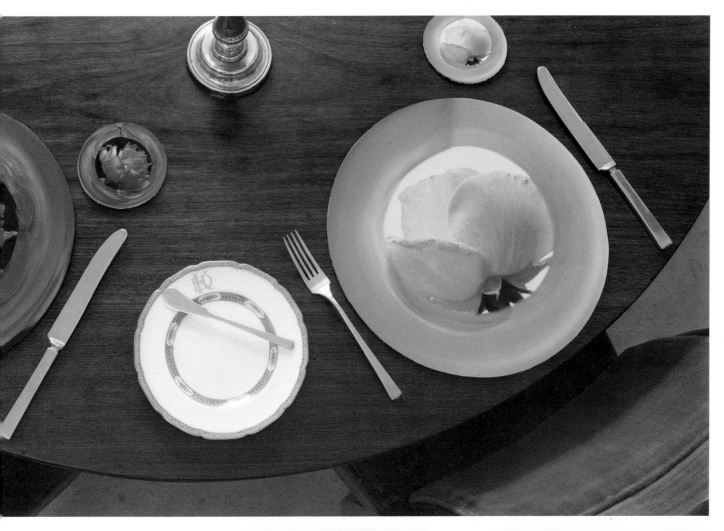

The pictures on the charming and rather elegant placemats and coasters, above and right, were taken by photographing the flowers through a reflecting tube. This technique causes the colour of the object photographed to sweep around in a perfect, enclosing circle.

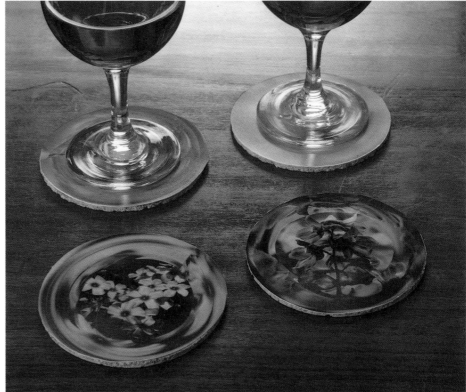

The point of the shoeshine kit on the left is clear, and made amusingly. It is just the thing to encourage a recalcitrant adolescent.

Taking Circular Pictures

If you place a cylindrical or reflecting object, such as a bottle, on a picture, you will find that the image reflected in the bottle is distorted by contraction into a tiny version of the original. This simple scientific principle of circular reflection was used by a clever painter in eighteenth-century Scotland. His painting on a tray is totally undecipherable until a decanter is set down in the centre of the tray. Then a portrait can be seen reflected in the glass—Bonny Prince Charlie, the outlawed claimant to the throne, to whom some Scots still pledged secret allegiance. In bygone days they "drank the loyal toast" over the tray, which can still be seen in the Fort William museum in Scotland.

The photographer can use the same principle in reverse to take quite stunning circular pictures. The subject will be enlarged, rather than contracted, because the reflecting cylinder encircles the lens and therefore extends the image area.

Photographing a subject—a flower perhaps—through a reflective tube creates a striking and unusual effect. The subject dissolves into a swirl of colour at the edges of the picture while remaining sharply in focus at the centre. The finished prints, lovely in themselves, can be made into attractive placemats or coasters.

The reflecting cylinder need only be short—six to eight inches (15 to 20 cm) is long enough—but should be wide enough to wrap snugly around the lens of the camera and fasten without any gap. Make the cylinder of mirror foil, or any high-gloss foil without wrinkles. Thin foil can be used, but it should be glued to light card or heavy paper to ensure that it is completely smooth. Close the cylinder with clear tape and be sure the join is

neat. Otherwise it will be unattractively evident in your pictures.

After you have securely fastened the cylinder to the lens of the camera, focus on the selected subject in the usual way and with normal exposure. An SLR camera—fitted with a standard or macro lens—is best since it is possible to compose the picture directly through the viewfinder, and choose exactly the right effect. What you will see at the end of the tube is the subject, surrounded by its own dilated reflection in the cylinder. The texture and colour of the subject will be continued, but the form will merge in this coloured rim. If there is any strong variation of colour in the subject, check that this does not give an unbalanced effect to the circular border when it is distorted by reflection.

This technique does not have to be limited to photographing in nature. It can be used to give bizarre effects to faces and places. Nor do the reflections necessarily have to be circular. That is only the beginning for photographers interested in optical distortion.

Stronger and more specific reflections are achieved by converting the tube into an equilateral triangle of reflectors. This can be done by using three small mirrors or mirror tiles bound together with masking tape to meet exactly at their three connecting edges.

The triangular reflector is connected to the camera by fitting it into a tube made of card. Fit a cover with a hole just big enough to take your lens to one end of this tube, and tape or push them together. Mask the other end so that

the triangle is the only source of light, otherwise the reflected image may be diffused and indistinct.

As with all new photographic techniques, the key is necessarily personal experimentation. The length the mirrors extend from the lens, for example, will affect the result. The reflected image can be altered by rotating the entire tube like a kaleidoscope. You don't have to be on location to produce interestingly distorted images from brilliant scenic views. You can use a colour transparency brightly projected on a screen to produce myriad variations on a theme.

Many photographers feel that distortions in pictures can be a waste of the camera's potential to record and interpret. But these optical distortions, which are controllable at the taking stage and can be designed in the viewfinder, are poles apart from random darkroom distortions. They use the colour and form of the subject itself to create intriguing visual variations, and elegant pictorial results can be achieved. It is a technique that can be enjoyed by the colour photographer who has no processing facilities, or who simply prefers to use professional services for development and printing. The creativity lies in composing the picture, and requires only a standard lens, a small rectangle of reflective material, and a little imagination.

Here are the cross-bars of a window taken through a reflective tube.

Setting Up a Still Life

Photographs can be used to customize and personalize a variety of household effects, including a sewing box, kitchen drawers, a shoeshine box, or the doors of cabinets. By photographing a typical assortment of the contents of cabinets, boxes, and drawers, the function of the objects can be identified in a way that is not only useful but stylish, individual, and decorative.

For this purpose, it will probably be necessary to take special still-life photographs, using an ordinary table, as shown below. This is the simplest type of still life, requiring no elaborate composition or lighting, only maximum definition of the objects being photographed and as little distraction as possible from the background.

The objects should be isolated against white or strongly contrasting colour, with no folds, creases, or shadows showing in the background. The best way to achieve this is to make a curving background by attaching a large sheet or heavy paper to the wall and hanging it over a sturdy chair of suitable height.

The paper should be large enough so that the edges do not show in the picture. For colour photographs, obviously, coloured paper can be used. Rolls of background paper, widely used by professional photographers, are available in a variety of widths and colours from photographic suppliers.

An infinite number of effects can be achieved with different types of lighting. Details can be brought out or suppressed and different moods created. When you want a simple photograph for use as a kind of label, a simple flash is sufficient.

The photographs of the shoes on the shoeshine box (page 110) were taken with a bounce flash. This does not point directly at the object being photographed, but at a white reflective surface above or to one side of it. This surface can be a white wall or card. The light bounces off it and on the subject. Such indirect lighting softens and diffuses the flash and eliminates the hard lines which usually result. Bounce flash diffuser kits are available, but an ordinary flash and hand held card can be used.

Reflectors on either side of a still life will also help to give a more even spread of light and to eliminate hard shadows. A projector screen, if you have one, makes a good reflector, and large sheets of white card can be propped up against chairs.

If you are using a flash, the camera can be hand held, but placing it on a tripod or chair will make certain that it remains steady.

Flat objects, such as the cutlery on the kitchen drawers on page 106 must be photographed from above. They can be placed on the floor on a sheet of paper. The camera can be placed on a table or on a tripod with an overhang. In some tripods, the centre column can be reversed. If your enlarger has a copying stand, the camera can be fitted on it and the objects arranged on the enlarger baseboard.

Pop Art

In the early 1960s, the art world and thousands of innocent viewers wandering into galleries were shocked into astonished laughter by a proliferation of plastic hamburgers, huge replicas of Campbell soup cans, deceptively simple enlargements of comic strip frames, complete with bubbles saying "POW!" or "ARGHHH!" or "BAM!", portraits of Marilyn Monroe that looked like posterized photographs, and hundreds of other extraordinary objects and images that seemed far more likely to be gags or advertisements than anything the critics or the public had become accustomed to think of as Art.

Whether as the exploding of a myth or as a sardonic commentary on a society that responded only to the imagery of advertising, Pop Art captured the public consciousness and, after the initial shock, the decorative possibilities of the mode began to be explored with enormous élan. As an avant-garde artistic movement it is no longer with us, but as amusing, strikingly graphic decorative punctuation, Pop Art is solidly part of Western culture. Photographs provide a sharp, clean, and colourful way to create in the home environment pop experiences that have an air of humorous elegance.

Blue, black, and white make a coolly elegant composition of the Gitane box as tabletop, and the reflections in the glass create an interplay of abstract patterns.

The blow-up of sweets in trays on a shop counter makes the doors of an otherwise ordinary record cabinet colourful and eye-catching.

The hamburger on the placemat is a playful, and more functional, descendent of those made of plaster or ceramic that were so startling in the 1960s.

Learning to See Design

Seeing is invariably selective. If it were not, we would be overwhelmed by the sheer flow of visual phenomena. Even the most casual glance is an act of organization, the creation of a design out of what might be a senseless multiplicity of stimuli. A deliberate look through the viewfinder of a camera is even more selective, for its very purpose is the creation of a design. It involves organizing visual elements— forms, spaces, light, colour, line, depth, perspective. Anyone taking even the most rudimentary snapshot will be aware, often unconsciously, of these elements and will be working with them.

Ordinarily, we see only what we already recognize, so that seeing is to a very large degree a matter of habit. We see what we are accustomed to seeing, or what we need to see, or, often and sometimes unfortunately, what we want to see. It is a form of reassurance, a way

of telling ourselves, fallaciously, that our visual reality, at least, is relatively constant. In terms of visual awareness this reassurance can all too easily become a kind of blindness.

The photography of design, exciting in itself and with great potential as decor, is based not so much upon technical skill as upon learning to see differently, perhaps upon learning also to reclaim for our older selves the freshness of vision we had as children, when everything was new and we did not yet have visual habits. But this freshness can, and often does, work well with a kind of visual sophistication, a capacity to see when an image will "work" even better in another context than the one in which it is found.

Our vision is constricted—not only our visual field, but the flexibility within it. Learning to see differently can, therefore, be thought of, initially, as a form of exercise like any other—a kind

of loosening up, relaxation, becoming more supple. One of the most ancient and universal ways of beginning to do this is to look at trees, and to look not, as one usually does, at the branches, but rather at the spaces between, to see what shapes those spaces make, and what patterns and designs are formed by the interaction of those spaces. An afternoon in a park can, in this simple way, become the incipient awareness of a whole new world of visual configurations and spatial relations—design, in short.

It is by no means only the natural world that can be freshly looked at in this way. Most of us live in towns and cities. Most of our lives are spent in an urban and industrial landscape. Much of it may be humanly appalling, but it will feel less so if we can begin to find its potential visual excitement, and for a photographer this element is almost limitless. Graffiti alone could provide days of picture-taking fun, especially if the graffiti is seen not as what it says, but as snatches of calligraphic shape and colour, against the textural background of rusting corrugated iron, old brick, or cracked concrete.

Something else to try, and this applies when looking at almost anything, is to search out unfamiliar angles. Look at a street from the top of a building, or look up from below. Simply tilt your head to look at an unfamiliar juxtaposition of walls. Or look at part of a truly hideous chemical plant only in terms of the shapes some of the pipes make. Just for a moment glance at the most apparently banal shop window as if you've never seen it before. Try to capture a child's head-on vision of a window full of sweets or cakes. Any of these perspectives can yield up the most suprising delight—and some excellent and unusual photographs.

If what you want is not simply an interesting photograph, but a photograph designed to become an integral part of a particular object, then questions of

The photographs on these pages each illustrate how interesting designs can be achieved when viewing ordinary scenes and objects from a different perspective.

angle, perspective, and scale become crucial. The photograph of the sweets used on the cabinet doors on page 114 and the cigarette-pack table top on page 115 are examples of successfully finding the right angles and scales for particular purposes. They were taken by amateur photographers who had developed an eye for design.

Learning to see design means being alert to the possibility of patterns even in the midst of ordinary scenes and objects. It is learning to see relationships between shapes, to think in terms of patterns rather than things. An interesting experiment might be to forget the names and functions of things, to look at them as if you were a visitor from another planet who had not only no preconceptions, but no conceptions, who was pleased, in a child-like fashion, by shapes and colours and the visual aspects of textures. Learning to see design is also learning, again, to play.

Create Illusions

Illusions created with photography can range from a source of hilarity to an imaginary, but refreshing, glimpse of fresh air. Whether you are working with the usual kind of *trompe l'oeil,* which involves an illusion of perspective or three-dimensionality, or are interested in some more esoteric effect like, for example, some of René Magritte's paintings, you will be working in the charmed, witty, and expandable area where fantasy and reality overlap and may be indistinguishable.

While care must be taken in the craft, there is almost endless room for imaginative play, for jokes, visual puns, dream-like apparitions and evocations of natural scenes you would like to see in reality but cannot. Cleverly done, a false window in your bedroom could open into the courtyards of the Alhambra, or a friend could reach for a photographic pear on a printed table. On the other hand, more sensibly, you could make a cramped, dark hallway appear to be spacious and light, or create the appearance of a garden (or at least a windowbox) in a dim corner where nothing could possibly grow. Successful photographic illusions are really all in the angles, and the clarity of the prints.

The table on the left, with its rich, warm, wood grain and welcoming plate of pears is, except for the two real pears at the side of the plate, entirely illusory. The illusion hinges on the quality of the print and the angle from which it was taken. The print was simply block mounted on a piece of board and set on a simple base.

The effective window on the right is a wonderfully appropriate touch on the natural brick wall of a staircase, and creates a real sense of space and airiness. The only artistry involved is care in making the frame and in choosing a photograph with the right perspective.

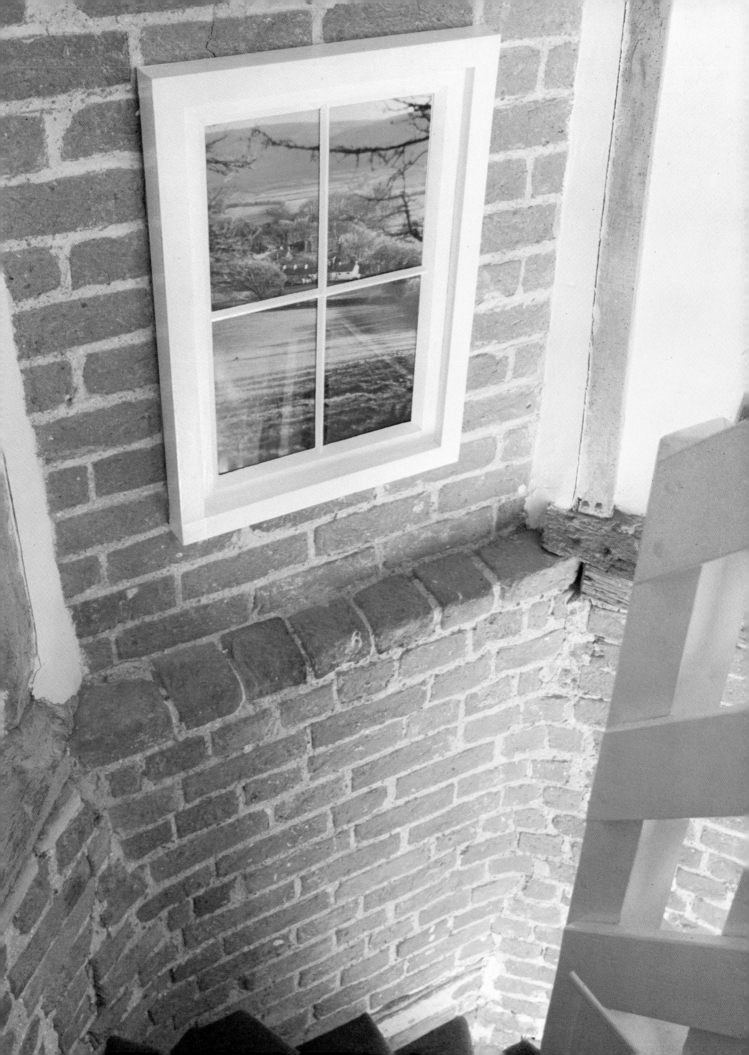

Create Illusions

The desire to create an apparently three-dimensional image on a two-dimensional surface goes at least as far back as classical Greece. Whether as a means of extending the limitations of the environment or as a practical joke to play on unsuspecting visitors, painters for centuries have created the illusions that sculpture, landscapes, figures, fruit, and flowers exist on flat walls, ceilings, and doors.

Using photography, the most naturalistically precise of media, the possibilities of *trompe l'oeil* for decorative purposes can be extended. You do not need the skills of a Renaissance painter to create an exact likeness of a person, place, or object. This is now within everyone's reach.

Nevertheless, some basic common sense points must be considered, even when using photography. For the illusion to work, the object or person in the photograph must be the same size and colour, and seen from the same angle, as they would be in real life. Consider whether the subject of the photograph would be seen, in that particular situation, from above, below, or from the front and take the photograph accordingly.

Obviously, no photograph will have a *trompe l'oeil* effect unless it is integrated, rather than set apart in a frame. The *trompe l'oeil* photograph must, therefore, be skillfully blended in with the rest of the room, the objects and furniture already there. Perhaps it will have to masquerade as a piece of furniture itself, like the table top with pears shown on page 118. The pears inevitably cause passers-by to do a double-take, and a real pear near the photographed ones adds to the confusion. The photograph was lit from one side, to create sculptural shadows, and taken from the angle at which the pears would be seen by someone sitting in an armchair near the table. Sometimes, to make an illusion more convincing, a prop has to be added. The window frame around the landscape print on page 119 helps to fool the eye. Look around your home and use your imagination to discover the way in which a photographic illusion can be incorporated. Look not only in rooms, but at staircases, blind corners, and even at doors.

Making a Window Frame

A false window, skillfully and carefully made, with the right photograph behind the frame, can be one of the most successful forms of *trompe l'oeil*. It can also serve the practical purpose of opening up a dull wall or claustrophobic space by creating the illusion that there is an expanse of beautiful countryside out there, instead of a town yard or cheerless blank wall.

The window on page 119 was made by putting a colour print in a wooden frame shaped like a window. The frame, which had to be as light as possible, was made from balsa wood, obtainable from craft shops, instead of ordinary wood. The window panes are acrylic rather than glass and the outer frame is hollow.

To create a successful illusion, the landscape was chosen judiciously. The photograph gives an impression of great space. The large expanse of foreground seems close to the viewer, and then the eye is taken to the middle distance, over the valley to the distant hills and sky. Even the branches in the top right-hand corner add to the illusion that there is a country scene just outside.

The sixteen- by twenty-inch (40- by 50-cm) colour print was made from a transparency. Even a very small window can create an effective illusion of space, however, so the print you use need not be enormous.

Equipment

To create a *trompe l'oeil* window, you will need: a suitable colour print; lengths of one-half-by-one-inch (1.25-by-2.50-cm) balsa wood for the inner frame (the exact measurement depends on the size of your prints); lengths of three-sixteenths by one-and-a-half-inch (4-mm-by-4-cm) balsa wood for the outer frame; lengths of triangular balsa wood, with two sides one-half-inch (1.25-cm) wide, for the bevelled edge of the inner frame; a piece of narrower triangular balsa wood for the window fittings; a sheet of acrylic; a piece of strong hardboard for the backing; moulding pins; a balsa knife; balsa glue; cellulose dope for sealing the wood; gloss emulsion, paint, or stain. To hang the window flush to the wall, maintaining the illusion, you will need sawtooth hangers or picture plates.

How to Do It

Begin by making the inner frame, fitting the lengths of one-half-by-one-inch (1.25-by-2.50-cm) balsa wood around the print and then gluing them together. The inner frame should fit snugly around the print, overlapping it slightly so that the borders are hidden. It is essential that this frame is absolutely accurate, since the rest of the window is built around it and any inaccuracy will distort the whole construction. Give the inner frame a bevelled edge by gluing on pieces of the triangular balsa wood with one-half-inch (1.25-cm) sides around the inside, next to the print.

Make the outer frame hollow, so it is light. Glue together lengths of the three-sixteenths - by - one - and - a - half - inch (4-mm-by-4-cm) balsa wood so that each side is a rectangular tube. Assemble the outer frame by fitting the sides around the inner frame.

Cut the two side pieces to the exact length of the inner frame. (Always cut a fraction longer than necessary and shave the excess away.) Then cut the top and bottom to length. Cover the hollow ends with squares of cardboard, glued on and painted white. Cut the ends a fraction

short so that the card does not stick out.

Assemble all the components— mounting board, print, acrylic, and inner frame.

Glue the inner and outer frames together.

Secure the hardboard in place with moulding pins.

Put in the window fittings, using the narrower length of triangular balsa wood. Cut them to roughly the right length, making them long rather than short, and shave down to the right size and angle. Glue in position.

As an optional finishing touch, a window handle can be added.

Cover the frame with cellulose dope to seal it.

Hanging the Window

To maintain the illusion of a real window, hang the frame flush to the wall using sawtooth hangers or picture plates (see page 28).

Colour Posterization

To produce a colour posterization print, three black and white tone separations are made from a suitable negative, as described on page 101. Each separation is printed through a filter of a different colour—red, blue, and green—on one sheet of colour printing paper. Either negative or positive separations can be used and the colours may be printed in any order. Test strips should be made for each filter.

As with black and white prints, correct registration is vital. The paper also must be protected from light between every filter change. A simple folder can cover the paper and also serve as a registration device. Make the folder from two pieces of card slightly larger than

the printing paper, joined along one edge with tape. Fasten it to the enlarger baseboard with double-

sided tape. Place a sheet of colour printing paper inside the folder, secured with small squares of double-sided tape.

Close the folder and project the first separation on it. Trace around

the important details. Open the folder and expose the negative on the paper, through one of the colour filters. Close the folder.

Register the second separation on the tracing, then open the folder and

expose, using another filter. Repeat with the third separation. Do not alter the enlarger focussing controls between separations.

A variation on this technique is to print each separation on a separate sheet of transparency film, using a different filter for each sheet. When the transparencies have been processed, bind them in register, place them in the negative carrier of the enlarger, print on colour paper and process in the usual way.

Big, Big Pictures

To those people whose idea of photography has been confined to the snapshot or, at most, to ordinary enlargements, the decorative possibilities inherent in the idea of giant enlargements may come as something of a surprise. But as a source of bold dramatic accents, vigorous and inventive changes, and reflections of the exuberant explosions of newly confident sensibility, huge blow-ups are almost unbeatable. Finding the courage to use giant enlargements is like suddenly being able to shout for the sheer pleasure of it, or sing at the top of your lungs. There is the story of the eighty-year-old lady who decided she had to go to the Arabian desert and ride a camel; it was something she had wanted to do all her life. She did it, and for the occasion wore a straw hat, the ribbon around the crown embroidered with the words *"Pourquoi pas?"* (Why not?)

In the same adventurous spirit, why not turn one of your favourite nature photographs into a room divider or a screen? Why not have life-size photographs of your children on the doors of their rooms? Why not open one wall into another world with a photomural?

Not only are the photographs of the youngsters on the bedroom doors on the left charming in themselves, but they will provide a continual source of interest to the children as they compare their growing and changing selves to the photographs. And since children have such powerful territorial instincts, the big pictures keep everything perfectly clear.

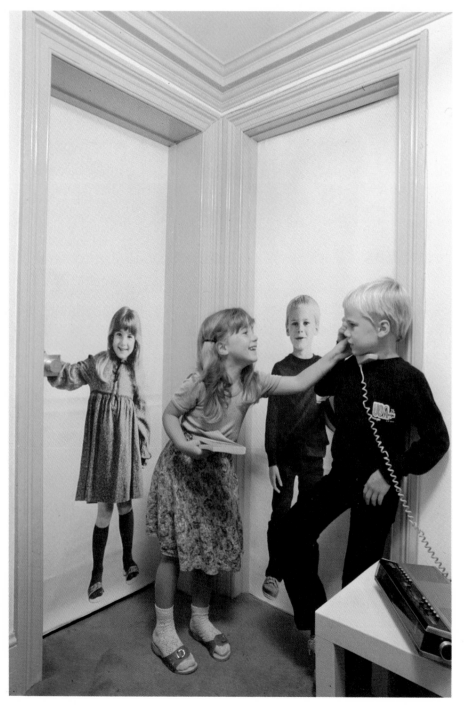

The screen on the right is a giant enlargement, printed in sections on opal film, of a felicitous but ordinary photograph. As a screen the picture really comes into its own, not only lovely in itself, but acting as a dramatic accent in the room and serving a practical purpose as well.

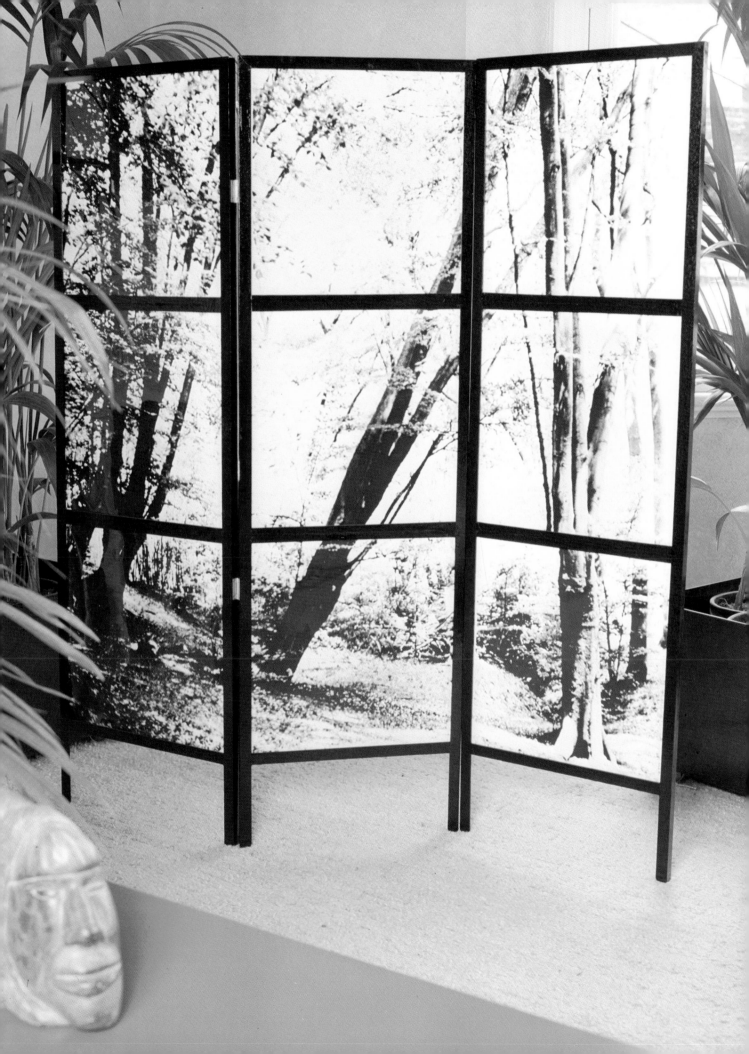

Making Giant Enlargements

A black and white photograph can be strikingly altered when it is enlarged to a height of several meters. Such enlargement can bring out unexpected detail and emphasize qualities which went unnoticed in a conventional print. Giant enlargements can be used in many ways in photo decor—on doors, room dividers, screens, and as photomurals. Because the image is observed from a point closer than the true distance, the picture seems to surround the viewer. Considering the effects giant enlargements can have, it is clear that they can be used to dramatically alter the mood of any rooms in which they hang.

Giant enlargements are not difficult to make for anyone accustomed to working with prints of up to sixteen by twenty inches (40 by 50 cm). The most common problem is developing and fixing the print in the average small home darkroom.

No special equipment needs to be bought. The enlarger head, however, must be capable of swinging around on its column so that it can project on the floor or a wall. It is imperative to have an absolutely spotless negative, since any marks will be proportionally enlarged. A dust-off aerosol or even the type of anti-static gun used by hi-fi enthusiasts would be a big help.

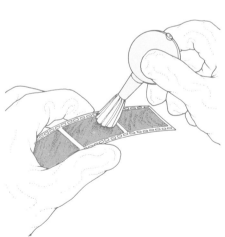

Sheets of bromide paper can be taped together and used for the giant print, but rolls of paper and Photo Linen (see page 80) are available which are up to fifty-one inches (1.25 m) wide.

The negative must be absolutely

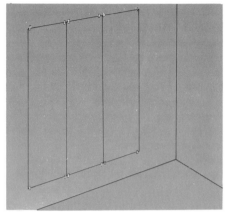

sharp, with detail in both the highlight areas and the shadows, and no dense areas of thick black. Remember that photographs taken on fast film will be grainier than those taken on slow film. This can produce interesting results, but it depends what effect you want. The projected image tends to become dimmer as it gets larger, so use bromide paper one or two grades harder than usual to compensate for any lack of contrast.

The enlarger will have to be adjusted for making the giant enlargements. Depending on the height of the enlarger column, it is possible to make prints of different sizes. For a really large print, however, swing the enlarger head around on its column through 180 degrees to project on the wall. Weight

the base with heavy objects so it is absolutely steady. With a very long projection throw, it is important to reduce the chances of vibration, or the print will suffer. The axis of the enlarger head must be at right angles to the surface of the paper and the enlarging lens, condenser, and negative carrier must all be spotless.

How to Make the Print

Project the negative on a white wall or on a sheet of ordinary white paper fastened to the wall.

Focus the image, checking the focus in several places. Mark the edges of the picture on the wall or paper. Switch off the enlarger.

Make a test strip by pinning a strip of bromide paper about five inches (12 cm) wide across the paper. It should be long enough to stretch from one side to the other and should be placed across a

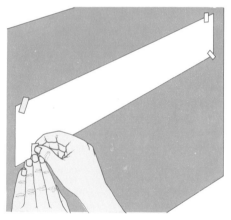

part of the picture which has a good range of tones. Stop down two click stops on the enlarger.

Make the test strip as explained on page 134, but in sections about three inches (7.50 cm) wide, using exposures of three minutes. Take from eight to ten stages so that the test strip shows exposures ranging from three to twenty-four minutes. (Prints of five by three feet—1.50 m by 90 cm—may need the longest time.) To prevent aching arms, the masking card can be taped in place. To make the print, fasten the bromide paper to the wall, either in one large sheet or in a mosaic of small sheets, slightly overlapped, or in long strips. Expose as described on page 134.

124

Processing the Giant Print

The print can be processed either by using sponges or by immersing the print in specially constructed tanks.

When using sponges, cover the work surface with a strong plastic sheet. Lay out a dish of developer, one of stop bath, and one of fixer, with a sponge for each dish. Lay the print face up on the plastic and liberally swab the surface with a sponge soaked in developer. Work down from left to right and make sure the whole surface is generously covered. Watch for full and even development over the entire print.

Clean away the developer with a clean sponge soaked in stop bath. Apply the fixer with the third sponge. Wash the print with a sponge soaked in water, then transfer it to the bathtub for a final wash in running water, lasting about forty-five minutes.

Developing with sponges is rather messy so if many giant prints are projected, it may be worthwhile to construct a simple three-stage tub from timber and heavy gauge plastic sheeting. Make the frame a little longer than the width of the paper. The one illustrated here was made from lengths of six-by-one-inch (15-by-2.50 cm) timber, nailed together and will take a print four feet (1.2 m) wide.

Spread a large sheet of heavy gauge plastic sheeting over the top of the frame, tuck it into the three wells and fold it over the sides. Use upholsterer's tape to secure the sides and staple firmly.

The three wells will act as tanks. Use the central well for water and the outer ones for developer and fixer.

The necessarily large volume of chemicals will make the tank quite heavy, so it may be best to place it on the floor, rather than overloading the worktop.

When processing, roll and unroll the print into each solution in turn, wetting the entire surface. Then transfer the print to the household bathtub and wash it in running water. Dry the print by pegging it on a clothesline above the bathtub. The tanks will be too heavy to allow the solutions to be tipped out, so ladle them into a bucket.

Opal Film

Opal film is a material which looks opaque when lit from the front, but is translucent when a light shines through from the back. A print made on opal film combines the qualities of a glossy bromide print and a transparency, and can be used as whichever you want, depending on the lighting.

When an ordinary transparency is backlit, the light must be diffused in some way, usually with a ground glass screen. This is not necessary with opal film. The base contains a white pigment which makes the film opalescent when backlit and automatically diffuses the light.

Opal film, which is .008-inch (.002 cm) thick, is coated with normal contrast bromide emulsion. This is the only grade available, but the contrast is slightly increased when the print is lit from behind.

The film is available in sheets or rolls. It is printed and processed in exactly the same way as bromide paper. The print usually takes one and a half to two minutes to develop fully and it is best to use a stop bath immediately afterwards. If the print is going to be coloured, do not add hardener to the fixing bath because the gelatine will not absorb the dyes.

After rinsing, the sheets should be clipped to a washing line and air dried. Opal film dries quickly to an oyster shell gloss. It is unnecessary to glaze it.

Opal film can be hand coloured, either directly on the emulsion or on the back, which is matt. Albumen dyes are recommended for this purpose. Moisten the surface of the film with distilled water until it is slightly tacky; this will allow the colour to spread more evenly. A retouching light box makes this job easier.

If opal film is coloured on the back, an interesting effect can be achieved. When lit from the front, the print will look like a glossy black and white print, but when it is transilluminated the colours will spring to life.

The film may expand slightly in warm temperatures, so allow for this when mounting. Attach only on two sides, either top and bottom or left and right. Then the screen will, as it were, have enough room to breathe.

Techniques and Technical Tips

To display photographs most effectively it is often necessary to alter the prints. Sometimes they must be copied, enlarged, vignetted, or retouched and in some cases they have to be printed on surfaces other than paper. All of this can be done by commercial photographic laboratories, but it is often faster, cheaper, and far more satisfying to do these jobs yourself at home.

The idea of home processing may seem time-consuming, complicated, and altogether daunting. While it is true that some things, such as processing colour film, may be more easily done commercially, a surprisingly wide range of effects can be easily achieved with simple and basic equipment, set up in a corner of a room.

In the following pages you will learn how to set up a simple home darkroom, either permanent or temporary, how to make black and white and colour prints and how to copy old photographs so new prints can be made. The characteristics of different copying films and photographic papers are explained, to enable you to choose those best suited to particular projects. There is, too, all the necessary information on the best ways to protect and store negatives and slides.

This section provides you with a generous basic foundation of darkroom knowledge, which will enable you to explore many exciting photographic possibilities and to carry out not only the projects in this book, but others that may grow out of them.

The Home Darkroom

Home processing makes it possible to experiment with printing techniques and gives greater scope for the creative use of negatives than having them commercially printed and developed. Despite the aura of mystery with which printing and developing are frequently surrounded, these processes are quite simple, and fun, to undertake at home and require only a minimum of facilities and equipment.

The first requirement for home processing is a darkroom, which simply means an area that is lightproof, well-

ventilated, and has adequate electrical facilities and work surfaces. Running water is a great advantage, although a large receptacle will suffice, or the prints can be washed elsewhere. Most important, all the equipment used should be efficient and conveniently arranged.

Ideally, a darkroom should be a permanent and specially built room. There are many photography books available which give information about creating such a room. But the corner of any room that can be made lightproof can be set up as a permanent "dark-

room." A bathroom makes an excellent temporary darkroom and it has the advantage of running water and a large container—the bathtub—for washing prints.

A thick black curtain hung over a door will make it lightproof. For a permanent installation, strips of heavy black felt can be put along the door's top edge and opening jamb, and strips of black plastic, about six inches (15 cm) wide, can be used to seal the hinged edge. A keyhole can be blocked with putty and, when you are inside, a small

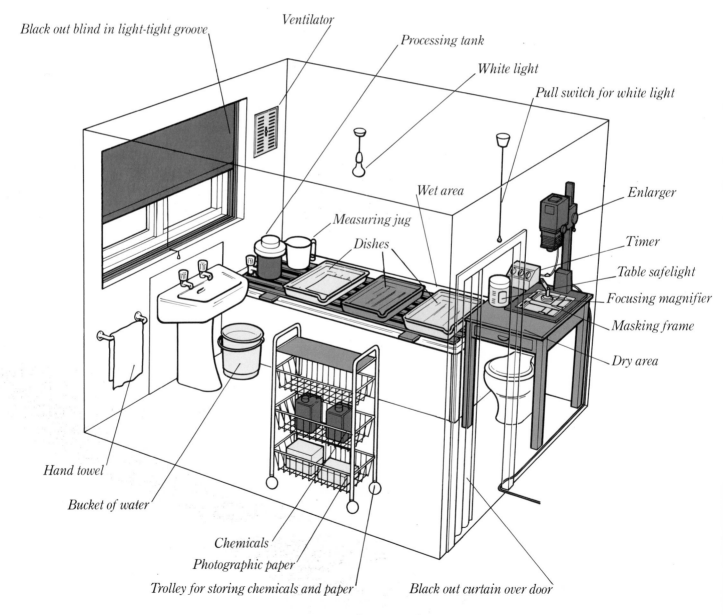

Black out blind in light-tight groove

Ventilator

Processing tank

White light

Pull switch for white light

Wet area

Enlarger

Measuring jug

Timer

Dishes

Table safelight

Focusing magnifier

Masking frame

Dry area

Hand towel

Bucket of water

Chemicals

Photographic paper

Trolley for storing chemicals and paper

Black out curtain over door

rug can be pushed against the bottom edge of the door.

The room should, ideally, be painted a light tone since it helps the safelight to give greater illumination. The area around the enlarger should be dark.

Ventilation is a top priority because so many chemicals are used in processing. It may, therefore, be worth installing a light-baffled extractor fan in or near the area where processing will be done.

Electrical installations in the darkroom should be simple and as far as possible from the wet bench where water and chemicals are used. Three, preferably four, light sockets are needed for the enlarger, safelight, and room, or white, light. It should be possible to switch each piece of equipment on and off independently, preferably with pull switches on long cords.

It is important to have a supply of water nearby for rinsing prints and hands after processing. If running water is not available, use a large receptacle to transport prints to the area where they will be washed, and for rinsing hands so that the prints are not stained by chemicals when they are handled. Always keep a roll of paper towels nearby.

The darkroom is organized into two main areas—the wet area and the dry area. These should be kept separate, yet close enough for prints to be easily transferred from one area to the other.

The dry area is where the enlarger, masking frame, contact printer, enlarging timer or switch, photographic paper, and other dry goods are used. Paper should be stored in drawers or on shelves within easy reach of the enlarger. Tools, too, should be within reach.

The processing dishes, washing tanks, and solutions are used in the wet area. Any solutions which are made up are stored here. In this area the work surface should be waterproof and easy to wipe clean and dry. A work top of a plastic laminate or rectangular steel trays large enough to hold all the dishes are most practical.

The Equipment

The enlarger, which is similar to a slide projector, enables negatives, or details from them, to be blown up to different sizes. It also makes it possible to achieve many special effects. When buying an enlarger, consider what negative formats it can take, whether it can be adapted for colour printing, how big its maximum enlargements can be, and whether it can be adapted to make giant prints. Be sure that spare parts are readily available and that the enlarger can take a range of lens mounts or a copying cassette, if required. If printing is done in a small or temporary space the enlarger should be easy to dismantle and to store. It should be guaranteed against overheating, even after prolonged use, and have minimum light spillage. Of course, a good lens is of vital importance.

The safelight is the darkroom illumination to which the photographic emulsions being handled are insensitive. Safelights are available in wall-mounted and table models. Some have interchangeable filters since different colours are needed for different papers. The safelight should illuminate both wet and dry areas. Indirect lighting which reflects off the walls and ceilings is best. The simplest safelight is just an orange dyed, 25-watt light bulb or a red bicycle bulb. A safelight with a special screen is needed for colour printing.

The masking frame holds the paper flat during exposure. The simplest way to keep the paper flat is to use magnetic corners on a flat surface. A borderless easel with a slightly tacky surface to hold the paper steady is commercially available. Most people use a masking frame with hinged flaps which can be adjusted to take different print sizes and which has the advantage that it can produce borders on prints. When buying a masking frame choose a model which will take the largest print you are likely to make.

The focusing magnifier is a small piece of equipment which is used to accurately check the focus of the projected image.

The contact printing frame has grooves which hold the strips of film in place and in contact with the printing paper when contact prints are being made. A large piece of glass can be used instead of a frame.

A washing tank which attaches to a tap holds the prints when they are being washed. It prevents them from sticking together and circulates the water automatically. Models are available which take up little space and complete the wash in about twenty minutes.

A glazer is an optional piece of equipment which dries and glazes a print, improving the tonal contrast by making it shiny. A flatbed glazer has a cloth lid which holds the print tightly in contact with the glazing sheet. A rotary glazer is faster and more efficient; wet prints are fed in one end and come out the other dried and glazed. A squeegee and a clean, polished surface—glass or a chromium-plate glazing sheet—can also be used effectively. Glazing is not necessary for prints made on resin-coated paper which is already shiny.

Chemicals are usually purchased in powder form or in concentrated solutions. Processing chemicals should be diluted according to the manufacturer's instructions before beginning to print. While printing it is desirable to keep chemicals at about 69°F (20°C).

Various developers are available; the choice depends on the grain and contrast desired. The stop bath halts development immediately and the fixer fixes the image and hardens the emulsion. The wetting agent helps to prevent water marks forming on the paper. A reducer is used to bleach overexposed prints. Washed prints are soaked in a solution of hypo-eliminator to clean the fixer from them. All chemicals come with manufacturer's instructions and these should be followed exactly.

Dishes, made of plastic or stainless steel, are needed to hold the developer, stop bath, and fixer. To economize on chemicals, use small dishes for small prints. Plastic dishes are available in sets of three, each dish a different colour to distinguish the different chemicals. Dishes should be rigid, with grooved bases to prevent the prints from sticking and to permit solutions to circulate.

Other equipment needed includes a print forceps or tongs, a photographic thermometer with which to check the temperature of solutions, and, for cleaning negatives, a "dust off" aerosol, puffer brush, or anti-static gun. Additional equipment is necessary for colour printing. This is explained on page 136.

Copying Photographs

When producing a print to mount and frame, or when using various photographic techniques, it may be necessary to copy the original photograph by making a copy negative. This is not a complex procedure, as long as a few simple rules are followed when setting up the camera and lights.

A vertical copying stand is ideal, but a tripod and desk lamps can be used almost as effectively.

The camera should be one that is familiar, and can be anything from a four-by-five-inch (10-by-12-cm) monorail to a TTL metering 35 mm. If a 35 mm camera is being used, it should ideally be fitted with either a macro lens, supplementary close-up lens, extension tubes, or bellows.

Place the print which is to be copied flat and square to the camera. The camera should be trued up with the centre of the print, at right angles to it. Place the lights about three feet (90 cm) away from the print, at an angle of 45 degrees.

The light should be evenly distributed across the surface of the print. To test this, hold a pencil upright in the centre

of the enlarger baseboard or of the print being copied and be sure that the shadows on either side of the pencil are the same length and tone. The two shadows should make a straight line from end to end.

Focus the image through the viewfinder and check that the edges of the print are parallel with the sides of the viewing screen.

Place a Kodak 18 per cent reflectance card or a mid-grey card over the subject and set the exposure with the TTL metering system of the camera or with a separate exposure meter.

Remove the card and make the exposure. It is a wise precaution to make two extra exposures, one which is one stop over the exposure indicated and one which is one stop under. If bellows or extension tubes and a separate exposure meter are being used, remember to make allowance for the extension when exposing. This is, of course, unnecessary when using supplementary lenses.

A medium speed film, such as FP4 or Plus X, is adequate for copying a continuous tone original in this way. If the original is soft or flat, it is a good idea to use slightly stronger developer and a rather longer development time. The actual strength of the developer needed can be found by experimenting, but, as a guide, start by reducing dilution and increasing development time by about one-fifth. Special copying films, for creating different effects, are described on page 132.

When copying with a non-reflex camera, such as a twin lens reflex, the problem of parallax arises. With such a camera, the lens and viewfinder are separated so that the picture seen through the viewfinder is different from that seen by the lens. The problem is particularly acute when working in close up.

There is a simple method of correcting parallax. Set the camera up either on a stand or on a tripod ready for copying. Before loading it with film, open the back of the camera and tape a piece of tracing paper to the film path. Open the shutter on its B setting, using a locking

cable release to prevent it from closing. By shading the tracing paper from the light, it will be possible to see the image cast by the lens.

On another, larger, piece of tracing paper, draw diagonals from corner to corner with a black, felt-tip pen and tape the paper to the copy-stand baseboard. Look at the image on the tracing paper in the film path and move the camera until the diagonals are centred.

Take another large sheet of tracing paper, on which the diagonals have also been drawn. Look through the

camera viewfinder and move the tracing paper until the diagonals are centred.

Then tape the tracing paper to the baseboard along one edge.

The two sheets of tracing paper now show the relative positions of the images seen by the camera lens and the viewfinder.

Remove the tracing paper from the camera and load with film. Close the shutter by unlocking the cable release. Place the picture which is to be copied under the sheet of tracing paper representing the images seen through the

viewfinder. Centre it, using the diagonals as a guide. Look through the viewfinder and focus. If there is no means of focusing through the viewfinder, it will be necessary to measure the distance from the film plane to the copy and set the distance on the camera's focusing scale.

Move the original to the other sheet of tracing paper and centre it, again using the diagonals. Make the exposure, using a cable release.

When a shiny surface or an original mounted under glass is being copied, it is possible that the camera may be reflected in the picture and show up in the final print. This is most apt to happen if the original has large areas of dark colour or tone and the camera has chrome fittings. It can be overcome by screening the camera and tripod from the original with a large sheet of black card. A hole should be cut in the card, just large enough to allow the camera lens to look through. It may be sufficient, however, to stick matt black adhesive tape over the shiny parts of the camera.

Other reflections may be caused by light areas behind the camera; these should be covered with dark material. You must also, of course, take precautions to prevent your own reflection from appearing in the final copy.

Colour Copying

When making colour copies, it is important either to use the right film for the lighting conditions, or to attach a conversion filter so that daylight film can be used in tungsten lighting. If the original being copied is lit by ordinary photolamps, an 80B filter is required. If 150-watt household bulbs are being used, filtration needs to be increased to a stronger blue, such as that obtained with a combination of 80A and 82A filters.

When photographing through filters, exposure needs to be increased by the length of time indicated on the filter itself or in the instructions. The leaflet accompanying the film also provides information on the filters required in different lighting conditions.

When making copies in colour on either transparency or negative film, it is a good idea to bracket exposures one or two stops in each direction (see page 137). This will give different examples of exposure and colour rendition from which the best can be chosen. If colour negative film is being used, colour patches can be included in the picture area and used as reference when making the final print. Standard colour patches are available from most photographic shops.

Copying Film

As opposed to the film which is used for actually taking pictures, copying film can be used with existing negatives or transparencies, either to create special effects or to copy photographs in larger formats. The negative or transparency is simply placed in the negative carrier of the enlarger and enlarged on the sheet film in the same way as on bromide paper. Some copying film is also available in rolls and can be used in the camera for copying prints (see page 130). Colour transparencies, as well as black and white negatives and transparencies, can be enlarged on copying film, to produce black and white negatives.

Film used for copying monochrome originals are unusually slow, with a fine grain and, being sensitive only to blue light, can be processed under an orange safelight. For copying colour originals, panchromatic film should be used. It is sensitive to all colours and must be developed either in total darkness or under a dark green safelight.

There are two main types of copying film—normal contrast, which reproduces the full range of tones in a photograph, and high contrast (also called line film), which reproduces only the blacks and whites, eliminating the greys. High contrast film must be processed in a special high contrast developer.

Black and White Film

Lith film is an extremely high contrast film, especially when used in conjunction with developers containing formaldehyde. It is produced mainly for the lithographic printing trade, but because it is capable of producing sharp and contrasty images, it is useful for derivative work, such as solarization, when strong graphic effects are desired. Instructions for its use are given on page 37.

Microfilm is a high contrast film with strong definition and very fine grain. It is extremely slow—surpassing the slowest of normal films—and can repro-

duce very fine detail. It is mainly used in the camera for copying from diagrams or books, where there is detail, but no half tones. Most types of microfilm are sensitive only to blue light although it is possible to obtain panchromatic versions. A special developer is needed.

Black and white reversal film is used to make black and white transparencies from negatives. Most black and white film can be specially processed with a reversal processing kit to produce positives instead of negatives. As fine grain is important here, negatives on slow film produce better results. Reversal processing requires careful control of exposure and temperature and it is often easier to have the film developed commercially. Transparencies made on reversal film will have a richer range of tones than those made on print film, although the photograph must have been correctly exposed to begin with.

Autoscreen is the name for a lith film which has a fine screen built into it, enabling it to reproduce half-tones. It produces an image composed of very

small dots, like the photographs reproduced in newspapers. The size of the dots in the final print naturally depends on the degree of enlargement. Autoscreen is often used with a photo silkscreen (page 88) when a half-tone image is desired. It is processed in lith developer.

Print film is used to make transparencies from existing negatives. Monochromatic print film is usually blue sensitive and can be handled in an ordinary yellow safelight. It contains an emulsion, similar to that used on bromide paper, on a transparent base and is processed in normal film developer. It should not be confused with the material used for making large colour transparencies from colour negatives.

Stripping film is a lith film which contains an extra layer of gelatin under the emulsion. When the film is immersed in warm water, the gelatin softens and the image floats off like a transfer and can be applied to such objects as mugs or plates. It will not survive rough handling, so the objects are best kept for display.

Film for Special Colour Effects

Agfa contour film is a black and white film which can be exposed on colour paper, through different colour filters, to give a striking, poster-like effect. It is usually used for scientific and technical purposes, such as aerial photography, but the manufacturer produces a booklet giving details on how to use it creatively.

When a negative or transparency is exposed on a sheet of Agfa contour film, areas of equal density are transformed into outlines. The width of this line can be controlled by filtration, using the yellow range from a colour printing set. The tones which will be affected are decided by the exposure time. A short exposure time produces a line effect in the light areas of the photograph, a long exposure in the darker areas.

Photographic Paper

After producing a good black and white negative, the next step is to print it on suitable paper.

Photographic printing paper is coated with a light-sensitive emulsion, rather like film, but slower and more fine grained. Its colour sensitivity is confined to the blue end of the spectrum, so it can be used without difficulty in a home darkroom which will usually be lit with a red or amber safelight.

Most papers, whether they are white, coloured, resin-coated, or translucent are coated with halides of silver bromide, and are, therefore, referred to as bromide papers. Most types come in a range of grades, or degrees, of contrast. Bear in mind that paper should be stored well away from moisture, fumes, and heat. In cool, dry conditions it will stay fresh for two or three years.

A wide range of paper is available. The two main types are paper-base and resin-coated. The paper-base has a coat of baryta (barium oxide or hydroxide) under the emulsion which makes it highly reflective and gives bright highlights. White, cream, and ivory are most popular, but other colours are available.

Resin-coated paper has many advantages over the paper-base kind. The coating—actually a polyethylene plastic—makes the paper waterproof, so it does not absorb the processing chemicals. Washing is easier and faster, you are less likely to contaminate the stop-bath with carryover from the developing tray, and because there is less carry-over the chemicals will last longer. The amount of stretch is minimal during processing and washing, which makes resin-coated paper useful for accurate work. When dried in a current of air, resin-coated papers do not curl.

Paper is available in a variety of thicknesses or weights. The most popular types are single and double weight. Single weight paper, is easy to wash and glaze, but it tends to crease easily when used for large prints. Double weight paper, which is like thin card, is better for prints which are more than sixteen by twenty inches (40 by 50 cm). Resin-coated paper is usually between the two.

The emulsion surface of photographic paper varies and many different textures are available. They range from glossy to matt. A glossy finish is best for fine detail and gives the richest blacks, characteristics further emphasized by glazing. Glossy paper reflects light all in one direction, however, so take care when viewing to avoid the mirror-like "hot spot" that may develop from this concentration of light.

A matt surface gives softer effects, but will not produce a rich deep black because the surface reflects some light in all directions. There are various degrees of matt and glossy finishes. Lustre, for example, is between them.

Three types of emulsion—bromide, chloride, and chlorobromide—are used on photographic papers. Bromide gives an extremely rich black and is the most popular paper for enlarging. Chloro-bromide is slower than bromide, warmer in tone, and can produce a brownish-black colour very effective with images rich in shadow detail, or with certain kinds of portraits. There is some room for experimentation with type and degree of development, both with bromide and chlorobromide papers. These factors will affect the image colour, and some deliberate variations can be interesting. Chloride emulsion is used for contact paper.

Grades of paper range from very soft to extra hard, indicating the degree of tonal contrast which can be obtained when printing. The same negative can be high contrast when printed on a hard paper and have more gradual tonal transitions when printed on a soft paper. The grades are numbered from 0, the softest, to 4 or 5, the hardest. Grade 2 is best for general work. Different manufacturers number their grades differently so grade 3 in one range is not necessarily the same as grade 3 in another. A multi-grade, or polycontrast, paper, with which the contrast can be controlled by using different colour filters, is also available.

Most photographic paper should be handled under an amber safelight. Graphic arts papers, such as lith, are orthochromatic, which means they are sensitive to all colours except red, and need a red safelight. Lith paper is very high contrast, and reduces continuous tone negatives to straightforward black and white. It must be developed with special lith developer. It is usually used either for printing from thin, under-developed negatives, or to prepare photographs for offset printing. Panchromatic papers, sensitive to all colours and used to print black and white from colour negatives, are best handled in a dark green light or in complete darkness.

Paper for colour printing is available in a limited range and often only resin-coated. The paper is usually white, the grade medium, and the choice of surfaces is somewhat restricted. Most manufacturers produce paper specifically suited to their film, so it is best to be consistent.

When buying photographic paper for the first time, it is advisable to choose a medium grade for general work. Experiment a bit at the beginning to find the paper grade and surface that suits your method of work. The confidence to choose different or unusual papers for special effects will come with experience.

Making Black and White Prints

There are basically two kinds of print, the contact print, which is the same size as the negative, and the enlargement. The contact print is made by placing the negative on the printing paper and exposing it. Contact printing a whole film on one sheet of paper makes it possible to see at once which negatives are worth enlarging. The contact sheet can be filed with the negatives for future reference. The enlargement is made by placing the negative in the enlarger and projecting it on the paper.

Making a Test Strip

Before making a print, it is necessary to discover the exposure time needed for each particular negative. This is done by exposing sections of a strip of bromide paper for different lengths of time and deciding which exposure is best.

Focus the image from the negative on the masking frame and, with the red filter over the lens, place a strip of bromide paper over a representative selection of tones. For the fullest possible information, a whole sheet of paper can be used, but it is more economical, and usually just as effective, to use about one-third of a sheet; most negatives will provide enough information within this area.

Cover all but one-fifth of the strip with a piece of black card.

Switch on the enlarger light and expose for five seconds.

Move the card and expose an additional one-fifth of the strip for another five seconds. Continue in this way until the whole strip has been exposed in sections of five, ten, fifteen, twenty, and twenty-five seconds. The first section will have been exposed for twenty-five seconds and the last for five.

After processing and fixing the test strip, switch on the white light and study the strip to assess which of the exposure times is best.

When the best exposure seems to come between two bands, it is worth making a further test in two-second stages. If all the exposures are too dark, stop the lens down by two f-stops and make another test strip, still using five-second intervals. If the exposures are all too light, the lens should be opened up or the exposure times increased.

When the degree of enlargement or the grade of paper is changed, the exposure will be affected. A new test strip should, therefore, be made.

Contact Printing

The only special equipment needed is a contact printing frame, but a sheet of glass can be a quite adequate substitute. Clean the glass or the frame before use.

Clean the negatives on the non-emulsion side. The nonemulsion side is shiny, while the emulsion side has a flat, dull appearance.

Place the frame or sheet of glass on the enlarger baseboard. Be sure that the light from the enlarger overlaps the edge. Stop down the enlarger by two stops from wide open.

When using a contact-printing frame, place the negatives in the frame with the nonemulsion side facing the glass. Be sure the pictures are all the same way up. Place a strip of photographic paper over the negatives, emulsion to emulsion, and close the frame.

If a sheet of glass is being used, place the bromide paper emulsion side up on

the enlarger baseboard and the negatives emulsion side down on the paper. Then place the glass on top of both negatives and paper.

Make a test strip, then place a whole sheet of paper in the frame.

Expose the print by switching on the enlarger light for the length of time decided from the test strip. Process and wash the print.

When the print has dried, examine the contacts under a magnifying glass, marking the best ones with a china-graph pencil for later enlargement. File the contacts with the negatives for future reference.

When negatives on the same film are of different densities, they will require different exposure times. The obvious problems this can cause when contact printing can, to some extent, be overcome by grouping the thinner negatives together and shielding them from the light for part of the exposure time. The

difference in exposure should be noted for future reference.

Contact prints can be made from prints on single weight paper as well as from negatives. They will produce softer images which sometimes reveal the texture of the paper. Of course, the first contact print will come out as a negative and a second print will have to be taken from it to produce a positive.

Enlarging

To make an enlargement, place the negative in the negative carrier of the enlarger, emulsion side down and with the top end towards you so that the image can be seen the right way up. Replace the carrier in the enlarger.

Adjust the masking frame to the size of the print being made and switch on the enlarger light to see the image.

Raise or lower the enlarger head to obtain the degree of enlargement required.

Open the enlarger lens diaphragm to its largest aperture and focus the image. Focusing is easiest if a sheet of the paper which is going to be used and has already been developed is placed in the masking frame. Then, using a focusing magnifier, close down the lens to mid-aperture and focus on the grain of the negative.

Make a test strip and set the selected time on the timer.

In safelighting, place a sheet of printing paper in the masking frame. The image can be checked by switching on the enlarger light, with the red filter over it.

Developing the Print
Develop the print by sliding it quickly into the dish of developer. Be sure it is completely submerged. Rock the dish gently so that fresh developer reaches the entire surface of the print. A correctly exposed print should be fully developed in two minutes.

Using print tongs, transfer the print to the stop bath. Do not permit the tongs to touch the stop solution. A fifteen-second immersion, rocking the dish, should be sufficient.

Using a second pair of tongs, transfer the print to the fixing bath and rock the dish gently for thirty seconds. After about two minutes, it should be safe to turn on the room light and look at the print.

Washing
Wash the print thoroughly in running water in a print washer or in a sink, changing the water frequently and separating the prints from each other every few minutes. Wash prints on paper-base paper for about thirty minutes. Those on resin-coated paper need only about ten minutes washing.

A hypo-eliminator used between fixing and washing can shorten the washing time. It is important to wash for the length of time appropriate to the paper used, otherwise the prints may bleach or stain later.

Drying and Glazing
Dry the prints by blotting off surplus water from both sides and hanging them up to dry. Bromide prints can be glazed at the same time as they are dried. This helps to bring out the detail and to heighten tonal contrast. Prints on a resin-coated paper dry to a high natural gloss. They should be dried in a current of warm air and should not be glazed.

To glaze a print, squeegee it down on a clean, polished surface, such as glass or a chromium-plated glazing sheet, and leave it to dry. Soaking the print in glazing solution for five minutes beforehand helps to prevent air bubbles. Flatbed or rotary glazers are commercially available and easy to use.

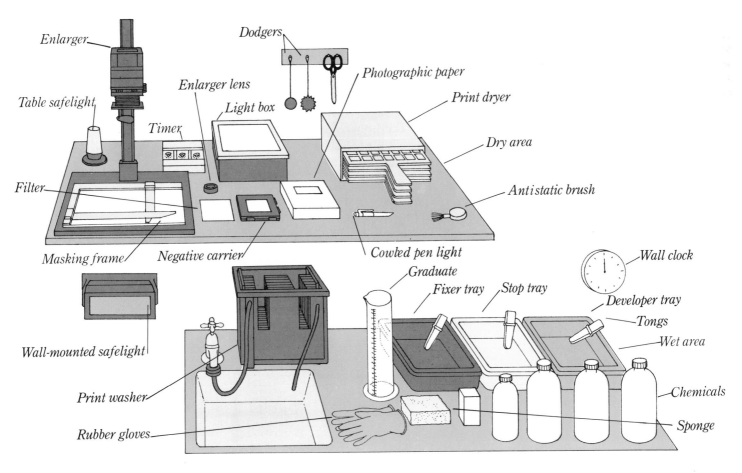

Making Colour Prints

Although colour printing demands a higher standard of processing than black and white work, modern processing methods have made it possible to achieve excellent results even in a makeshift home darkroom. The making of colour prints is, however, more expensive and time-consuming than monochrome printing and greater care is needed in handling and processing the print. Particular care must be taken when mixing and using colour chemicals. Dangerous and often toxic, they should always be mixed in a well-ventilated room, and the darkroom itself must also have good ventilation. Always wear rubber gloves when using colour chemicals.

There are two methods of colour printing, the subtractive system, and the less common additive method. Most home enlargers now available are fitted with colour heads that make the subtractive system the almost universal choice for use in a home darkroom. A black and white enlarger can either be fitted with a colour head or a filter drawer, which fits under the lens, and a selection of filters can be used. When using a filter drawer, however, a heat filter should be placed above it.

There is also the option of printing in colour directly from negatives or from transparencies, which involves printing internegatives. There is much more exposure latitude when printing from a negative than when printing from a transparency, which requires extremely accurate exposure when the picture is being taken.

Additional Darkroom Equipment

A darkroom that has been organized to produce black and white prints is relatively easy to convert for colour processing. The following checklist includes all the necessary additional equipment.

The enlarger requires a colour head or a filter drawer. For additive printing you can mount the three necessary filters below the lens on a rotating disc. It may be advisable to paint the enlarger baseboard with matt black and to remove the red filter that is used for monochrome processing. The lens on your enlarger should be the best you

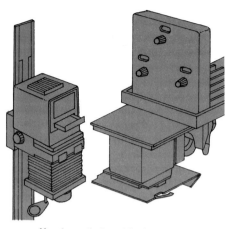

can afford, and should always be kept immaculately clean.

Filters for colour printing (if a dial-in colour head is not being used) are made in a series of progressive densities to compensate for variations in negatives, light sources, and printing paper characteristics. A set covering 100 cc on the Durst scale should be sufficient to correct most work. For the subtractive process, the colours needed are cyan, magenta, and yellow. For the additive process red, blue, and green filters are required. These can be used in the filter drawer or can be fitted to a rotating disc below the lens. One home enlarger uses three light sources that are mixed in the head and work on the additive principle.

The safelight, with a Kodak 10H screen, can be used to help you to orientate yourself in the darkroom if the light is indirect. Colour printing should ideally take place in absolute darkness, and it is best to organize the darkroom so that you can work without any light at all.

A daylight processing drum is necessary for processing colour prints because dishes cannot maintain the chemicals at the necessary temperature. There are a number of models on the market for home use. Most process one

print at a time and use small amounts of chemicals for economy. After the test strip or print has been exposed and loaded into the drum, all other stages can be carried out in white light.

A white light source is important because test strips and prints must be assessed for colour accuracy. Flourescent daylight-equivalent lights are available. Take prints into good lighting to check them if your darkroom is not fitted with a white light source.

Other equipment needed includes rubber gloves, paper towels, a dust-off aerosol, a sable brush, cotton gloves, enough containers for the chemicals you will use, a bucket to pour away used chemicals while working, a large container for pre-wash. Some form of voltage stabilization is recommended since voltage variations can be the cause of mystifying printing inaccuracies.

Colour Chemicals

There is a wide range of colour chemicals on the market and the best advice to the aspiring photographer is to work with the chemicals and follow the procedures recommended by the manufacturers of the materials already being used in the darkroom. Most processes are essentially similar, but there are small differences in time, temperature, and control, so pay particular attention to the manufacturer's recommendations and instructions. Try to maintain clinical standards in the darkroom.

Subtractive Colour Printing

For the test sequence, prepare all chemicals according to the manufacturer's instructions.

Wearing cotton gloves, clean the negative carefully, using a brush or aerosol. Insert the negative, compose and focus on the enlarger baseboard.

Use the matrix device or colour analyzer to measure the filtration needed. Dial it in on the colour head, or assemble the filter pack suggested for your paper by the manufacturer.

Make a test strip to ascertain the correct exposure time (see page 134) and to enable you to assess filtration.

Process carefully.

Assess the results in white light. Mark the filtration and exposure on the test strip.

The correct exposure is likely to have a colour cast. To remove it, the filters matching the cast should be dialled in or added to the pack.

Make an additional test strip, bracketing exposures more closely around the correct one found in the first test.

Process and assess in the same way.

Work logically towards the correct exposure and filtration. (Neutral density results from equal amounts of all three filters, and the lowest value should be removed from all filters. This allows a shorter exposure and a simplified pack.)

Having found the optimum exposure and filtration, make the final print.

Making and Processing the Print

Make the exposure at the ascertained optimum time and filtration.

Wearing rubber gloves, load the drum and turn on the white light.

Pour pre-soak into the drum at the recommended temperature. (This will vary with each type of drum and you should follow the manufacturer's advice exactly.) Save the pre-wash for further use after draining it off.

Pour in developer and agitate the drum by rolling or placing it on a drum-rotating device. Keep the rolling continuous and the timing accurate. Pour out developer several seconds before the end of the process. This pouring time varies with each drum and you should know how long yours takes. In colour development, timing is critical.

Pour in bleach/fix and roll the drum as before.

Wash. (All washing stages should use the prepared pre-soak water.)

Stabilize, rolling the drum throughout.

Remove the print from the drum and dry off the surface. Blot excess moisture and dry, using a fan heater or a dryer for resin-coated paper.

Wash the drum and equipment thoroughly, paying particular attention to the drum light trap. Contamination must be avoided in colour printing, so clean working methods are vital.

When processing colour prints, the most important points to watch are consistency of method, accuracy, and maintenance of temperature. Cleanliness in all stages is essential, as is the wearing of protective rubber gloves.

Additive Printing

Additive printing is not a common method in the home darkroom, but it has the advantage of allowing the photographer who only makes a few colour prints to turn out good prints with a minimum of financial outlay. One exciting use of the additive method for the printer who usually works in monochrome is the production of graphically exciting pictures using line or continuous tone negatives, and exposing the colour printing paper to these negatives through each colour. Processing is done by the normal colour print method.

The red, blue, and green filters used for additive printing will have to be held under the lens one by one. You must be able to select each one in the dark as it becomes appropriate. Also, when you are making the print you are actually exposing the emulsion layers separately, so the printing paper image must be kept still.

The test patch for additive printing is made by enlarging the image on the baseboard and selecting a representative area about three or four inches (7.50 or 10 cm) square. Adjust the masking frame to that size. Use the manufacturer's packaging reference for suggested exposure times for each filter.

Making a Test Patch

Expose the paper patch to the blue filter for ten seconds.

Put the green filter under the lens or in the filter drawer after removing the blue filter.

Using black card to mask off, give vertically stepped exposures to the patch for ten seconds, twenty seconds, and forty seconds.

Remove the green filter and replace it with the red filter.

Using black card, give horizontally stepped exposures for ten seconds, twenty seconds, and forty seconds.

After processing you will be left with a patch exposed as in the diagram.

If there is no satisfactory patch in this group, decide what the necessary change should be. To increase cyan give more red exposure. To increase magenta give more green exposure. To increase yellow give more blue exposure.

Once having made a test that produces a correct patch, make the final print, using the individual exposures for each filter which made up the total for that patch. Processing is the same as the method used in the subtractive printing process.

Matrix Devices

An average colour print that is both correctly exposed and colour balanced contains a number of colours that, if mixed, would probably produce a neutral grey. A matrix device makes use of this phenomenon to enable you to interpret the results of a test.

A matrix device has a number of translucent patches each of which has colour correction filters of progressive densities. (These run from a central, neutral grey patch.) One of these patches on the test print will be a neutral grey and a chart provided with the matrix will give the filtration needed in the enlarger to produce the final print. The matrix also has a step wedge for calculating exposure time.

To use a matrix device, place a piece of colour paper under the matrix and expose the paper to the negative in the enlarger, the light from which has passed through a diffusion disc or light scrambler installed under the lens. Process the paper and you will have a print from the matrix.

Printing from Transparencies

It is possible to make prints from transparencies by first making an internegative and printing from it. It is much quicker, easier, and cheaper, however, to enlarge on colour reversal paper and expose, using either subtractive or additive filtration. The prints must be given reversal processing. The paper comes with detailed manufacturer's instructions.

A special colour reversal paper, Cibachrome, is quite easy to use and requires only three solutions when developing — developer, dye bleach, and fixer.

While colour printing may at first seem quite complicated, materials and methods have in recent years become sufficiently standardized to promise rewarding results in return for care and practise.

Protecting Negatives and Slides

Storing Negatives

The basis of quality prints, negatives should always be protected from accidental damage and dirt. They are most easily damaged by humidity, high temperatures, and chemical fumes so don't ever store them in the darkroom where the air is always moist and impregnated with chemical fumes. Any storage system has to protect negatives and permit easy retrieval of individual negatives for future reference and printing.

Negative storage systems vary a great deal so choose the one that best suits the format you work in and the space available. Large formats aside, negatives are best stored in strips together with the contact sheets made from them. This provides an easy reference system and permits you to examine the contacts together with the negative. Negatives of 35 mm and 120 film can be stored in album pages divided into sleeves, which hold a complete film—the 35 mm in six strips of six negatives and the 120 film in four strips of three or more depending on the negative format.

The pages and the contact sheets can then be held in sequence in a ring binder or hung in the drawer of a filing cabinet. These transparent pages are the most convenient way to store negatives and there are a number of capacious designs on the market.

Negative bags are also available. They will hold either a large size individual negative or one strip in the small to medium formats. These can be filed separately from the contact sheets and cross-referenced to them.

Information about subject matter, date, and technical details, together with development information, can be written on the negative bag or page before placing negatives in them. Sheets of contact prints often have space with title lines to allow details to be written on each sheet.

The great photographer Edward Weston always filed his negatives in translucent envelopes. This method can be awkward for storing 35 mm negatives, but it is effective for those that are larger. It is important, however, to protect the negative, with a piece of paper perhaps, from the glue line of the envelope.

Contact sheets and negatives should be numbered together. The numbering system you use should be consecutive and progressive so that you can always add new pictures, locate an individual negative with ease, and return it with the same certainty. When printing, it is a good idea to number the back of your prints so you can always find the nega-tive when you want to repeat the print. If you also keep a notebook or reference file of subjects, you should be able to find any negative quickly and easily.

Storing Transparencies

The humidity, high temperatures, and chemical fumes that attack negatives are also responsible for the deterioration of transparencies, but they also fade in strong light. Transparencies should therefore be stored in the dark. A little bag of silica gel crystals in the box with the transparencies will help keep them dry.

There are several ways to store transparencies and the one you choose will depend on what you intend to do with them. If you only want to print from them, then cut them into strips like negatives and store them in the same way. Most people, however, want to project them for viewing and only make the occasional print.

Mounted slides can be stored in the boxes in which they are returned from the processor, and labelled with the date and subject matter on the outside. They can also be kept in special transparency boxes or drawers, of which there are several types available. A possible method is to keep them in projector magazines, although this can become expensive as a collection grows. Some manufacturers produce relatively inexpensive slide trays that hold the slides in sequence in such a way that they can be tipped directly into a magazine for projection. This is quite a good system since you then need only one or two magazines.

The big disadvantage of all these systems is the difficulty of previewing a group of slides. From this point of view, a more convenient approach to storage would be to use viewpacks. These are plastic sheets with pockets to hold individual slides, a clear front, and a translucent or frosted back so that the slides can be viewed on a light box or held up to the light. These viewpacks come as pages for a ring binder or with metal hangers along the top for use in a filing drawer. They have one small disadvantage which should be mentioned. The leading edge of the pocket can scratch transparencies unless they are removed and replaced care-

fully. With gentle handling this should not be a problem.

Viewpacks can be numbered and filed in the same way as negatives. Like negatives, transparencies should not be stored in the moist, chemical, atmosphere of the darkroom.

Mounting Transparencies

Transparencies are usually mounted for viewing or projection. This is done either by the processor or by the individual photographer. There are three main types of mount—card, plastic, and glass.

Card mounts are economical and, provided they are treated carefully, should last a long time and be perfectly adequate for most purposes. They may, however, gradually become creased and bent and jam in the projector. Sometimes, too, the apertures in card mounts have small fibres hanging from the edges which show up when the slide is projected.

Plastic mounts come in a range of types from simple folding ones that are fast becoming as cheap as card mounts,

to quite complex designs with pin registration for use in audio-visual presentations. They are simple to use, the aperture edges are neat, and they are extremely tough. They can also be used many times over, unlike card mounts which have only one lifetime. Projectors take more kindly to plastic mounts than to card mounts, since they are less likely to jam. They are the best mounts to use if you want to enlarge transparencies on reversal processing paper.

Glass mounts are usually made of two extremely thin sheets of glass on either side of the transparency held together by a metal or glass frame. The great advantage of glass mounting is that the transparency is held absolutely flat and consequently will not pop out of focus in the heat of the projector light path. They break easily, however, so don't use them for slides which will be sent through the mail.

Transparencies are most effectively labelled by sticking a small self-adhesive blank label to the mount. Information about the slide can be written on it.

Alternatively, use a felt-tip marker to write directly on the mount.

It is also important to put a "thumb spot" in one corner to indicate which way up the slide should be, so that it can always be placed in the projector the right way around and the right way up.

Index

Index

Acknowledgements

We would like to extend our thanks to all those who let
us use their photographs in this book. They include:
Fiona Almeleh; Martin Atcherley; Felicity Bryan;
Kay Casebourne; Kathy Dunster; Monique Fay; Derek Grace;
Arthur Hale; Anthony Jones; Robert Lamb; Robert Leong;
Peter Morgan; Alex Morrison and his family;
Paulette Pratt, Mary Rose; Susan Rose; Lucy Su; and
R.E. Tubb.
We would also like to thank the Offcentre Gallery,
London, and Vision International, as well as all those
who kindly allowed their homes to be photographed.

Photography
Special photography by:
Monique Fay 98, 99
James Johnson 46 *top,* 54 *top,* 58 *right,* 110, 111, 114 *top*
Di Lewis 18, 22, 23 *left,* 26, 27, 30, 31, 34, 35, 39 *top,*
43, 46 *bottom,* 47, 54 *bottom,* 55, 58 *left,* 59, 62, 63,
66, 70, 71 (except top centre), 79, 83, 86, 87, 90, 91,
94, 95 *right*
Kim Sayer 1, 4, 5, 11, 14, 38, 39 *bottom,* 50, 51, 67,
75, 78, 82, 103, 118, 123, 127, *cover photograph*
Tony Weller 6, 114 *bottom, back cover*

Additional photographs were supplied
by **Elizabeth Whiting Associates:**
David Cripps 15 *bottom*
Clive Helm, 19
Tim Street-Porter 15 *top*
Jerry Tubby 71 *top centre,* 95

Illustrations
Line drawings by:
Janet Allen 88, 89
Fiona Almeleh 12, 13, 53 *bottom right,* 69, 73 *right,*
96, 97, 120, 121 *left*
Phil Holmes 24, 25, 128
Rob Shone 28, 29, 37, 40, 41, 44, 45, 48, 49, 52, 53,
56, 57, 64, 65, 68, 72, 73, 77, 81, 105, 108, 109,
121 *right,* 124, 125
Ken Stott 16, 17, 20, 21, 33, 60, 61, 80, 84, 92, 93,
101, 105 *top,* 112, 113, 130, 131, 136, 138, 139

Index by **Naomi Good**

10.00